For
Fritz and Gwen Frost
&
Russell and Mildred Lynes
who often take Joan and me in
but seldom are taken in by
what I say.

Half a Truth Is Better Than None

John A.
Kouwenhoven

Half a Truth Is Better Than None

Some Unsystematic Conjectures about Art, Disorder, and American Experience

The University of Chicago Press
Chicago and London

John A. Kouwenhoven is emeritus
professor of English at Barnard
College, Columbia University. From
1941 to 1954 he was on the editorial
staff of *Harper's* magazine. He is
the author of, or contributor to,
numerous books in American studies,
most notably *The Beer Can by the
Highway: Essays on What's Ameri-
can about America* (1961), *Made
in America: The Arts in Modern
Civilization* (1948), and *The
Columbia Historical Portrait of New
York* (1953).

The University of Chicago Press, Chicago 60637
The University of Chicago Press, Ltd., London

©1982 by The University of Chicago
All rights reserved. Published 1982
Printed in the United States of America

89 88 87 86 85 84 83 82 5 4 3 2 1

Library of Congress Cataloging in Publication Data

Kouwenhoven, John Atlee, 1909–
 Half a truth is better than none.

 Includes index.
 Contents: A preliminary note on the lay of the
land—American culture: words or things?—The
trouble with translation—[etc.]
 1. United States—Popular culture—Addresses,
essays, lectures. I. Title.
NX503.K67 700'.973 81-24051
ISBN 0–226–45155–0 AACR2

Contents

Preface

Soon after I joined the staff of *Harper's* magazine in the summer of 1941 as one of Frederick Lewis Allen's assistant editors, we bought and published a remarkable poem entitled "Let Your Mind Wander over America" by Thomas Hornsby Ferril.[1] These lines are from its opening section:

> Let your mind wander, fluidly, freely,
> Marker or meadow, something your mother
> told you
> Not to be told of any other land,
> Birds, bison, cornfields, Model-T's,
> Brave men, cowards, songs you change for
> yourself
> .
> It's easier, I tell you, wandering that way
> Than being told too hard, too tight,
> too quickly,
> It will be gone if ever comes the time
> For being told to love America.

In the body of the poem a number of apparently unrelated particulars, inconsonant with one another in time or space or magnitude, become fused in a highly personal

1. *Harper's* magazine, February 1942, pp. 274–76. Also in Ferrill, *New and Selected Poems* (New York, 1952), pp. 153–57.

awareness of the nation's history and prehistory, somewhere

> Along the Lincoln Highway in Wyoming,
> Along the Union Pacific in Wyoming,
> Where Chinamen died and bison and Cheyennes,
> Where palm trees died and elephants and fish,
> Where oceans died and slowly changed to stone.

I remembered Ferril's poem with envy as I set out, at the publisher's request, to write a preface which might provide the reader with some notion of how essays dealing with such disparate aspects of American experience came to be juxtaposed as they are in the following pages. One of the prepublication readers had the impression that some of the essays were "more or less incidental" and that one in particular—the one on translation—did not fit the sequence. I hope I can make it apparent that from the point of view which is the real subject of this book the essay on translation is central and that *all* of the essays are designedly incidental.

Nothing is true or even half true except from the point of view where it appears so; that is why the first essay attempts to coax readers stationed at other viewpoints to move over, temporarily at least, to mine.

In the second essay I state one of my major themes as clearly as I can: the dangers inherent in accepting words (generalized verbal symbols) as the equivalent of the realities whose sensory particularity words are absolutely incapable of specifying. And in the course of the essay I make the point that our habit of accepting verbal symbols as the equivalents of things is "only one of many ways in which we have taught ourselves to accept translations of reality for the original."

Appropriately, it seems to me, the third essay moves directly to an analysis of the particular risks involved in the kind of translation we most often think of *as* translation—

the translation of the verbal symbols of one language into those of another. And the reader may notice that whereas the second ("American Culture: Words or Things?") essay ends with the assertion that "our primary allegiance, as sentient creatures, is surely not to the creations of our verbal ingenuity, but to the particular sights, tastes, feels, sounds, and smells that constitute the American world we are trying to discover," the essay on translation ends with the assertion that "humanity is not an abstraction but a set of particulars. There is no way to be universal, as Huck Finn for instance is, without being idiosyncratic, or to be international without being untranslatably localized."

From literature I turn, in the fourth essay, to urban history in the paired reviews of Mumford and Jacobs, but my subject is once again the consequence of permitting verbal generalization to substitute for the multifarious particularlities of the actuality we perceive with our senses. From cities I turn, not unreasonably, to architecture, and here again—as in the "Words or Things?" essay—I am dealing with that often ignored class of particulars which are the product of the "vernacular" when it is not inhibited by "the encumbrances of a massive culture."

That term "vernacular," to which I tried to attach a special meaning in *Made in America* (1948), has been widely misunderstood for reasons I deal with in the next essay ("Democracy, Machines, and Vernacular Design"). So it seemed to me important, in a book designed to clarify my point of view toward American experience, to clear up the misunderstandings. This essay is a major effort to overcome the generalizing obfuscation of the words "vernacular design" by scrupulously referring those verbal symbols to some of the concrete particulars I had in mind when I used them. It is my hope that those who read the essay will be convinced that it is a mistake to praise or to blame me for being a partisan of "the machine aesthetic," which—to the best of my recollection—I have never been.

Having (I hope) cleared up that misconception, I move on to a consideration of the Eiffel Tower and the Ferris Wheel, two significant vernacular structures, one European and the other American. My intention here is to give a clear sense of the particulars upon which I base my generalized assertion in the preceding essay that the vernacular developed more uninhibitedly in America than in Europe. And from this subject I turn—perhaps too lightheartedly—to an examination of a particular item of the vernacular (a dime novel) which, it seems to me, calls in question some approved generalizations about the American response to the technological elements of the vernacular.

Then come two essays on aspects of photography—the most important visual art (if art it be) whose roots are wholly in the vernacular though (like jazz—the other major art which grew out of the vernacular) it has been influenced, if not distorted, by the criteria of the cultivated tradition. If these two essays suggest to the reader ways of extending their insights into areas where I am unable or disinclined to carry them, I hope he or she will do me the kindness to believe that I felt a positive obligation to stop where I did and let my reader proceed unfettered by my company.

In the final essay I have tried to state the principal generalizations I have made on the basis of my earlier observations of the untranslated particulars of American culture, but even here I have tried to tie my generalizations rigidly to specifics. Like many others in my lifetime, here and elsewhere, I have wanted to understand the dynamics of American life. ("You can never tell when you will discover America. Columbus couldn't either," as the Hungarian journalist József Vetö told his readers some years ago.)[2] But I have become increasingly aware that what may seem to one or another of us to be a full and shining truth is, like the

2. "From a Journalist's Notebook," *New Hungarian Quarterly* 45, no. 20 (Winter 1965): 215.

full moon, only half of the actual object. What we call the half-moon is really only one quarter of a sphere whose dark side is absolutely invisible from the world I live in.

Township of Rupert, Vermont
23 June 1981

A Preliminary Note on the Lay of the Land

I own that to a witness worse than myself and less intelligent, I should not willingly put a window into my breast, but to a witness more intelligent and virtuous than I, or to one precisely as intelligent and well intentioned, I have no objection to uncover my heart.

Ralph Waldo Emerson, *Journal*
November 1841

I remember, as a child, having been shown a mountain named Camel's Hump. It did not look at all like a camel's hump to me; so I decided the name was a stupid one. It did not occur to me that the people who named the mountain might have seen it from a point of view whence it looked very much indeed like a camel's hump.

I think of this sometimes when I look eastward from the farm where I now live in the township of Rupert in southwestern Vermont—a farm whose meadows, cultivated by my neighbor Raymond Croff to grow extra corn, oats, alfalfa, and hay for his dairy herd, lie on the small of the back of a mountain range near the state border. Whether you turn right or left as you leave our driveway, you go downhill. If I turn right (westward), I am usually on my way down past Raymond and Pat Croff's house to New York City, where I used to work at Barnard College and now do occasional odd jobs. If I turn east, I am generally on my way down past Frederick and Judith Buechner's place to Dorset village to get the mail and shop and visit at Peltier's store (where the best Colby cheese in America is sold), or to Manchester, seven and a half miles beyond, which is our banking and market town.

As you drive down into the Dorset valley, the road curves south of east and then descends on a fairly straight

stretch where the highway points at Green Peak on the far
side of the valley. Though rather blunt and asymmetrically
knobby, the 3,185 foot mountain rising more than two
thousand feet above the valley floor looks enough like one's
idea of a peak to content you with its name, even if you
have seen Long's Peak or the Matterhorn. But if you turn
right in East Rupert and drive south along the West Road
toward Dorset, it becomes more and more symmetrically
pointed until its outline is that of a generous up-ended slice
of pie—a picture-book peak. Should you drive on to Man-
chester Center, however, and look back at it from there, it
no longer resembles a peak; it looks like the hump of a huge
camel (the cigarette-pack camel, or dromedary) dominating
the northern horizon.

There are many more people in Manchester than in Dor-
set and Rupert combined, and for them and the thousands
of tourists and vacationers who visit their town in summer,
fall, and ski-time, Green Peak may seem as stupid a name
for that hump as Camel's Hump seemed to me for that
mountain I saw as a child—unless they realize, as most of
them certainly do (though I did not), that things look dif-
ferent from different points of view.

A mountain is a fact and, as facts go, a relatively durable
one. Calling it Camel's Hump or Green Peak is making an
assertion about a fact. The assertion may be true yet seem
inappropriate or downright false to someone who sees the
same fact from another side or even from the same side by a
different inner or outer light.

In the essays that follow, written over the years since I
published *The Beer Can by the Highway* in 1961, I have
made assertions about a number of observable facts on the
cultural landscape eastward, westward, and southward of
where I live. At least I think they are facts; I have tried to
ascertain that they are, but a cloud on the horizon (or in
one's mind) can look amazingly like a camel's hump, or
very like a whale, and it is not always possible to get close

enough or wait long enough to make sure which it is. In any event, I make no pretense of having gone all around the facts about which I make these assertions. I claim only to have spoken as plainly as I was able about how they looked to me by the light available where I live—a not very populous region, as yet.

The facts that interest me most are objects and events testifying to the vital energies of what is called, wherever in the world it asserts itself, "American" civilization—that often untidy vernacular ferment produced when the technology of manufactured power and the democratic spirit work together. About some of these objects and events much has already been said by those from whose point of view they look like threats to long-honored systems of value. Indeed their threatening aspect has been so effectively portrayed—by such diverse publicists as Lewis Mumford, Herbert Marcuse, and the Friends of the Earth—that the portrayals have for the most part displaced the things themselves as focuses of attention. Once again we have an illustration of a truism first stated by William M. Ivins in his iconoclastic book *Prints and Visual Communication* (1953): that at any given moment the accepted report of an event is of greater importance than the event, because we base our opinions and consequent actions upon the report, which is a symbol, not upon the event itself.

One reason for this is, of course, that it is impossible to have firsthand knowledge of more than a very few of the things about which we feel obliged to have opinions. Even when neighborhoods were small, people based their opinions largely on the available gossip about what was happening in the community. But my neighborhood and yours is already worldwide and on the verge of being interplanetary; so there are more and more things we can persuade ourselves it is our responsibility to have opinions about. Thanks to television, the press, and the other worldwide gossip media, we have plenty of highly convincing

reports, verbal and visual, on which to base doctrinaire conclusions on matters of which we are really quite ignorant.

There are unheeded dangers in this, it seems to me. At a moment in history when it is increasingly difficult to cope with our private obligations, it is becoming easier and easier to mind other people's business instead of our own. Being more and more aware of the need for responsible action in our huge and interdependent neighborhood and less and less disposed to take responsibility for the things we are actually responsible for (our jobs, our family relationships, our daily decisions about what it is right or wrong to do), we play at being responsible for all manner of things we cannot in fact be held accountable for. This has, indeed, become almost a national pastime in recent years. By taking militant sides on matters of which we have no firsthand knowledge, we satisfy a deep need to feel like responsible citizens without really having to be responsible. No wonder the game is popular, and no wonder we decry whatever threatens to make our actual responsibilities so exigent that we have to stop playing and attend to them.

Much of the contemporary aversion to technology, for example, may well derive from presentiments that it will put an end to the game. For despite the commonplace assertion that technology dehumanizes mankind, the evidence I see suggests that it is in fact forcing more and more of us to assume the responsibilities of being human.

Think for a moment about our attitudes toward the technology of electronic surveillance—bugging, taping, and the rest. Surely part of the outrage we feel at the thought of someone's bugging our telephone or our living rooms is traceable to our consciousness of how irresponsibly, indeed inhumanly, we often talk behind other people's backs. We say so much we don't really mean that we shudder at the thought of being held to account for it. We do not really believe other people are human enough to understand the difference between what we say flippantly or

with a lazy indifference to truth and things we say with de-
liberate evil intent.

So we welcome legislation and regulations outlawing
evidence procured by bugging—not because we think the
criminal acts that bugging might reveal should go unpun-
ished but, in part at least, because we ourselves do not
relish being accountable for the thoughtless, stupid, or in-
decorous things we may have said. We don't want our
fellow human beings to catch us being human; we don't
sufficiently trust their humanity, because we do not trust
our own.

Bugging is simply electronic eavesdropping, and men
and women have no doubt eavesdropped since the first
house had eaves they could stand under, listening unseen
at the windows. Eavesdropping is the natural consequence
of our unauthorized curiosity about one another, and it was
inevitable that once the technology was available we would
use it. But it is also inevitable, I suspect, that if we gave
free rein to our unauthorized curiosity we would discover
only what eavesdroppers have always discovered, and
should have known without eavesdropping; that people
everywhere exemplify some of the less inspiring character-
istics of being human, including a proclivity to be too lazy
to speak and act responsibly at all times and a certain pro-
pensity to be cowardly, irrational, selfish, nosy, prurient,
or otherwise unattractive more often than they wish to be
reminded of. We would discover, in other words, that
other people are, like us, human beings—mostly decent,
though sometimes too lazy or weary or scared to be as
decent as they want to be; occasionally evil; now and then
splendidly wise and kind.

We are scared, of course, about having Big Brother
watching us, as the available electronic devices certainly
make it possible for him to do. We have legitimate doubts
about Big Brother's kindly intent. But unless, in a fatuous
neo-Luddite aversion to technology, we surround bugging
devices with so many safeguards that only Big Brother has

access to them, little brother will find ways to bug Big Brother—provided Big Brother does not spare him the necessity to do so by bugging himself, as has already happened in one notable instance.

Meanwhile it seems evident that the proliferating technology we denounce as a dehumanizing agent is, from one point of view at least, irresistibly pushing us a little farther toward the humanness whose responsibilities we are so reluctant to undertake. Like the candid cameras of an earlier period, electronic bugs will no doubt have their day of frenzied overuse, then take their place as useful extensions of our firsthand sensory awareness of our expanding neighborhood, as one more means by which we can see how things look from other points of view than the one available on the heights or in the lowlands where, for the moment, we happen to live.

American Culture

Words or Things?

A less succinct version of this essay
was published in 1963 by the Wemyss
Foundation as a pamphlet entitled
American Studies: Words or Things.
An amended version was included in
American Studies in Transition,
edited by Marshall W. Fishwick (Uni-
versity of Pennsylvania Press, 1964).

You may have read about Sir John Hawkins, the tough-minded and vigorous Elizabethan seaman who visited the French colony in Florida, at the mouth of the St. John's river, in the 1560s, in the course of one of his slave-trading voyages in Queen Elizabeth's good—but ironically named—ship *Jesus*. Hawkins reported, on his return to England, that there were unicorns and lions in Florida. The unicorns he knew about because some of his crew got pieces of unicorn horn from the French, who said they got them straight from the Florida Indians. So there was no doubt about the unicorns. As for the lions, Hawkins hadn't actually seen any of them, but there was no doubt about them either. Lions, as everyone knew, are the natural enemies of unicorns. It was therefore obvious, as Hawkins put it, that "whereas the one is, the other cannot be missing."

It is easy enough to see how absurdly funny Hawkins's report on Florida becomes when he accepts—as he does here—his own verbal ingenuity as the equivalent of reality. But I wonder if those of us who report nowadays on America are not as likely as Hawkins to be bewitched by our own verbal ingenuities. At all events, I shall ask you to follow me, along a somewhat circuitous route, through

some speculations about the verbal traps we lay for our-
selves, and about a possible way to avoid them.

II

Some years ago there was a trial in the New York Court
of General Sessions that the newspapers referred to as "the
Circus." It was a fantastic affair in which at one point a
defense lawyer called the prosecuting attorney as a defense
witness; at another the prosecuting attorney cross-
examined himself; and everybody on both sides repeatedly
lost his temper. Once, when the exhausted and frustrated
judge was trying to follow the rapid-fire argument of one of
the lawyers, he interrupted with a plaintive comment that
has haunted me ever since. "The only thing you say," ex-
postulated the judge, "that I don't understand are your
words."

Perhaps the judge's remark is especially haunting be-
cause we hear so much these days about the need for
greater speed in coping with words. Speed-reading is getting
to be the rage. Children in school, suburban matrons, and
business men are taking speed-reading courses. If they are
not careful, the only thing said to them that they don't
understand will be the words.

For words are deceptive enough, even if we take them
slowly, as the recent studies in semantics have shown. And
is it not curious that the science of semantics—the syste-
matic study of the relation between verbal symbols and
what they denote and connote, and of the way these word
symbols affect human behavior—should be flourishing at
the same moment in our history when we are energetically
learning how to hasten over those verbal symbols? The more
we are aware that words can be treacherously misleading,
the more we want to race through them, lest we be misled.
Perhaps we are doing so in justifiable self-defense.

For words are, in fact, deceptive and misleading—not
just because they are ambiguous, as we all know they are,
but because of an inherent limitation of language itself.

That limitation was pointed out a hundred and fifty years ago by a banker in Utica, New York, who made a hobby of the study of language. His name was Alexander Bryan Johnson. In 1828 he published a small volume entitled *The Philosophy of Human Knowledge; or A Treatise on Language,* made up of lectures he had given at the local Lyceum. Eight years later he published an expanded version with the title *A Treatise on Language, or The Relation Which Words Bear to Things,* and eighteen years later, in 1854, a third and even more fully developed version.

In none of its versions did the book make any impression upon learned circles at the time, since Johnson had no university connections and was unknown to the intelligentsia of Boston, New York, or Philadelphia. He sent copies to eminent men, such as Professor Benjamin Silliman at Yale and August Comte in Paris; but why would such people be interested in the ideas of a banker in Utica? As Comte said, in a curt letter of acknowledgment: "Although the question which you have broached may be one of the most fundamental which we can agitate, I cannot promise to read such an essay. For my part, I read nothing except the great poets ancient and modern . . . in order to maintain the originality of my peculiar meditations." The only serious review any of the three versions received was a long and favorable discussion of the first in Timothy Flint's *Western Review,* published in the frontier city of Cincinnati in 1829. Not until 1947—more than a century later—was the book rediscovered and republished by Professor David Rynin of the University of California, another frontier community.

Since its rediscovery, Johnson's book has come to be acknowledged as a pioneering study in semantics and one of the most original philosophical works ever written by an American. I take both these evaluations on faith, since I am neither a student of semantics nor a philosopher. All I can say on my own authority is that Alexander Johnson's ideas have profoundly impressed me, and that the objec-

tions brought against them by Professor Rynin himself, in his introduction to the reprint, and by other semantics scholars seem to me irrelevant. I intend to use and develop some of Johnson's perceptions although my comments do not find support in current semantic theory.

As Johnson saw it, the radical limitation of words (their radical "defect") is that they are general terms or names referring to things that are individual and particular. Even though we know, for example, that no two blades of grass are alike, the word "grass" suggests an identity. This suggestion of identity encourages us to disregard the different looks, feels, tastes, and smells of the uncounted blades that constitute the actuality of grass as we experience it.

Since words have this generalizing characteristic it is inevitable, Johnson argues, that if we contemplate the created universe through the medium of words, we will impute to it a generalized unity that our senses cannot discover in it. In our writing, thinking, and speaking, we habitually "disregard the individuality of nature, and substitute for it a generality which belongs to language."

One result of the delusive generality of verbal symbols is that two people can be in verbal agreement without meaning the same thing. You can say to me that television commercials are sometimes revolting, and I may reply, "Yes, they certainly are revolting sometimes." We are in complete verbal agreement. But the particular commercials you had in mind may not be the ones I was thinking of. Perhaps, indeed, I have never seen commercials like those you were referring to; perhaps if I had seen them, I would not have thought them revolting. I might have enjoyed them. The less our direct, firsthand experience of television commercials coincides, the less chance there is that any verbal agreement—or disagreement—we arrive at in discussing them will have any significance whatever.

III

Verbal symbols, then, are inherently "defective." They are at best a sort of generalized, averaged-out substitute for

a complex reality comprising an infinite number of individual particularities. We can say that a pane of glass is square, oblong, round, or a half-dozen other shapes, and that when it is shattered the pieces are fragments or slivers. But for the infinite variety of forms which those slivers in reality assume, we have no words. The multiple reality we generalize as "slivers of glass" can never be known through words. We can know that reality only through our senses, the way we experience blades of grass in lawns or commercials on TV.

This generalizing characteristic of language is, of course, its great value. It is what makes human communication possible. A language consisting of separate words for each of the particularities in the created universe would be bulky beyond reckoning. No one could ever master its vocabulary. We have good reason to be thankful for the ingenious symbol system that averages out reality into the mere ten thousand words that are necessary for ordering meals, writing love poems, and composing essays on American civilization. And no harm would come of it if we did not fall into the habit of assuming that reality corresponds to the words we have invented to represent it.

More often than not, however, we do fall into that habit. "What is this?" our child asks us, showing us what he has in his hand. "A stone," we reply—or, if we have had Geology I, "a hunk of quartz." Long practice has habituated us to this device for eliminating all those particularities of texture, of color, and form, of smell and taste that were the very things that interested the child. The averaged-out concept inherent in the word "stones" is admirably efficient for many purposes of communication, as when we are admonishing people who live in glass houses. But it does not tell your child what he has in his hand.

His senses tell him that. If he has learned anything from your words it is only that he must disregard the evidence of his senses. For the thing he has in his hand is not at all the same shape, or color, or feel as the one he asked about yesterday, which you also said was a stone (or a hunk of

quartz). You have begun to teach him to interpret reality by words, instead of interpreting words by the specific realities of which they are the symbols. You have given him an effective lesson in the convenient but deceptive process by which we habitually translate the individual particulars of existence into the generalized abstractions of language. Unless he talks about stones only with people who are familiar with hunks of quartz more or less like the one he has examined, he is on his way, like the rest of us, to the Court of General Sessions.

I have magnified the difficulties he faces in order to emphasize an important point. People who have not experienced similar particularities cannot receive from one another's words the meaning those words were intended to convey. For meaning is not a property of words, a static entity that words somehow embody. Meaning is a process that words sometimes facilitate: a process in which awareness passes from one consciousness to another. Words do not *have* meaning; they *convey* it. But they can convey it only if the receiving consciousness can complete the current of meaning by grounding it in comparable particulars of experience.

A man who has never been out of the American Southwest—who grew up in and has never left Santa Fe, New Mexico, for instance—and a man born and brought up in the Hebrides, off the western coast of Scotland, could not conceivably mean the same thing by the word "sunlight." The less our cluster of experienced particulars corresponds to that of people by whom our words are heard or read, the less chance there is that those people will understand what we are saying.

What makes language function as satisfactorily as it generally does, despite its limitations, is that we use it chiefly to communicate with those who share the set of experienced particulars we call our common culture. One way and another, we acquire some shared familiarity with a tremendous number of things. We get around, vicariously

or otherwise. Even in the Hebrides there are no doubt people who have visited Santa Fe—or Las Vegas, whose sunlight will pass for Santa Fe's except among the finicky. And if our words are heard or read by those with whom we share a significant accumulation of experiences, they *can* convey our meaning well enough for all practical purposes —and even for some impractical ones as well. They can do so, that is, provided neither we nor those to whom we speak abandon our allegiance to the particulars we have experienced.

IV

So far, my argument adds up to something like this: Our words can convey meaning only to those who share with us a community of experienced particulars, and to them only if we and they scrupulously refer the generalized verbal symbols to concrete particulars we are talking about. Your translation of an experience into words can be understood only by someone who can interpret those words by referring them to a similar experience of his own. If he cannot do that, the current of meaning is short-circuited. A Santa Fe experience that might be adequately translated by the words "My wife has a smile like sunlight" cannot be the experience into which those words would be translated by a habitual Hebridean.

It seems obvious, therefore, that we must determine the limits of our community of experienced particulars. This is another way of saying that we need to discover how common our common culture is. Otherwise we will waste a great deal of energy and time in feckless attempts to communicate with people who cannot help misunderstanding what we say.

To some extent our common culture is limited by geography. There are many places in the world where particulars like those we experience in New York, or Wichita, or Walla Walla are simply unavailable. To be sure, it would be naive to assume that geographical or political bound-

aries are the bounds of our common culture. A turret-lathe operator in Wichita might share a more significant community of experienced particulars with a turret-lathe operator in Bombay than with a professor of American literature who lived two blocks away. An economics student in New York or Walla Walla might share a more significant community of experienced particulars with a student of economics in Heidelberg than with a fine arts major at his own college. But the particulars that constitute American culture are by and large available in New York and Wichita and Walla Walla, whether or not the professor and machine operator, or the economics major and fine arts major, are aware of them; whereas in many areas of the world those constituent particulars are not available at all.

No doubt it is with some awareness of this problem that those of us concerned with American culture devote our efforts to programs like the international exchange of students and teachers, the encouragement of foreign tourism in this country, and the sending abroad of such cultural emissaries as Peace Corps groups, theatrical troupes, musical performers, and exhibitions of arts and crafts. Unwilling to trust to such routine agencies of international contact as commerce and the armed forces, we are deliberately making available to those in other lands certain particulars of our culture that we hope will serve to ground the current of meaning when we talk to them about ourselves. The only trouble is that we disagree among ourselves about which particulars we should make available. The State Department has its own ideas; some Senate committees have others; and private agencies like the American Legion, the Hollywood film exporters, and the Institute for International Education have others still.[1]

The lack of general agreement about which clusters of particulars constitute the distinctively "American" experi-

1. I dealt with some aspects of this problem in "The Movies Better Be Good," *Harper's* magazine, May 1945 (condensed as "Will We Lose the Freedom of the Screen?" *Reader's Digest*, July 1945).

ence emerged clearly from a symposium entitled *American Perspectives*, published by Harvard University Press in 1961 as one of the Library of Congress's series on twentieth-century American civilization. Ten distinguished authorities contributed essays to that symposium, discussing such "clusters of particulars" as American literature, American business, American philosophy, and American popular culture. The volume was edited for the American Studies Association by Professor Robert E. Spiller (a past president of the association) and Eric Larrabee (then managing editor of *American Heritage*). The auspices were impressive.

But despite a good deal of preliminary consultation and planning, and the best of intentions, the symposium admittedly failed of its purpose. As the editors ruefully acknowledge in their preface, "the hoped-for unity of the book did not materialize"; the contributors "found themselves in no firm agreement" either in their premises or in their conclusions.

I refer you to this book as one of the particulars I have in mind when I say that, up to now, we have not determined the limits of the community of experienced particulars we call "American culture." To put it bluntly, our verbal attempts to discover America fail because we do not know what we are talking about.

V

It is my conviction that part of our difficulty stems from an excessive preoccupation with verbal evidence. The particulars to which we refer—whether we are talking about politics or mass production, painting or social behavior—are too exclusively literary. Historians and social scientists are almost as bad as the literary critics in this respect. And so are the nonspecialists.

I do not mean to suggest that novels, poems, and plays —and other writings—are not significant particulars of our culture. I think they are, and I have earned my living as a teacher of courses in literature. But as I have tried to

suggest, we have a weakness for mistaking words for things. We tend to forget that a novel about life in the slums of Chicago is not life in the slums of Chicago.

The novel is a cluster of verbal symbols whose arrangement conveys to us, with more or less precision, the emotions and ideas aroused in the writer by those particulars of Chicago slum life that he happened to experience. The writer's emotional responses to Chicago slum life, and his ideas about it, may be in themselves significant facts of American culture—especially if the novel communicates them to many readers, or even to a few who act in response to them. But these emotions and ideas, and the novel that conveys them, are not Chicago slum life. That is something that can be known only by direct sensory experience; and if you or I experienced it, its particulars might arouse in us emotions and ideas very unlike those we acquire from the novel.

If we can accept some such view as this of the significance of literature and other verbal documents (including "case histories" and other data of the social sciences), we will realize how necessary it is to consider other kinds of evidence in our speculations about American civilization and culture. Verbal evidence is, plainly, not enough—especially if we remember that not all civilizations have found, in literature, the most complete or significant expression of their vital energies. It may be true that the creative genius of England has been most fully expressed in literature, and that we can more or less ignore English music, painting, and architecture without seriously distorting our image of England's achievement. But other cultures have obviously expressed themselves most significantly in other forms. One thinks, for instance, of Roman building, of Dutch painting, of German music. The fact that we are heirs to much of England's culture, including its language, does not necessarily mean—as Constance Rourke long ago pointed out—that we have, like the English, expressed ourselves most fully in literature.

In all of our studies of the past we probably rely, far more than we should, on verbal evidence, wherever it is available. As Lynn White, Jr. says in the preface to his book on *Medieval Technology and Social Change:*

Voltaire to the contrary, history is a bag of tricks which the dead have played upon historians. The most remarkable of these illusions is the belief that the surviving written records provide us with a reasonably accurate facsimile of past human activity. . . . In medieval Europe until the end of the eleventh century we learn of the feudal aristocracy largely from clerical sources which naturally reflect ecclesiastical attitudes: the knights do not speak for themselves. . . . If historians are to attempt to write the history of mankind, and not simply the history of mankind as it was viewed by the small and specialized segments of the race which have had the habit of scribbling, they must take a fresh view of the records.

The general pertinence of Lynn White's words to the problem of discussing American culture will, I hope, be clear. But I want to apply them in a special way.

It is important to recognize that, as White indicates, major segments of the population do not speak for themselves. Not everyone has the habit of scribbling (though it sometimes seems so). And I think it is true that in American civilization—and perhaps in what we call modern civilization elsewhere in the world—men and women whose work has most creatively expressed the energies of their times have often been nonscribblers. All of us, insofar as we rely upon our senses rather than upon verbal preconceptions, would acknowledge that American culture is expressed more adequately in the Brooklyn Bridge than in the poem Hart Crane wrote about it.

VI

I have talked a good deal about words, rather than about things. I have done so in an effort to call attention to the

limitations of words as evidence of the realities that consti-
tute our culture, hoping thereby to remove the chief obsta-
cle to the consideration of things. If we can get rid of those
verbal lions and unicorns, we may be able to see and hear
and touch and smell and taste the things that are really
here.

Archaeologists and anthropologists have long known
how important things are as testimony. And historians in
some areas have learned a good deal from nonverbal
evidence. Lynn White's book rescues the nonscribbling
knights and other medieval people from oblivion by ex-
amining things such as the stirrups that gave the knights
unprecedented control over horses and the cranks that gave
medieval mechanics new control over power. Similarly,
museums of folk art, and museums like those affiliated
with the Smithsonian Institution, acknowledge the impor-
tance of tangible objects as evidence of the culture of large
numbers of people who did not have "the habit of scribbl-
ing."[2]

It is chiefly from archaeologists and anthropologists that
we might learn techniques that we can adapt to the recog-
nition, appreciation, and evaluation of the nonverbal ele-
ments of American culture. We must, I am convinced,
learn to perceive and savor with our five senses the things
nonscribbling Americans have made, in somewhat the
same way that archaeologists or anthropologists approach
the artifacts and folk arts of other times and places.

A good deal of attention has been devoted recently to the
study of what are called American folk arts; but those en-
gaged in such study can contribute little to our under-
standing of American civilization for the simple reason that

2. Even such museums lapse all too often into preoccupation with
verbal evidence. See my review, "The 3-D World in Two Dimensions,"
of *A Nation of Nations: The People Who Came to America as Seen
through Objects, Prints, and Photographs at the Smithsonian Institu-
tion* (New York, 1976), in *Bookletter* 2, no. 24 (2 August 1976).

we really do not have any folk arts, properly so called. Those we have are other people's. For the term folk arts is properly applied to artifacts made in traditional forms and patterns that originated, and survive, among groups cut off, in one way or another, from the mainstream of contemporary life. The things we call folk arts are things like Navaho sand-paintings, Pennsylvania Dutch fraktur.

Surviving remnants of traditional folk arts can still be found in isolated communities of even this highly industrialized and urbanized nation. And many are the collectors and students who cherish them. So many, in fact, that the folk arts will soon be—if they are not already—a big business. But delightful and interesting as these handcrafted variants of traditional forms and patterns may be, they cannot tell anything much about American culture. The love of them, or the faddish popularity of them, can tell us a good deal. But the objects themselves cannot.

The nearest thing to folk arts that American culture has produced are those artifacts that I once labeled "the vernacular arts." The term has its limitations, but I meant it to serve as a generalized label for nontraditional forms and patterns of many sorts. By it I referred to objects shaped empirically by ordinary people in unselfconscious and uninhibited response to the challenges of an unprecedented cultural environment.

The principal novelties in that environment, in nineteenth-century America, were, it seems to me, a technology based upon power-driven machines rather than handcraft, and a social and political system based upon the mobility-oriented institutions of democracy rather than the status-oriented institutions of aristocracy. Specifically the products of the vernacular arts were the tools, toys, buildings, books, machines, and other artifacts whose texture, shape, and so on were evolved in direct, untutored response to the materials, needs, attitudes, and preoccupations of a society being shaped by the twin forces of democracy and technology.

VII

It is my contention that direct sensory awareness of such vernacular objects provides an important kind of knowledge about American culture. Perhaps, indeed, the most necessary kind if we are searching for a community of experienced particulars that embodies the dynamic energies of an emergent American culture.

Until very recently these important constituents of our culture were entirely overlooked by scholars and critics, and even now they are known chiefly through verbal accounts of them. It is no wonder that our verbal theories about American culture have seemed so irrelevant to people who know its everyday vernacular realities at first hand in factories and filling stations, on farms and in offices. If we are ever going to formulate useful verbal generalizations about our culture, we are going to have to look at, and handle, and contemplate the particulars of this vernacular tradition.

Ideally, of course, we should experience these particulars in the cultural context that produced them, not isolated from that context as displays in museums or World's Fairs or exhibitions. But wherever we encounter them, let us respect the things themselves and test whatever is said about them against our firsthand sensory awareness. It will not be enough to approach these vernacular things as we customarily approach the fine arts and folk arts displayed in museums. Go to any museum and you will observe how ready people are to permit words to usurp the dignity and authority of things. Some unfamiliar object on display catches our eye because of its form or color. We go over to examine it more closely, but before we have done more than glance at it we notice the label that the museum's curators have supplied in their ardor to educate us. The label probably provides valuable knowledge *about* the object—what it was made for; when, where, and by whom it was made; and so on—knowledge that might well sharpen our sensory awareness of the object if we returned to the contemplation of its form and color and texture. But

more often than not the label replaces the thing as the center of our attention; having mastered the words we are satisfied that we have mastered the thing. So we pass on to the next display and read its label.

As Joyce Cary says, in his little book *Art and Reality,* there is a good deal of truth in the notion that "when you give a child the name of a bird, it loses the bird. It never *sees* the bird again, but only a sparrow, a thrush, a swan." In all phases of our lives the primitive magic of words still works its spell among us, and we think that we have mastered creation by naming it. Like the child who is attracted by the form and color and feel of a particular stone or bird and asks "What is it?" we ask the label what it is that caught our eye. And like the child, we have been educated to accept the verbal reply as a substitute for the thing itself.

This is, of course, only one of many ways in which we have taught ourselves to accept translations of reality for the original. Even in nonverbal realms we increasingly encounter reality at one remove. More and more of us know the game of baseball not as a cluster of directly experienced sensations, including the mixed smells of cold beer and hot franks and peanuts and cigars, but as sights and sounds only, as selected and translated by TV cameras and microphones. Fewer and fewer of us know the taste of tobacco on the tongue, or the taste and feel of tobacco smoke, now that cigarettes have filter tips, some with the filters recessed a quarter inch away so you can't even touch your tongue to them. More and more of us experience the arts—literature, painting, sculpture, and music—filtered through some translating device. Many of us know painting and sculpture primarily through two-dimensional photographic translations that either distort the colors or average them out into tones. Most of the music we hear has been translated, with higher or lower fidelity, by microphones and electronic tubes or transistors.

These various forms of translation all differ in an important way from the sort of translation that occurs when we translate the particulars of experience into words. They all

alter some aspects of the thing, but they do not generalize it or average-out its uniqueness. A photograph of a scene on some Main Street translates a three-dimensional reality that can be experienced with all five senses into a two-dimensional reality that we experience only with our eyes; but the pictorial image, like the original, is a specific and individual thing, not a generalization. Any verbal description of the scene would, on the other hand, be composed of words that are generalized symbols, each capable of standing for (or referring to) many different particulars of the same general class.

VIII

To discover America, to become aware of American culture as a community of experienced particulars about which we can effectively communicate our perceptions to one another, we must first of all be aware of the limitations of verbal translations of reality. Then we can set about the job of training our young people and ourselves to think with our senses as well as with words.

At present our educational system is almost exclusively concerned with training our capacity to think verbally. What this means is that we learn to think words such as "bridge" or "beer can." We can think *about* those words and link them with others to form verbal concepts. These concepts are articulations and juxtapositions of words that have properties we call syntax, logic, and so on. And they can be recorded, memorized, and easily made available to others in identical copies.

The ease with which verbal concepts can be recorded and repeated is a great and powerful advantage. Word-thinking has become the basis of our educational system— except in those areas (notably the exact sciences) where vagueness and generalization are intolerable. In those areas apprenticeship, laboratory or studio work, or some other system of acquiring firsthand familiarity with specific particulars, has necessarily been retained. But so impressive

are the properties of language that subjects to which its generalizing properties are appropriate—subjects like philosophy, sociology, theology, and history (including literary history and art history)—dominate the academic curriculum.

I do not wish to belittle such subjects or to depreciate the wonderful powers of language. But we must not permit our admiration of word-thinking, and our respect for its achievements, to blind us to its limitations—limitations that derive from the inescapable limitation of words themselves: that is, their averaging-out tendency.

The danger is not that we will underestimate the importance of word-thinking in education, but that we will overlook the importance of what might be called sensory thinking. I do not know if there is a better word for it. But I know that just as we can think the words "bridge" and "beer can," we can also think the appearance of a bridge, or the appearance of a beer can. That is sight-thinking. As Alexander Bryan Johnson remarked, the properties and limitations of sight-thinking differ from those of word-thinking. A sight-thought of a bridge is evanescent; it flashes on our consciousness, then fades. Also, it is comprehensive, including all visible aspects of the bridge at one and the same instant, whereas a word-thought about a bridge has to be accumulated gradually by adding words together. Finally, and most importantly, the sight-thought of a bridge is specific, not generalized. We can sight-think an individual bridge, or even a group of individual bridges; but we cannot sight-think the generalized concept "bridge."

Just as there are sight-thoughts, there are also feel-thoughts, smell-thoughts, taste-thoughts, and sound-thoughts. The terms may sound odd and unfamiliar, but we all know the realities to which they refer. With a little effort we can think the feel of a cold beer can in our hand, and think the taste of the metal as we drink from it. And we know that these other sense-thoughts, like sight-thoughts, are evanescent, comprehensive, and specific.

These sense-thoughts share, then, a significant property that differentiates them from word-thoughts. They are specific, not generalized.

They also share a significant limitation, as compared to word-thoughts. They cannot be arranged in logical or syntactical patterns. The kind of direct and specific awareness we derive from sensory thoughts, unlike the awareness we derive from word-thinking, cannot be communicated symbolically to others in conventional forms that can be easily recorded, memorized, and reproduced in identical copies.

Yet, if we trained our capacities for sensory thinking, instead of discouraging them as our educational system customarily does, it would be clear that this limitation is an asset, rather than a liability, if only because the nondiscursive properties of sense-thoughts can serve as a check on the discursive thinking we do with words. The editors of that scholarly symposium on American civilization mentioned earlier concluded their preface with a wistful reference to the possibility that "if there were more unity in modern man's total view of himself and his world," the symposium itself might have produced a more consistent and unified image of our culture as one part of that world. What interests me in that conclusion is the implied assumption that there could be (or should be) a unified total view of the sort described. The very idea of such a unified and consistent view is, I suspect, a verbal illusion. It is an illusion we could not entertain if we had not become habituated, by our schooling and long practice, to accept words—unhitched from particulars—as the ultimate realities. Such terms as "modern man himself" and "modern man's world" are only remotely affiliated, if at all, with any of the infinitely diverse individual existences to which the terms pretend to refer. Who on earth, the reader should ask, is "modern man himself"? To what, if any, specific reality do the words refer?

But this is the very question we do *not* ask. Because we are educated as we are, we expect to find in actuality the

unity and consistency that verbal symbols can be arranged to express, forgetting that the unity and consistency are properties of a system of verbal symbols, not of the multifarious particularities that are averaged-out in our nominative generalizations. Because we are educated as we are, we too readily assume that in the realm of speculative discussion, as in the realm of faith, "in the beginning was the word."

In American Studies, as in the humanities generally, we have been largely preoccupied with records left by those "who had the habit of scribbling" (and more recently, thanks to the "oral history" projects, by those who had the habit of prattling). And it is chiefly from this verbal evidence that we have happily or gloomily deduced the lions and unicorns (as logically demonstrable and as nonexistent as Sir John Hawkins's) about which we theorize and argue. If there are no unicorns hereabouts, let's stop arguing about them. Our primary allegiance, as sentient creatures, is surely not to the creations of our verbal ingenuity, but to the particular sights, tastes, feels, sounds, and smells that constitute the American world we are trying to discover.

The Trouble
with
Translation

This essay, in a shorter version,
originally appeared in *Harper's* maga-
zine, August 1962.

There is an anecdote, possibly apocryphal, about a woman at a cocktail party in Paris telling James Thurber how much she had enjoyed his "delightful sketches" in French translation. "Thank you," said Thurber. "It is undoubtedly true that my writing loses a good deal in the original."

Thurber's humor, here as elsewhere, obliquely points to a truth: this time to the truth that a translation may be better literature than the work which inspired it. For example, for more than a century the best poets and critics in France have thought Edgar Allan Poe a much greater poet than English-speaking poets and critics have thought he was. Aldous Huxley, in *Music at Night,* points out that "the substance of Poe is refined; it is his form that is vulgar"; the distinctively "literary" part of Poe's work (his "walloping dactylic meter," for example), which is vulgar, is untranslatable into French. We can account for Baudelaire's admiration of Poe, Huxley suggests, only by the "happy ignorance of English versification" which permitted him to misread Poe's verse as if the stresses were even, as in French verse, and to hear in it "heaven knows what exotic subtlety of rhythm." Poe was himself aware of Frenchmen's insensitivity to the metrical effects of English versification. In his *Marginalia* he recorded "a striking instance of the Gallic rhythm with which a Frenchman regards the English verse," an inscription to the memory of

the English poet Shenstone by a French poet named Gerardin (writing in English):

> In his writings he displayed
> A mind natural;
> At Leasowes he laid
> Arcadian greens rural.

"There are few Parisians, speaking English, who would find anything *particularly* the matter with this epitaph," Poe asserted.

To say that translation may have such startling effects is not, however, to say that there is anything wrong with a reader getting what he can out of the work of writers in other languages, even if what he gets is not there in the original. The danger lies elsewhere. Translations are not the same thing as their originals. My purpose here is to call attention to some of the consequences of ignoring that fact.

A popular and respected young American writer was quoted a couple of years ago as saying that he was troubled because his writing sounded to him as if it had been translated from Russian. A good many young writers write as if they were being translated from some foreign tongue. And the reason, I suspect, is that a great many young men and women of literary inclinations form their tastes and their styles on translations.

If you look at the catalogue descriptions of college courses in "modern" literature; if you read the "literary" essays in undergraduate magazines or in the "literary" quarterlies; or if you listen to "literary" conversations among the young—you will notice that a high percentage of the books discussed are translations. Books originally written in English, or in American-English, are no doubt read in even greater quantities—but the literary touchstones, the dominant influences are foreign-language writers such as Camus, Sartre, Perse, Gide, and Proust, Moravia, Lorca, and Kafka; the great Russians, the masters of Zen, and the writers of *Haiku*.

A recent catalogue of paperbacks selected especially for classroom use listed forty-six titles under "Poetry"; exactly half were translations. Roughly one third of the titles listed under "Literature" were translations. Of the pick of the paperbacks in drama, more than half the titles were translations.

In many ways this is an encouraging situation. The implied awareness of universal humanity which is involved in such interest, and the breadth of sympathy which it suggests, are admirable. The "literary internationalism" that prevails among young American readers is obviously a significant fact, without any parallel in history. For the universality of literary culture in medieval Europe—which is the nearest approach to what we seem to be getting these days—was provincial by comparison. The medieval writer who, like Chaucer, kept in touch with contemporary literature on the continent, did not have to cope with anything like the diversity of material which now floods our book-racks from the other Americas, Europe, Asia, Africa, and the Middle East.

Moreover, the international literature of medieval times was written in an international language. Writers in all countries had at their command at least two languages: their own vernacular, and the Latin which was shared by educated readers throughout Christendom. Furthermore, most educated people knew more than one of the living vernacular tongues, and such a writer as Chaucer could read his French and Italian contemporaries.

Nowadays things are different. No generation of young "literary" people has ever been more linguistically illiterate than our contemporary Americans. Very few of them know any foreign language well enough to read it with an appreciation of its literary qualities. They talk of having read Dostoevski and Proust and Kafka; they have even "had" them, as they put it, in courses. But they can read Russian or French or German only with a dictionary, if at all.

What they have read is a translation—by no means the

same thing as the work itself. It may be better; it may be worse; theoretically it may be equally good or bad. But it is not the equivalent of the work which activated the translator.

The ways in which a translation differs from the original, and the peculiar qualities translations tend to share, are matters that should be of interest to writers as well as to readers. Yet they are commonly ignored. We all talk as if we had read Dostoevski, Plato, and Jules Verne even if we cannot read a word of Russian, Greek, or French. And those who edit and publish translations are as careless of the distinction as we are.

A conspicuous example was *The Question,* published in New York by George Braziller, Inc., in 1958. According to the title page it was by Henri Alleg, with an introduction by Jean-Paul Sartre. Nowhere in the book itself or on its dust jacket was there any indication that the words it contains were not written by either Alleg or Sartre. The book was completely printed, bound, and jacketed before anyone noticed this. Then a small slip of paper was inserted into each copy, bearing the words, *"The Question* was translated from the French by John Calder." Even with the belatedly inserted slip, the reader is unable to tell whether Sartre's introduction was translated or not, and if so, by whom. So we do not know, for example, whether it was Sartre or Calder or someone else who wrote the sentences obviously intended to convey the notion that the colonized people of Algeria were "undernourished, uneducated, unhappy" but which says instead that "the system of colonization" was undernourished, uneducated, and unhappy.

If this volume were unique in its disregard of the distinction between original work and translation, it would be merely a publishing curiosity. But there are many translations on the market which either ignore the distinction altogether or make so little of it that the reader is encouraged to assume that the book he is reading is the one written by the author whose name appears on the title page.

II

Many Americans have read what purport to be the plays of Henrik Ibsen in a volume published by the Modern Library. Nowhere is there any indication that the plays it contains were not written in English and that the texts here printed are translations from the Norwegian originals. Similarly, Dolphin Books issued a paperback edition of *Nana* which bears no indication of the fact that Zola wrote it in French and that some unspecified person made this English version of it.

It is bad enough that publishers are so casual about the distinction, but it is more surprising (and more damaging) that the scholars and critics who write introductions to these works ignore it. A Modern Library College Edition of *Faust,* for example, acknowledged on its title page that it is Bayard Taylor's translation of Goethe's original, but the scholarly introduction by Professor Victor Lange, Chairman of German Studies at Cornell University, makes only one oblique reference to the fact that the reader is not going to encounter, in this volume, the poetry of Goethe. The reader is told that he must remember that *Faust* is a work of the imagination and that he should recognize "the power of its poetic effects"; but nowhere does Professor Lange indicate that the poetic effects he will encounter are those achieved by Bayard Taylor's English, not those achieved by Goethe's German.

It was while reading Goethe that George Henry Lewes, the nineteenth-century English critic, became convinced that poetry was untranslatable. And in his discussion of the problem, he began by showing that it is even impossible to translate a line of English poetry into other English words.

Each of the following lines (which Lewes provided as examples) means, in a superficial way, what the others mean.

1. The river runneth free from all restraint.

2. The river flows, now here, now there, at will.

3. The river, self-impelled, pursues its course.

4. The river glideth at his own sweet will.

The last line, of course, is Wordsworth's, from the sonnet "Upon Westminster Bridge." Notice that each of the others conveys quite accurately a part of the sense of Wordsworth's line. Notice also that each of the "translations" preserves the basic pentameter movement of the original, which is rarely possible in translating to a foreign language, and that one of them even preserves the original rhyme sound. But notice also that the wayward rhythm of Wordsworth's line, with the swift movement over "at his" and the slowing down on "own sweet will," echoes the waywardness that is denoted by the words, while the strict de-dum, de-dum, de-dum of each of the "translated" lines is so disciplined that it denies the waywardness the words assert.

If the English language, which is so full of what we call synonyms, cannot provide an adequate translation of a line in English, it should be no surprise that translations into other languages are impossible. The Frenchman who reads André Gide's translation of Hamlet's speech to the players is certainly not getting the equivalent of Shakespeare's "trippingly on the tongue" in "d'une manière cursive et bien articulée." Abraham Lincoln's most famous utterance becomes somehow absurd when Etienne Gilson has to refer to it as the "Harangue de Gettysburg."

Such examples are not merely amusing; they illustrate a real problem—a problem whose implications for international cultural exchange are quite serious.

Just after the second World War, Sartre's magazine *Les Temps Modernes* published a special U.S.A. issue designed to give its readers an overall view of American culture. It included an article on "Les Negro Spirituals"—an excerpt from James Weldon Johnson's *American Book of Negro Spirituals,* translated by Charles Levinson and Sidney Pel-

age. Johnson points out (in the French version) that "beau-coup de ces chants perdent en charme lorsqu'ils sont chantés dans un anglais pur" and insists that "il serait pres-que sacrilège de rendre: *What kinda shoes you gwine to weah?* par *What kind of shoes are you going to wear?*" Yet the French translators apparently have no qualms about translating the spirituals into pure French, wherein "Jo-shua fit de battle ob Jericho" becomes "Josué combat devant Jericho" and "All God's chillun got wings" be-comes "Tous les enfants de dieu auront des ailes." Surely a Frenchman who read these translations would have little awareness of the essential qualities of Negro spirituals.

Dialect, it may be argued, presents special problems to the translator, but all colloquial language is difficult to do justice to in translation. It has been said that the reason Robert Frost never received the Nobel Prize for literature is that his idiomatic and colloquial diction is so much a part of the meaning of his poems that no translation gives any conception of their intensity. What is translatable of a de-ceptively simple poem like "Stopping by Woods on a Snowy Evening" would surely not suggest that it is one of the great lyrics in our language.

There are vast obstacles, however, to translating any poems from one language to another. Let us look, for example, at the opening lines of the *Faust* translation which Professor Lange offers the student in the Modern Library edition, and compare them with the opening lines of another translation, made some years ago by John An-ster. Both translators are working from the same original. Both passages picture the sun singing on its destined path, and both evoke the sound of thunder. But Anster's lines are an image of continuing motion:

> The sun, as in the ancient days,
> 'Mong sister stars in rival song.
> His destined path observes, obeys,
> And still in thunder rolls along.

Taylor's are an image of cessation:

> The sun-orb sings, in emulation,
> 'Mid brother-spheres, his ancient round:
> His path predestined through Creation
> He ends with step of thunder-sound.

One might argue that the differences are not important to the overall effect of the verse drama; that even the finality of Taylor's sun putting its foot down thunderously doesn't really alter anything essential to the whole. But the images of which a poem is composed are parts of an organic whole; they act upon one another and their effect is cumulative. Two *Fausts*, composed of two different sets of images, are two different poems.

As Reuben Brower demonstrated in a perceptive study of seven English translations of the *Agamemnon* written over a period of several centuries, each gave the reader of its time the kind of experience they expected dramatic poetry to give. In an Elizabethan translation Aeschylus sounds like Marlowe or Webster; in the eighteenth-century translations he sounds like Pope. But it is not just the sound that changes.

Near the end of Gilbert Murray's versions of the *Agamemnon* Clytemnestra calls upon "the Living Wrath which haunts this hall" to make a truce with her. In exchange for her accepting "all the affliction" he heaps upon her, he must go elsewhere now to haunt other men's houses. She concludes:

> I will keep
> Some little dower, and leave behind
> All else, contented utterly.
> I have swept madness from the sky
> Wherein these brethren slew their kind.

In Louis MacNeice's more recent version, Clytemnestra's bargain is with "the Evil Genius of the House of Atreus." She is willing to accept all that has happened, hard though

it is to do, provided he "leave this house" and afflict others
hereafter. And she concludes with:

> Of my possessions
> A small part will suffice if only I
> Can rid these walls of the mad exchange of murder.

Murray's utterly contented heroine is convinced she has
dispelled the atmosphere of madness in which the murders
were committed. MacNeice's is less sure of her success. She
will be satisfied "if only" she can rid the house of murder.

III

Some translators insist that, in spite of the admitted diffi-
culties, translation without loss is possible. One of them is
Dudley Fitts, whose knowledge of foreign languages was
infinitely greater than mine, who was a fine poet himself,
and who was the author of a most interesting play which he
entitled *The Antigone by Sophocles,* as well as of other
translations.[1] He argues that even though translation is, by
definition, a "carrying across," and even though it is
impossible to "carry across" from one language to another
those "nuances of diction, of sound, of tone" that make any
good poem an entity, poetry can nevertheless be translated.
The "proof" he offers is that, as I have already noted, there
are some translations which are better poems than the ori-
ginals—though how this proves his point I cannot imagine.
He concludes that although a translator's job is difficult, it
is not desperate if he is "poet enough to make a new poem
in the place of the other." This seems to me an argument
that "carrying across" a poem from one language to
another is possible because a poet can write a poem which
can pinch-hit for another.

Essentially the same argument is offered by Monsignor
Ronald Knox, translator of the Bible and other books, in

1. Mr. Fitts contributed to an important volume of essays, *On Trans-
lation,* ed. Reuben A. Brower (Cambridge, Mass., 1959). I am indebted
to several of the essays in that volume for data and ideas.

an essay "On English Translation" published in his *Literary Distractions* (New York, 1958). Monsignor Knox claims that the rhetoric and emphasis of the original can, with intelligent care and sympathetic understanding, be rendered in English. The only elements which cannot be given an English equivalent, he says, are such minor things as "tricks of manner," which the translator need not feel bound to imitate.

But what does he mean by "tricks of manner"? He answers this query by giving specific examples. The *Iliad,* for instance, need not be rendered in English hexameters, because the prosody of Homer is, presumably, a "trick of manner." Again, there is no reason, he says, "to use long sentences in your translation because your author (Cicero for example) uses long sentences. There is no harm in subordinating your sentences where your author—the Book of Proverbs, for example—is content to co-ordinate them."

This argument seems to me to lead to nonsense. Surely sentence length, co-ordination, and subordination are matters of rhetoric and emphasis and not mere "tricks of manner." A sentence is "a way of thinking" (as the derivation of the word from the Latin *sententia* suggests), and its grammatical and syntactical structure embodies and reveals the distinctive qualities of the writer's thinking process. Short sentences that reflect (and induce in the reader) discrete ideas in sequence, are certainly not the equivalent of long ones that interweave ideas and relate them to one another in complex patterns of thought. Nor is a sentence that subordinates one idea to another the equivalent of one that presents the ideas as coordinate equals. It is probably true that the *Iliad* should not be translated into English hexameters, but the reason is not that the original Greek hexameters were a mere trick of style. English hexameters have a ludicrous seesaw effect, which is anything but the equivalent of the Greek.

Elsewhere in his essay Monsignor Knox says, quite rightly I think, that the translations we call great ones—the ones we like to read—are those by men such as North (who

translated Plutarch) and Florio (who translated Montaigne), who, although "not always accurate," were determined "to produce a work of art, not a mere transcript of foreign phrases and foreign idioms, set out under the deadly apology, 'Well, that's what it says!'" Which I shall translate as the assertion that the great translations are the ones in which, though a good deal be lost, a great deal is gained. North's version of Plutarch may well owe some of its greatness to the fact that it is twice removed from its source, North having made his English classic from Amyot's French translation of the Greek original. Like the King James version of the Bible, great translations are not literally accurate, but they carry over from the original what *can* be carried and incorporate it in a unified work of art in another language. Those which do this come to have an authority of their own, the kind of emotional authority which led one devotee of the King James version to defend it against the claims of a more exact and literal modern translation by saying that what was good enough for Jesus was good enough for him.

IV
No one these days would, I suppose, maintain that the kinds of difficulty I have illustrated rob translations of literary works of usefulness. Nor would anyone be likely to argue that it is socially undesirable to have so many translations of great books cheaply available. The most recent argument of that sort I have encountered dates from the seventeenth century in an English version of *The Visions* of the Spanish satirist Don Francisco de Quevedo y Villegas. In one of the *Visions* a bookseller in Hell tells Don Francisco he was sent there because he sold translations so dog-cheap (in the language of the English translator, Sir Roger L'Estrange) "that every *Sot* knows now as much as would formerly have made a Passable Doctor, and every *Nasty Groom,* and *Roquy Lacquay* is grown familiar with *Homer, Virgil, Ovid,* as if 'twere Robin the Devil." There may still be traces of such snobbery in some quarters, but it is less

fashionable than it once was among the upper classes to assert exclusive rights to the best that has been thought and said in the world. Nevertheless, like most blessings, plentiful translations can be curses in disguise.

More than a century ago Emerson noted in his *Journal* that he was delighted by the way the "cheap press" and "universal reading" had called forth so many translations from the Greek, German, Italian, and French. "To me," he wrote, "the command is loud to use the time by reading these books, and I should as soon think of foregoing the railroad [which he loved to ride on] and the telegraph as to neglect these."

Yet, three years later, Emerson had some second thoughts on the subject. The "multitude of translations from the Latin and Greek classics" had played havoc with the study of those languages, he observed, since every student now had access to a translation of his author. "The only remedy," he wrote, "would be a rage for prosody, which would enforce attention to the words themselves of the Latin or Greek verse."

It seems to me that Emerson was right on both counts. My feeling is that readers should as soon (though no sooner) forego the airplane and television as neglect the translations of Oriental and European literature which are becoming so abundantly and cheaply available. But I also think they should be constantly aware (and that publishers, editors, and teachers should constantly remind them) that what they are reading is someone's English version of a work which, in its original language, had unique and untranslatable qualities. Further, they should remember that the more the original work depended for its effect upon those qualities which make literature a fine art, the less is translation able to provide equivalent effects. Mallarmé's translations of Poe may be "better" poems than those Poe wrote; North's translations of Plutarch may be as great a book as Plutarch's original; but those who read them have read Mallarmé's version of Poe and North's version of Plutarch; not Poe, not Plutarch.

We must, of course, have translations, especially in a world in which people who speak different languages are increasingly coming in contact with one another. And a good deal of the translation we make use of is quite exact enough for all practical purposes—even for distinguishing which door to go through if you are in need of comfort at some International Airport.

But even in the translation of nonliterary works, the difficulties are enormous. The *Rocky Mountain Herald* reported, some years ago, an instance of Moscow's difficulties with English. According to Claud Cockburn, former correspondent of the London *Daily Worker,* the Comintern put out an English-language weekly for the faithful. In one notable issue it solemnly proclaimed that "The lower organs of the Party in Britain must make still greater efforts to penetrate the backward parts of the proletariat."

Our own attempts to communicate with the Russians in their language may be no more successful. Thanks to Robert E. Alexander, the architect, I can pass along this cheering bit of news. According to Colonel Vernon Walters, President Eisenhower's official interpreter, some electronic engineers invented an automatic translating machine into which they fed 1,500 words of Basic English and their Russian equivalents, claiming it would translate instantly without the risk of human error. In the first test they asked it to translate the simple phrase, "Out of sight, out of mind." Gears spun, lights blinked, and the machine typed out in Russian: "Invisible idiot."

On the theory that the machine would make a better showing with a less epigrammatic passage, they fed it the scriptural saying: "The spirit is willing, but the flesh is weak." The machine instantly translated it, and came up with "The liquor is holding out all right, but the meat has spoiled."

Even so, the future of the automatic translating machine seems to be assured. Machines with larger and more discriminating vocabularies are being built. But the enormous cost of machines capable of translating enormously com-

plex language will, I suppose, result in powerful pressures to simplify and regularize the language in which we communicate, officially and otherwise, across national boundaries. I have heard that similar pressures are forcing the Japanese and Chinese to simplify their languages to meet the requirements of the typewriter, typesetting machines, and other mechanisms essential to modern industrial society.

Machines have a tendency to demand simplification and standardization of the material they work on, whether that be sugar beets which must be bred to sizes and shapes suitable for mechanical harvesting or language which must be modified to suit mechanical translators. And since translating machines can be helped to classify patterns of words (such as adverbial clauses and appositives) by punctuation and word order, there will be a tendency to stabilize and regularize conventions of punctuation and word order. There will surely be a tendency, also, toward a reduction of the inflected forms of words, an elimination of idioms, and the discovery of a minimal vocabulary with few, if any, near synonyms to discriminate shades of meaning or to convey overtones of feeling. There will be, in short, increasing pressures toward a language incapable of literary use.

V

To some extent all translating has a tendency to produce language unsuitable for literary use—at least to the extent that accuracy and fidelity to the original text are the translator's objectives. For one of the aims of a conscientious translator is, as Monsignor Knox has said, to become as nearly as may be Goethe, Proust, or whoever, so that all traces of the translator's personality disappear.

But if the translator conscientiously tries to eliminate his own personality from what he writes, and if the elements of the original which convey the author's personality are the very ones least likely to carry over into another tongue,

what can we expect in translations but writing that tends to be stylistically neuter? If the translator has a style of his own, he is under a kind of moral obligation to negate and unsex it in an effort to subordinate it to his original. Yet the style of the original is the untranslatable essence of the author's handling of his own language.

It is probably true that the vast majority of generally used words are translatable enough for all practical purposes. Joshua Whatmough, the eminent linguistics scholar, describes a statistical study showing that of the three thousand words, more or less, which make up the core of our vocabularies, as many as 95 percent are neutral in value. Such words, one presumes, have relatively exact equivalents in other languages—at least in languages spoken by people whose cultures are similar to our own. We need not consider here the staggering problems we would face with languages like that of the South American Indian tribe to whom the past lies ahead (since we can "see" it) and the future lies behind (since it is out of our range of vision). Imagine trying to provide that tribe with an adequate translation of "Backward, turn backward, O Time, in your flight."

In most translating, fortunately, we can count on a high percentage of neutral words which can be given neutral equivalents without much loss. But as Professor Whatmough points out, 5 percent of the words we ordinarily use are far from neutral. They have what he calls "strong and high-pitched overtones" which in fact "call the tune" and convey the real meaning of what we say. Such words, of course, form a much higher percentage of the words in literary prose (and advertising) than of those in everyday speech, and a still higher percentage in poetry. And it is their "overtones," their emotive and aesthetic values, which are precisely those "nuances of diction, of sound, of tone" which cannot be "carried across" to any words substituted for them.

What is "carried across" is the "purely referential"

meaning of the neutral meaning of the neutral words. To that will be added meanings deriving from the less numerous words which, however reverently the translator respects the "tune" of the original, can at best parallel or suggest the emotive and aesthetic overtones of the work he is translating. Whatever overtones a translation has, whatever real meanings it conveys, are supplied by the translator. To the extent that he translates freely, these overtones express his own personality; to the extent that he abjures freedom and strives for fidelity, his writing becomes stylistically neutral, or even neuter—which is to say, incapable of generating life.

VI

The significance of this fact is generally overlooked. Readers and writers who form their literary tastes upon a heavy diet of such neuter prose and verse may easily become habituated to a style which sounds—as the young writer I have quoted feels that his own does—like "something translated from the Russian." It is true, as John Hollander has pointed out, that writers of the past few decades have read widely in other literatures than their own, and that much recent poetry "has sprung from, or even consisted in, translations from writing in other languages." Ezra Pound and T. S. Eliot are only two of the most eminent and influential of the poets who have translated foreign works and incorporated translations in their own poems. It is also true, as Hollander was, I think, the first to observe, that "the styles worked out in connection with certain particular renderings" of foreign writing "have proved influential as poetic styles in themselves."

English prosody, and even English prose, has no doubt been enriched thereby—as it has been enriched by earlier influences from other languages. But not every translator has the genius to work out styles in connection with his translations which are desirable models of English writing. The great majority of translators evolve styles which, as we

have seen, are doubly deficient in personality since both the original author's and the translator's have been suppressed.

By all means let us read the great writers who have written and are writing in languages other than our own. But if we are going to learn style from Chekhov or Proust or Kafka, let us learn Russian, French, or German. In this area at least, translations are no remedy for our ignorance. The only remedy, as Emerson said, is "a rage for prosody," enforcing attention to the words the masters wrote in their own languages.

From the reading of literature in translation one can learn much, but not how to write in one's own tongue. Not even, I am convinced, how to read with due appreciation those who do write in that tongue. And I am disposed to wonder, when I look at a French translation of *Huckleberry Finn* for example, if we do not commonly exaggerate the extent to which translations broaden (or at least deepen) international understanding and our sense of mankind's universal humanity. For just as the Ideal of Woman can never, as the novelist Herbert Gold says, "replace the way Sally scratches her head," an abstracted ideal of the American world as seen by a boy adrift on the Mississippi can never replace the untranslatable particulars of the way Huck sees and describes that world.

Humanity is not an abstraction but a set of particulars. There is no way to be universal, as Huck Finn for instance is, without being idiosyncratic, or to be international without being untranslatably localized.

Urban Despair
and the Cities'
Hope

Lewis Mumford's *The City in History* (New York: Harcourt, Brace, & World) and Jane Jacobs's *The Death and Life of Great American Cities* (New York: Random House) were published within a few months of each other in 1961, and I was given the opportunity to review both of them for readers of the since-defunct *Herald Tribune*'s Sunday book section. (The review of Mumford's book was published 7 May 1961; that of Jacobs's book 5 November 1961.) In retrospect, neither review does anything like justice to the book under consideration, but when juxtaposed as they are here, they seem to me to add up to a comment I am willing to reiterate about some still-prevalent attitudes toward cities and the people who live in them.

Mumford's Study of Five Thousand Years of Urban Experience

This massive compound of erudition, impressionistic criticism, and polemic augury deserves and requires more consideration than a newspaper reviewer can give it. It may, indeed, be a great prophetic book; it may be primarily a somewhat cumbersome personal testament of not altogether explicable despair.

The book is a study of the development of cities from their roots in prehistoric villages to the contemporary megalopolis and the emergent symptoms of what may become a new urban order. Mr. Mumford deliberately limits his coverage to cities and regions he is acquainted with at first hand, but, even so, the scope of his work is enormous. The greater part of Western civilization is his province. A lifetime of dedicated observation and reading has given Mr. Mumford resources for apt and pointed illustration of his thesis which no other writer of our time can, I think, equal.

The fundamental questions he sets out to answer are: "Can the needs and desires that have impelled men to live in cities recover, at a still higher level, all that Jerusalem, Athens, or Florence once seemed to promise? Is there still a living choice between Necropolis and Utopia; the possibil-

ity of building a new kind of city that will, freed of inner contradictions, positively enrich and further human development?" The answers are distilled from the data of five thousand years of urban experience, as those data are seen through the eyes of a man who hates injustice, despises tyranny, and regards with anguished horror anything which robs the human personality of fulfillment.

It would be, I am convinced, unfair to pick out sentences or paragraphs from the book as "the answers" which Mr. Mumford gives. It is fair, however, to say that the book's tone is not hopeful, despite some passages which conscientiously present the more hopeful possibilities. There is, after all, an inadvertent bias against hope in the very questions Mr. Mumford sets out to answer. For if our choice is really between Necropolis—the city of the dead—and Utopia—the perfect city, even the most optimistic of us may justly doubt that cities will ever be "freed of inner contradictions." Indeed, Mr. Mumford's telling of the fateful story of urban transformations makes it clear that it is precisely because they embody man's own inner contradictions that cities are worth studying and writing about.

Cities are man's greatest and most interesting achievements, and Mr. Mumford tells us absorbing things about them. Readers will surely delight in his accounts of Knossos and the other Cretan cities, where windows were apparently first introduced in houses; or of Miletus and the systematic introduction of the rectangular city plan; or of Venice and its "functional zoning," facilitated, if not enforced, by its location upon islands. They will be moved, if not altogether persuaded, by his description of the pleasures of living in a medieval city and of the horrors of life in the new industrial towns of the nineteenth century.

In prose which has, at its least charming, a certain jargon-cluttered majesty, and at its best the passionate eloquence of Old Testament prophecy, Mr. Mumford challenges us to look squarely at the worst that man's cities have produced. Only then, he maintains, can we under-

stand what their potential role as "world centers" can be—a role to which he devotes only seven out of five hundred and sixty pages.

This proportion, which partially accounts for the generally despairing tone of the book, may be the chief structural defect of *The City in History*. Mr. Mumford's aims and purposes are high ones: he wishes to help us achieve a "life-oriented" civilization in which men are free of "the sterile dreams and sadistic nightmares that (now) obsess the ruling elite." If he emphasizes the "disintegrations" of the metropolis, he does so because he believes, rightly, that "only those who are aware of them will be capable of directing our collective energies into more constructive processes."

Yet his emphasis remains upon disintegration. The very mood of his rhetoric reinforces the structural proportions. Affirmative possibilities are stated, but at once undermined by negative qualifications. The whole book is haunted by dire second thoughts. A brief passage asserts the existence of signs of "a new pattern of life" from which we can deduce and anticipate "the next act in the human drama"; but the augury is at once clouded by a final condition: "provided mankind escapes the death-trap our blind commitment to a lop-sided, power-oriented, anti-organic technology has set for it." Again, a vision of fresh regional and civic patterns, by means of which we might transcend the "frustrations that have dogged the city throughout its history," is itself dogged by negation: "Otherwise," Mr. Mumford cannot help adding, "the sterile gods of power... will remake man in their own faceless image and bring human history to an end."

It is not unjust to question this despairing rhetoric, because the author invites attention to his prophetic role. Near the end (p. 556) he reminds us that his earlier book, *The Culture of Cities* (parts of which are incorporated in this), seemed to some critics to be unduly pessimistic. Lest we similarly dismiss his present portrayal "of our even

more dire condition," he tells us that all his prophecies in the 1938 book "were abundantly verified" by the destruction of cities in World War II. Yet the pertinent chapter of *The Culture of Cities* does not seem, on rereading, to support quite so absolute a claim. Neither the London blitz nor the bombing of Hamburg, for instance, revealed that "the dwellers in Megalopolis" had been reduced to "cowards upon whose blank minds the leader writes: Bravery."

Destruction there was, vast and terrible. But Mr. Mumford had underestimated the "creative" and recreative resources which had evolved in city life. The question arises whether he may not have done so again, this time in a book whose essentially historical structure does not permit the extended presentation of such imaginative and fruitful suggestions as those which made *The Culture of Cities* an exciting and forward-looking book. *The City in History* may, despite its noble intentions, appal more readers than it inspirits. Yet courage—informed courage—not dread is the mood in which man is most likely to achieve what Mr. Mumford's history was surely intended to help him achieve: a working equilibrium between those "inner contradictions" which throughout history have plagued him and the cities he has built.

Planning for a Lively and Diverse City Life

Mrs. Jacobs begins by announcing that her book is "an attack on current city planning and rebuilding," and so it is. An attack so devastating that it is unimaginable that city planning ever can be the same again.

Such an aggressive beginning may prove to have been a tactical error, even though the grand strategy of the book is sound. For Mrs. Jacobs's first sentence is likely to raise the hackles of a number of people who are as seriously concerned about the welfare of cities as she is. It will be surprising if the destructive part of her book—the clearing away of theoretical rubbish about cities which underlies everything from the design of housing projects to legislative

provisions for financing urban renewal—does not lead some reviewers and overhasty readers to conclude that Mrs. Jacobs is attacking the very idea of city planning itself.

Fortunately, she is doing no such thing. As she goes on to say, her book is "mostly" an attempt to introduce "new principles of city planning and rebuilding"—principles based upon the way cities actually work. And the way cities work is unrecognizable in current city planning, as Mrs. Jacobs's book will convince everyone from admirers of Lewis Mumford to admirers of Commissioner Robert Moses if they don't stop reading after they have finished the withering introductory chapter.

Starting with chapter two, Mrs. Jacobs examines the specific functioning of great cities (as distinguished from small cities and towns, which have characteristics and problems of their own). She shows us, for example, how the city's sidewalks function, when they are permitted to function, as "vital and irreplaceable organs of city safety, public life and child rearing." And when she has finished, she has forever demolished the current planning myth that city streets are inherently "bad" environments for human beings. She shows how and why many parks and open spaces remain desolate and unused instead of uplifting their neighborhoods and stabilizing real estate values. And in the process she forces us to see that it is nonsense to think of parks as "the lungs of a city" (since it takes three acres of woods to absorb as much carbon dioxide as four people create by breathing, cooking, and heating their homes) and that "open space" tends to increase air pollution (since the more open space there is, the more cars and buses are required to get around, as in Los Angeles). She shows how city neighborhoods really work to provide means for effective self-government. And by doing so she undermines that city-destroying ideal of "self-contained" neighborhoods which underlies all current project-building, most neighborhood renewal, and much zoning.

Having clarified the peculiar nature of cities, Mrs. Jacobs goes on to describe the indispensable conditions for the lively, diverse, and intense city life in which the seeds of regeneration germinate and flourish. The four chapters dealing with these conditions (chapters 8–11) are, it seems to me, the heart of the book, and no mere summary of them can suggest their force. They add up, as Mrs. Jacobs herself says, to the conclusion that in our great cities we need "all kinds of diversity, intricately mingled in mutual support."

The remainder of the book includes a section on the "Forces of Decline and Regeneration" at work within our cities, and one on "Different Tactics" for handling such familiar city problems as subsidized dwellings, traffic, and visual order, and for salvaging the slum-clearance projects which have degenerated into slums more demoralizing and dangerous than those they replaced.

Some of the tactics Mrs. Jacobs suggests seem to me almost as unsatisfactory as those she quite rightly wishes to supplant. For example, her proposal for a government agency to administer "guaranteed-rent construction" seems to me objectionable not only because of the opportunities for corruption which she admits it would offer, but also because I would be reluctant to entrust even to Mrs. Jacobs herself the decisions such an agency would have to make about what buildings could be built where, and what tenant can pay what rent. Mrs. Jacobs seems to think that colleges and universities have worked out satisfactory techniques for examining family incomes in allocating scholarship funds, and that similar techniques could be used in allocating rent subsidies. It is my impression, however, that income examination is far from satisfactory in scholarship allocation and that it would be even less satisfactory where the concentration of applicants under one roof encouraged the "gratuitous snooping and talebearing" which now goes on in public housing.

The value of Mrs. Jacobs's proposals, whether or not they prove to be applicable in precisely the form she suggests, is that they get us started on the job of putting her refreshing insights to work. Whatever modifications they would require in practice, they express the same invigorating belief in the creative and recreative resources of urban civilization that recently mobilized the citizens of Mrs. Jacobs's own district in New York in successful opposition to the kind of "urban renewal" her book unmasks.

It is a considerable achievement to have written a book that will irresistibly overturn the preconception of generations of city planners as Mrs. Jacobs's book will surely do. It is a still greater accomplishment to have formulated—out of firsthand observation and the suggestions of such maverick observers as Grady Clay, of Louisville, and William McGrath, of New Haven—a related system of fresh planning principles, especially when those principles are designed not to impose "a mask of pretended order" on underlying chaos but to foster the "innate, functioning order" which, as this book triumphantly reveals, is struggling in our great cities "to exist and to be served."

Architecture as Environmental Technology

An essay-review originally pub-
lished in *Technology and Culture*,
January 1970.

Reyner Banham's *The Architecture of the Well-Tempered Environment* (Chicago, 1969) succeeds in demonstrating that "outside the culturally protected circle of what is taught in architecture schools and discussed by architectural pundits" there has been, for almost a century, a tide of innovation in the technology of environmental management which has "dragged architecture with it, willy-nilly."

In the process of demonstrating this, Banham inevitably adduces evidence which will make it difficult to sustain the currently inflated reputations of some very famous modern architects, and of some of the historians and critics responsible for the inflation. He also provides data which will make it necessary to look more attentively at the work of a few architects and a number of nonarchitects whose role in creating a truly modern architecture has been largely ignored.

Modern architecture has hitherto been discussed and judged, as Banham observes, almost exclusively in terms of "the external forms of habitable volumes as revealed by the structures that enclose them," with little or no concern for the mechanical environmental controls which are largely responsible for the fact that the structures *are* 63

habitable. J. Burchard and A. Bush-Brown's *The Archi-
tecture of America* (1961) is, for example, the only ar-
chitectural history to point out that steel-frame construc-
tion and the elevator were not the only prerequisites for
skyscrapers; many other devices, including electric lights
and telephones, were also necessary. Yet, as Banham
points out, even these authors fail to mention two of the
principal devices which made skyscrapers habitable:
flushing toilets and the revolving doors which controlled
the tall building's thermal syphon—the strong updraft
which made doors hard to open and close, and which also
sucked in bad weather and dirt at street level and pulled it
up stairwells and elevator shafts to foul the whole interior.

The lack of interest in such things on the part of architec-
tural historians is, of course, a direct result of the fact that
the architects themselves have not been interested in them.
As long ago as 1898, the anonymous author of the "Review
of Architecture" in the *History of Real Estate, Building and
Architecture in New York City* (published by the *Real
Estate Record and Guide*) observed that no architect had
had much to do with the development of the sanitary
appliances, electric light and power, new building mate-
rials, fireproofing, and other "improvements" which made
skyscrapers possible. None of the forty-four mechanical
services involved in tall buildings, which this anonymous
writer listed in a footnote, had even, he pointed out, been
"in any great measure" the result of the architect's demand
"or of his perception of the requirements of his clients."

Architectural historians and critics have understandably
had small interest in things the architects themselves usu-
ally ignored or dealt with by proxy. It is interesting to note,
as Banham does, that little was written about the strong,
monumental external forms in which Frank Lloyd Wright
expressed his pioneer system of mechanical servicing in the
Larkin Building (1906), until they were discussed as a
stylistic source for the forms of Louis Kahn's Richards
Memorial Laboratories (1961) at the University of Pennsyl-

vania. Perhaps the explanation is that Wright, almost unique among architects in his vernacular-rooted acceptance of machine technology, simply allowed his mechanical services to become part of his overall architectural conception, so that those who were concerned with architecture as style did not even notice what he had done. Kahn, on the other hand, "thoroughly hates" pipes and ducts and therefore placed as many as he could outside the glazed towers containing his laboratories, in separate rectangular turrets, lest, as he put it, they "invade the building and completely destroy it." The "building," to Kahn, is distinct from the hated mechanical services that make it work (or at least are supposed to make it work); this separation is so crudely obvious in his overall design that not even the architectural pundits could overlook the effect of the mechanical services on the external form of the total structure.

It is Banham's contention that preoccupation with the external form of buildings reflects a basically nonhumane conception of architecture. The history of architecture (and, by implication, architecture as a profession) should, he maintains, "cover the whole of the technological art of creating habitable environments." Indeed, he reminds us that mechanical environmental controls have already produced "habitable volumes" which are not "structures" at all in the traditional architectural sense—for example, the movie drive-ins. The designers of these outdoor theaters need only provide a combination of landscaping, traffic engineering, electronics, and optics, plus a minimum of weather-shielding for the projection equipment, since the audiences bring their own portable "environmental packages" with them.

In the first edition of his splendid book *American Building* (1948), James Marston Fitch quoted the automobile manufacturer who, when asked what type of building would best serve his purposes, said, "No building at all." He meant, Fitch assumed, that the processes of automobile manufacture changed so often that none of the structures

known to the manufacturer were flexible enough or re-
placeable enough to be economically satisfactory. Fitch's
implication was that suitable structures could, and should,
be built. There was no implication that the car manufac-
turer might have meant precisely what he said, in exactly
the same way that a movie theater operator of that time
might have meant it. And the point of all this is that Fitch,
like the rest of us, was still thinking of architecture as
building, as structures, not as an activity which exemplifies
Buckminster Fuller's general theory of the progressive
ephemeralization of design (first stated in *Nine Chains to
the Moon* in 1938). Banham's book encourages anyone
familiar with Fuller's theory (and some of his subsequent
practice) to think that the time may come when homeseek-
ers as well as manufacturers may be able to specify "no
building at all" and be—like the movie theater operators
—satisfactorily accommodated. It does so precisely by its
persuasive insistence that architecture, rightly conceived,
is the art of creating habitable environments—whether
by means of structures, or by means of mechanical envi-
ronmental controls, or by an effective combination of
these.

Banham, the author of *Theory and Design in the First
Machine Age* (2d ed. 1967) and *The New Brutalism* (1966),
is reader in architecture at University College, London.
This new book of his began, he tells us, as a project for
writing a purely architectural history, one dealing with
"what architects had taken to be the proper use and exploi-
tation of mechanical environmental controls, and . . . how
this had manifested itself in the design of their buildings,"
but this turned out to be impossible. The specialized
studies and accumulations of data upon which such a his-
tory could be based had never been made, and in the end
Banham was able to produce a book which justly claims to
be only "a tentative beginning" in a field of study that has
been surprisingly neglected. When he set out to familiarize
himself with the history of the technology involved,

Banham was repeatedly told that Siegfried Giedion's *Mechanization Takes Command* (1950) had exhaustively covered the ground. That amorphous mass of valuable information, however, proved "in no way to deserve such a reputation." Its long sections on mechanization and the human environment, and mechanization and the household, completely ignore the history of artificial lighting by gas and electricity as well as mechanical ventilation and air conditioning.

The lack of any "general and compendious body of study" in the field meant that Banham had to ferret what he could out of scattered sources, such as trade magazines, and lectures to professional societies, encountered more or less at random. The result, inevitably, is a book not altogether satisfactory from the point of view of historical scholarship, however fruitful it is as an essay. Banham overlooked, for example, W. T. O'Dea's *Social History of Lighting* (1958) which might well have been useful to him, and he does not appear to have read C. Mackenzie Jarvis's chapter "The Distribution and Utilization of Electricity" in the fifth volume of the Oxford *History of Technology* (1958), which would have called his attention to R. E. B. Crompton's experiments with indirect electric lighting in the early 1880s. His book does have a brief note, "Readings in Environmental Technology" (p. 290), but only four books are listed. Beyond them the reader is referred to the books and articles mentioned in the footnotes; however, those notes are so constructed that it is difficult to make up a list of references from them, or even to track down the source of an interesting quotation or item of information.

More importantly, Banham's rather hit-and-miss methods of research resulted in his neglecting to follow up some of his most interesting perceptions. Early in his book, having distinguished between the traditional structural modes of controlling environment and what he calls "the regenerative mode" (involving applied power in the form of mechanical controls), he points out that "it is a fact—

though not an easy one to interpret," that the most vital advances into the regenerative mode were made in North America. "The history of environmental management by the consumption of power in regenerative installations, rather than by simple reliance on conservative and selective structures, is thus," he says, "a predominantly American history."

Of course, the problem is why this is so, and Banham suggests that the most important reason for it may have been the lack, in America, "of the encumbrances of a massive culture." European architects and inventors were not less ingenious or less determined than their American contemporaries; Banham points out that the Royal Victoria Hospital in Belfast, Northern Ireland, completed two years before Wright's Larkin building, was more advanced in its environmental controls than Wright's masterpiece was, though far inferior as architecture. "Doubtless Wright's towering genius had a great deal to do with this difference in quality," he concedes, "but that genius fed upon a far greater experience in the handling of regenerative tackle than any of his European contemporaries could boast, within the context of a culture that was far more convinced of the need for their exploitation."

For the purposes of Banham's essay this may be enough, but it would have strengthened his case, I think, if he had been able to make his readers aware of the vernacular cultural context in which Wright (and other less well-known American architects) became familiar with, and accustomed to handling, the "regenerative tackle."

Thanks in large part to the "lack of the encumbrances of a massive culture," Americans in general and American architects who did not have strong ties to Europe were evidently predisposed, from the beginning, to accept the concept of a dwelling as "habitable volume" rather than a structure. As early as 1848 Dr. Luther V. Bell, who designed some of the buildings for MacLean's hospital, told the Massachusetts Medical Society that proper methods of ventilating buildings must "commence almost at the cor-

nerstone and be kept in continuous design until the last finish." John Bullock's *American Cottage Builder* (1854) devotes 131 of its 326 pages to a chapter on "Warming and Ventilating," and it is significant of the vernacular "climate" that, in New York, E. V. Haughwout, who installed the first practical passenger elevator in the splendid iron-front store he built in 1857 at the northeast corner of Broadway and Broome Street (still standing), also adopted a very advanced built-in ventilating system for the residence he erected on Gramercy Square two years later. The system involved ventilating flues independent of the hot-air tubes which heated the house, but connected to them by lateral tubes with valves which permitted them to be warmed at night or whenever the hot-air registers were closed, thus causing an upward draft that insured effective withdrawal of foul air. The system, devised by Dr. John H. Griscom, was described and illustrated with a cutaway elevation of the west wall of Haughwout's house, in the 1859 volume of the *Transactions* of the American Institute of the City of New York, which awarded Griscom its large silver medal for his invention.

Banham does devote a few pages to Catherine Beecher's house plans of 1869—the fruits, as he says, of her "exposures to the facts of life and technology in the newly opened middle west"—with their now well-known radical innovations in planning, but despite his just appreciation of the way she left the outer shell of the house free of detailed relations to its internal economy and layout, he somewhat underrates her accomplishment so far as cooling and ventilating the house is concerned. "Every room used for large numbers should have its air regulated not only as to its warmth and purity, *but also as to its supply of moisture,*" she insisted (italics mine), and just as her ideas for her compact, efficient kitchen came from the steamboat galleys she had seen, she probably got her ideas about what we now call air conditioning from the railroad cars that ran between Cincinnati (where she lived) and Cleveland in the late 1850s and early 1860s. Thomas Low Nichols, who

traveled on that line in 1859, described the cars as "clean, airy, and cool" on the hottest summer days, thanks to "ingenious machinery" by which "a constant current of air was cooled and washed clean from dust by being made to pass through showers of water" (*Forty Years of American Life,* 1864).

One of Banham's heroes is the early German futurist Paul Scheerbart, whose book *Glasarchitektur* appeared in 1914. Scheerbart envisioned an architecture which would "remove the sense of enclosure from the spaces where we live," a glass architecture which would "let the sunlight and the light of the moon and stars shine into the room, not through a couple of windows but, as nearly as possible through whole walls, of colored glass." His vision, to be sure, was more firmly grounded in awareness of the technical realities than most such visions are (he knew, for instance, that double glazing would be necessary, that there would have to be new materials to replace wood for glazing bars, and that mechanical ventilation and radiant heating would be necessary), but its "visionary" quality would not have seemed to Banham so extraordinary if he had known of a book published forty years earlier by the American builder-architect Eugene C. Gardner of Springfield, Massachusetts, *Illustrated Homes: A Series of Papers Describing Real Houses and Real People* (1875). Gardner tells of a client, the invalid "Miss Moffat," who denounced contemporary houses as "not half warmed or ventilated. They are damp and dark, very well contrived to kill people, but not at all adapted to keep us alive." In her house she wanted her own room to be in the southeast corner. "Both the outer sides will be wholly of glass, and one entire side (the east side) will be movable; fixed so it may be raised up from the bottom and stand out like a piazza roof or awning." This will "turn the whole room out of doors without even moving the furniture." Furthermore:

> At the south side I shall have a glass bay-window with a violet glass roof. Somewhere in the top of the house I

shall put a large refrigerator, like an inverted furnace, to burn ice instead of coal, with pipes like furnace pipes running to each room to keep them cool in hot weather. . . . Of course the house will be warmed by steam as well as fireplaces. . . . This is a fearful climate at best (in western Massachusetts), and has to be made all over again if one expects to survive a single season.

Miss Moffat's bland assumption in the early 1870s that the architect's job was to make over the climate vividly documents Banham's contention that Wright's easy acceptance of the "regenerative tackle" was deeply rooted in a vernacular culture that was convinced of the need to exploit every device, structural or mechanical, which helped to create an architecture of the well-tempered environment. No doubt it was true, as said by Wright's forgotten midwestern predecessor, Louis Gibson of Indianapolis, that even in America "the architectural student's dream is not of kitchens, pantries, closets, convenient and economical arrangements of floor space," and that "no one ever heard of the matter of home-planning being discussed in a convention of architects." But Gibson was by no means alone in his conviction, stated in his book *Convenient Houses, with Fifty Plans for the Housekeeper* (published in 1889, four years before Wright designed his first house), that "it is part of the business of the architect to do what he can to make housekeeping easy," and that a distinctively American architecture would be "simply carrying out, in an architectural way, the requirements of the American people in their buildings. From their homes the march of progress will be through the kitchens, pantries, and dining rooms. . . . The exterior will be formed in a natural way by the requirements of the interior, and by the variations in climate." (He describes and recommends a heating and ventilating system provided with an automatic device for maintaining the proper equivalent of moisture in the air "at the temperature at which it reaches the rooms," thus providing "summer air in the winter time.")

Since there is no history of American architecture which is concerned with "the whole of the technological art of creating habitable environments," it is not surprising that Banham is unaware of men such as Bullock, Gardner, and Gibson. Their absence from his book merely points up the urgency of his insistence that we need a body of scholarship upon which such a history could be based. John Maas, in a recent issue of the *Journal of the Society of Architectural Historians* (March 1969), berated the architectural historians for the narrowness of their interests as revealed by an analysis of the 461 articles and book reviews published in that *Journal* from 1958 to 1967, inclusive. Yet even Maas, though aware of the need for studies of industrial architecture and what Bernard Rudofsky calls "nonpedigreed architecture," fails to call for the kind of history of the technology of environmental controls of which Banham's book is a pioneering example.

There are a number of things in the technological area that Banham might well have gone into more thoroughly. It is too bad, for example, that he did not pursue the suggestive remark, made several years ago by Russell Lynes in *The Domesticated Americans* (1963), that machine-made metal window screening was one of the most important nineteenth-century contributions "to comfort, to sanitation, to the preservation of sanity and good temper." No solid study of the manufacture and marketing of window screens, or their adoption by architects, has ever been made. Yet they were readily available in this country in the 1870s and as late as 1930 a group of sociologists at Connecticut Agricultural College found that people living in the country ranked them as the third most important of household amenities—after running water and sewage disposal, but ahead of electric lighting, central heating, and refrigeration.

As to air conditioning and the developments that led up to its widespread use in the late 1940s, Banham relies heavily on Margaret Ingel's *Willis Carrier, Father of Air*

Conditioning (1952), which includes a tabulated chronology of developments and inventions in ventilation and refrigeration, from the Renaissance to 1950. But it would have been interesting if he had been able to tell us more about the relation between air conditioning and such earlier developments as "controlled atmosphere" for the preservation of foods. I am thinking, for example, of Charles Alden's process for ripening vegetables and fruits, the "supermaturation" process, developed in Newburg, New York, as early as 1869. The process involved "rapid circulation of air, accurately adapted and progressive warmth, and a certain proportion of humidity" (see Horace Greeley and others, *The Great Industries of the United States* [Hartford, 1837]), and is one instance supporting Banham's assertion that the history of air-conditioning is a classic example of a technology applied first to industrial needs.

Despite its shortcomings, Banham's book accomplishes a good deal—enough, I think, to justify his modest hope that the buildings he has chosen to discuss typify the sort of architectural use (or abuse) made of various environmental technologies at various times in the past hundred years or so. Only after a great deal more technological history is known can we expect a detailed history of modern architecture conceived as "habitable volumes."

Meanwhile Banham's high-spirited and well-illustrated essay will have served at least two useful purposes. First (and perhaps most immediately), it will have made it impossible for architectural historians and critics, if not architects as well, to ignore vernacular developments in the design of houses and other types of buildings. Second (more generally), it will have required all of us to recognize the element of nonsense in pronouncements like that of Henry-Russell Hitchcock and Philip Johnson (in their joint communiqué of 1932) that technical developments were "rapidly forcing almost all commercial and industrial building into the mould of the international style." The fact is, as Banham makes clear, that the international stylistic

mould nearly strangled the technology it professed to exploit. While Le Corbusier, Oud, Gropius, and other architects were dogmatically devising the so-called international style in order, as Marcel Breuer claimed, to "civilize technology," the engineers and mechanics of the United States had, as Banham says, "devised a technology that would make the modern style of architecture habitable by civilized human beings"—and would ultimately create the possibility of a whole range of really modern architectural forms.

Banham's book shows that the range of choices now open to architects familiar with environmental technology is enormous and by no means confined to what can be done by mechanical controls. Near the end of his book he discusses at some length Emslie Morgan's Saint George's School building (1961) in Cheshire, England, where a high degree of environmental control is achieved with a minimum of mechanical equipment (not even a heating plant; just a time-switch for the lighting fixtures). By and large, however, the mechanical possibilities offer the greatest freedom of choice to those designers who are interested in evolving an unregimented (and unregimenting) "architecture of the well-tempered environment."

Democracy, Machines, and Vernacular Design

This essay was first published in the *Ohio Review* 14, no. 2 (Winter 1973). Earlier versions were delivered as lectures at the University of Vermont and at Ohio University, and those in turn grew out of lectures prepared for a course I taught at Barnard College, Columbia University, entitled "The Vernacular in the American Arts of Design."

It can be said, I think, that we see by means of our preconceptions. Our preconceptions are much like the blinders worn in the old days by horses in our cities—leather flaps attached to their bridles to cut off their peripheral vision, eliminating the chaos of confusing sights that might otherwise have bewildered them. By means of those blinders the horse's vision was focused on what he was supposed to see—the way ahead through the crowded city streets. Like those blinders our preconceptions make it possible for us to see clearly by directing our vision, but like them they do this by preventing us from seeing anything except what our channeled and restricted vision is aimed at.

For most of our history we Americans have looked at our civilization while wearing blinders composed of two related preconceptions. One of these is that American civilization is a mere extension across the Atlantic of Western European civilization. The other is that the arts consist of those forms of expression traditionally classified as arts in Western European culture: mural painting, easel painting, symphonies and sonatas, plays and novels and sonnets, temples and palaces and tombs.

The result is that we are accustomed to think of our

culture as imbedded in a continuum we call Western European Culture. Our historians and critics recognize, of course, that American conditions modified the techniques and forms brought over from Europe. They have studied with great care the way the design and construction of barns in southern Germany, or the repoussé decoration of French silverware, or the moldings and cornices of English Georgian architecture were modified in this country to suit the materials, climate, and different social circumstances existing here, just as English common law and French political theory were modified by transatlantic conditions. But these modifications of traditional forms did not alter the fact that the forms themselves were European. "What is the culture and genius of America?" asked Thomas E. Tallmadge, one of our most influential architectural historians. And he answered bluntly: "It is European." There has, to be sure, been increasing attention in recent years to our Oriental and African heritage, and even to our heritage from the American Indians. But the proliferating books and new college courses about these non-European influences have not significantly altered our habitual assumptions. All they seem to have done is make some of us feel a little guilty and apologetic about the Western culture we assume we possess.

The way most of us look at our civilization most of the time is still controlled by the two preconceptions I have mentioned: that our culture is at bottom European and that our arts are the arts of the Western European tradition. The blinders composed of these preconceptions have been enormously useful. Historians and critics wearing them have produced most of the important studies of our cultural history and have made valuable contributions to our knowledge and understanding of American painting and sculpture, literature, architecture, and music. Yet it became evident some years ago that if we limit our attention to the development and modification in America of forms

originated in the arts of Western Europe, we put ourselves into a strange box. Back in the early 1930s, when I was a graduate student, it was common to hear or read scholars and critics saying the American national genius had never expressed itself as adequately, as nobly, in the arts as it had in politics. "Our literature," one wrote, "has always been less American than our history," and similar statements were made about our music, painting, and architecture. American civilization, we were told, was inimical to the arts.

Such statements were obviously preposterous, since the arts are by definition the most complete and perfect expression of a civilization. If the arts seemed unrepresentative of our civilization, it must be that we were defining "the arts" too narrowly, leaving out forms of expression to which our preconceptions had blinded us. What was needed was a new set of blinders to focus our vision on the forms we had disregarded.

One response to this need was the development of interest in what is called folk art—the collecting and studying of everything from folk songs and hooked rugs to cigar-store Indians. This led to the formation of some great collections, most of which contain many fascinating and important objects that are not really "folk art" at all.

A different response was the one I first put forward in "Arts in America," an article published in the *Atlantic Monthly* in August 1941, and later developed in a book entitled *Made in America: The Arts in Modern Civilization* (1948).[1]

In the 1941 article I proposed a new method of approach to our artistic history, based on a new set of preconceptions. As I said in that essay, forty years ago, "The framework of the method, stripped of all elaborations, postulates two streams of art in our history, flowing in separate channels till they merge as a single stream of American art."

1. Currently available in paperback as *The Arts in Modern American Civilization* (New York: Norton).

One of these was the development of the transplanted arts of Europe, which I labeled "the tradition of cultivated taste." The other was what I labeled "the vernacular," a term I will return to in a moment. The true history of American Art, I contended, was the history of the interaction of the cultivated tradition and the vernacular and their alternate ascendancy in the creative work of different people in different periods.

That term "the vernacular" was not, as I acknowledged earlier in this book, altogether satisfactory, but it was the best I could find to distinguish the neglected stream of art I was interested in from the folk arts. One of the principal dictionary meanings of vernacular is "the common everyday language of ordinary people in a particular locality." The stream of art I was concerned with was what I described in my 1941 article as "a people's art, democratically patterning a technological environment," an art resulting from the efforts of ordinary people to make satisfying patterns and designs out of the novel elements introduced into their environment by democracy and the machine.

My conception of the vernacular rests upon a basic premise or assumption, namely that there has been a real, though only partial, discontinuity in human history. It is my premise that roughly two hundred years ago the idea of democracy, what might be called the democratic impulse, and the technology of manufactured power quite suddenly collaborated to introduce unprecedented psychological and physical elements into man's environment, elements for which it was necessary to find appropriate and satisfying forms. The innumerable, often anonymous acts of arranging, patterning, and designing that went into the creation of those forms constitute the vernacular as I conceive it. In contrast with the folk arts, whose makers are skilled craftsmen following an ancient and traditional sense of design, vernacular designs are evolved without traditional precedents. Their makers are necessarily tyros, since there

are no highly developed craft techniques or design standards for shaping new material to new ends.

In the years since publication of *Made in America* a number of historians and critics have reckoned with the vernacular as a significant aspect of the history of our arts, but many of them have proceeded on the assumption that by vernacular design I meant simply technological design. I still find myself being quoted, sometimes approvingly, as saying things about technology and the arts which I in fact said about the vernacular and the arts. My notion that the vernacular mode of design is a result of the joint influence of democracy and modern technology was evidently not stated forcefully enough in that long-ago book of mine. Even the historian Walter Prescott Webb, who devoted a whole chapter of his final book, *The Great Frontier* (1952), to an exploration of the implication of my thesis, minimized my concern with the democratic elements in the vernacular. "With his eye on technology," Webb says, "Kouwenhoven . . . proceeds from the simple tool to the complicated machines which surround us today, expounding the rational view that they are also American masterpieces of art." Since my eye was not on technology alone, I would like to take this opportunity to redress the balance and reassert the importance of democracy, or the democratic impulse, as one of the twin forces that produced vernacular design.

One way to do this, I suppose, is to trace the development of the design of an object we generally think of as a purely technological artifact and show that many of the elements included in its design were injected into the environment by democracy, not by technology. So I shall ask you to follow me in a genetic analysis of the design of the railroad locomotive.

Before looking at the locomotive, however, I want to make a few general points about vernacular design. A number of people have written or talked about the ver-

nacular as if it were an exclusively American development. Of course it is not. Neither democracy nor modern technology originated in this country. Both have collaborated in the past two centuries to affect human society everywhere. The steam locomotive whose design we will consider originated in England, not America.

But there is an American vernacular, just as there is an English, German, French, Japanese, Swedish, and Russian vernacular. And our vernacular has, it seems to me, a special significance—not just because it is ours, but because the United States is the only major nation whose civilization took form precisely in the two centuries since the combined energies of democracy and modern technology began to reshape the world.

I am aware, of course, that the idea of democracy and the drive toward it has a long history. I am also aware that many of the constituents of modern technology have been around a long time, and that, even before Columbus discovered America, mechanics in Flanders had invented the compound crank and made the Model-T Ford and the Mustang an inevitability. But no one, I suppose, would seriously argue that modern civilization dates from Ancient Greece or fifteenth-century Flanders.

For the sake of historical convenience, 1776 is a more sensible date to choose. That was the year of the Declaration of Independence, which gave operative significance to the assertion of the "self-evident truth" of human equality and effectively proclaimed the principle that governments exist to secure for individual human beings the right to "life, liberty, and the pursuit of happiness." That was also the year when James Watt's first practical condensing steam engine went into operation at John Wilkinson's Bradley Iron Works in England, inaugurating the era of manufactured power. That was the year when Abraham Darby III, together with John Wilkinson, formed a company to build the world's first example of iron architecture

—the cast iron bridge still spanning the Severn River at Coalbrookdale, England. And that was the year of Adam Smith's *The Wealth of Nations,* the most influential single exposition of the theory of modern industrial capitalism. American civilization has taken form, therefore, precisely during the years since these major events signified the beginning of what we recognize as modern times.

What makes the United States unique among those nations peopled predominantly by Western Europeans is that the vernacular was free to develop here more uninhibitedly than elsewhere. In England and on the continent the forms of the cultivated tradition had an authority and influence they never had here. For one thing, insofar as they could be transplanted to these shores, they lost some of their authority in transit. Many of them, such as the half-timbered house and thatched roofs of English architecture, were found to be unsuitable in our climate. Others, including many of the traditional forms of belles lettres, painting, and sculpture, fell into disregard for want of the aristocratic patronage that supported them. Even in urban centers on the Eastern seaboard, where contact with Europe was most effectively maintained by the educated and the wealthy, the prestige of traditional forms was weakened, and the farther out from the coastal towns one went, the less was their influence felt. There were never any thatched roofs west of the Alleghenies.

But geographical remoteness and differences in climate and terrain were not, I think, the principal factors in depriving traditional forms of their dominating influence. More important, in my judgment, was the fact that the people who came here to live were those least content with the traditional forms and values evolved in aristocratic societies founded upon agriculture and handcrafts. Those who were content with the traditional forms stayed home. It was the discontented, those in favor of change and psy-

Figure 1. British passenger-train engine, Midland Railway, 1875. (Reproduced from *Scientific American Supplement,* no. 27, 1 July 1876.)

chologically prepared to adapt to it, who came. Among such people the shaping of elements introduced into their lives by democracy and the technology of power-driven machines developed very differently than it did else-where—even in England, where many of these unprecedented elements first appeared.

The differences in the development of vernacular design here and in England are dramatically evident if we set a picture of a typical first class English passenger locomotive of 1875 side by side with its American counterpart of the same year. Figure 1 pictures an express engine built in 1875 for the British Midland Railway. Figure 2 shows an American express engine built that year for the Baltimore and Ohio Railroad. Each is typical of locomotive design in its country after almost a half-century of development.

As you look at these two forms, bear in mind that the basic original design problem, of which they are contrasting solutions, was the same: to combine in effective form an engine to manufacture power and the mechanism necessary

The "J. C. Davis" of the Baltimore & Ohio Railroad, 1875. (Reproduced from *Iron Horses: American Locomotives, 1829–1900,* by E. P. Alexander. By permission of W. W. Norton & Co., Inc. ©1941, 1968 by E. P. Alexander.) Figure 2.

to convert this manufactured power into easily controlled motion along iron rails. How then can we account for the striking differences we see here? Why is the British locomotive so massive and rigid and stubby compared to the American locomotive? Why does it have that heavy iron framing beam running the full length of the engine, while the American does not? Why are its huge driving wheels partly encased in metal shields though there is only a thin half-hoop over the smaller American wheels? Why are the number and arrangement of wheels different? Why are the smokestacks so different in shape? Why is there a bell on the American locomotive and none on the British? Why does the American locomotive have a cow-catcher and a headlamp at the front end, while its British counterpart has none? And why is there only a small windscreen to protect the engineer and fireman who operated the English locomotive, but a full cab with glazed windows on the American?

Let us go back to the beginning and see how these ver-

Figure 3. The "John Bull," built in 1831 by Robert Stephenson at Newcastle-on-Tyne, England, for the Camden and Amboy Railroad. (Reproduced from *American Locomotives*, by John H. White, Jr. By permission of the publisher. ©1968 by The Johns Hopkins Press.)

nacular variations originated. Figure 3 is a drawing of a typical English locomotive of 1830—the "John Bull," built at Newcastle-on-Tyne by Robert Stephenson, son of George Stephenson, who had designed and built the first really practical railroad locomotive, the "Rocket," just a year before. Figure 4 is the "Brother Jonathan," designed by the self-taught American engineer John B. Jervis and built at the West Point Foundry in New York City in 1832.

Stephenson's "John Bull" was built for the Camden and Amboy Railroad in New Jersey and was shipped here in parts to be assembled at the railroad company's Bordentown shops. It was probably the fifth English locomotive exported to the United States. The "Brother Jonathan" was

The "Brother Jonathan," designed by John B. Jervis in 1832 for the Figure 4.
Mohawk & Hudson Railroad. (Reproduced from *American Locomo-
tives*, by John H. White, Jr. By permission of the publisher. ©1968 by
The Johns Hopkins Press.)

designed by the same man and built in the same shop as the
first practical locomotive ever built in this country—the
"Best Friend of Charleston," completed in 1830 for the
South Carolina Railroad.

Notice that although the basic elements of the design are
the same, differences similar to those we pointed out in the
1875 engines have already appeared at this early date. The
massive horizontal beam, the side member of the frame
supporting the firebox, boiler, and smokebox, appears in
both of these engines. But in the English-designed "John
Bull" the axles of all the wheels are firmly secured to this

rigid frame and are set close together beneath the boiler. In the American-designed "Brother Jonathan," however, only the two large driving wheels were secured to the frame. The four small wheels at the front were independently mounted in what was variously called a "lead truck" or "track feeler." This lead truck, swiveling on a center bearing, was developed almost at once in America to offset the rigidity of English locomotive design.

According to John H. White, Jr., whose recent book entitled *American Locomotives: An Engineering History* (1968) is the first full study of the subject, the "Brother Jonathan" was the first distinctively American locomotive and established a national type that was almost exclusively adopted by American builders for the next ten years. Though its boiler and valve gears were copied directly from the English locomotive of the period, the running gear was a radical departure from the English design. The large driving wheels were set behind the firebox, and the front wheels of the lead truck extended forward beyond the smokebox, thus lengthening the wheel base and enabling the freely swiveling lead truck to carry the locomotive easily around the sharp curves and over the uneven tracks characteristic of American roads. In other words, the earliest distinctively American contributions to this evolving vernacular design were, from the purely technological point of view, designs adapted to cope with irregular, unanticipated, and unanticipatable motion—the kind of motion which in music is best exemplified in the polyrhythmic syncopations of jazz. But there is another difference between these early locomotive designs that men wearing the blinders of those concerned with technology alone, take no notice of. The platform at the rear of the "John Bull," where the engineer stood to manipulate the levers controlling the locomotive, is not provided with any device to protect him. The platform of the "Brother Jonathan" has a railing at the sides.

It is obviously impossible to trace here the development

of all the components of the locomotive. But that railing at the sides of the "Brother Jonathan's" platform is directly related to the point I am trying to make about the influence of democracy in vernacular design. Surely one of the major elements introduced into our environment by democracy was recognition of the importance of ordinary human beings, including workers. In the United States, where the democratic impulse was less inhibited than anywhere else in the western world, respect for the worker and the worker's respect for himself were from the beginning incorporated into the design of the locomotive engine, the dominant symbolic form of modern civilization throughout the first century of its existence.

If one follows the development of the design of American locomotives, it is clear that the platform railing of the "Brother Jonathan" is a precursor of the fully developed cab that was such an important visual element of the 1875 engine pictured earlier. Yet it is difficult, if not impossible, to determine when or by whom the first full cab to shelter the fireman and engineer was devised. For despite the prominence of the cabs as an element of the total form, engineering historians think of them as "relatively minor" parts of locomotives and mention them, if at all, only among such "miscellaneous considerations" as cowcatchers, bells, headlights, sandboxes, and decorative treatment.

As nearly as I can determine, from the extant drawings and lithographs of early locomotives, the earliest form of cab was a simple canopy roof with open sides. Usually constructed from wood, such cabs were apparently improvised by the engine crews after the engines were delivered to the railroad companies. This too is a point worth noting in connection with the democratic forces at work in the vernacular. In England no employee of a Railroad Company ever seems to have felt free to tamper with the design of such expensive machines, but in America the engine crews and shop men were forever modifying and tinkering with their engines.

The earliest picture I have found showing a full cab
provided by a manufacturer of locomotives, is of an engine
built by the Baldwin Locomotive Works in Philadelphia
about 1848 (figure 5). Matthias Baldwin had seen and been
impressed by enclosed cabs more than a decade earlier. In a
letter written in November 1836, he reported that on the
Utica & Schenectady Railroad in central New York state
he saw "engines completely boxed up thereby keeping
the works and engineer from the weather." No doubt
the wooden cab pictured here is a refinement of the de-
sign empirically evolved by anonymous train crews and
shop men all over the country in the 1830s and early '40s.
Notice the simplicity and plainness of its architecture:
the plain rectangular windows, the simple brackets sup-
porting the eaves of the curved roof, the severe *S* curve
made by simply sawing off the ends of the tongue-and-
groove boards where the side wall projects as a bracket
under the cantilevered extension of the roof, designed to

Figure 5. Locomotive built by Matthias W. Baldwin in Philadelphia
about 1848. (Reproduced from *American Locomotives,* by John H.
White, Jr. By permission of the publisher. ©1968 by The Johns Hopkins
Press.

shelter the firemen while getting wood from the tender.

Notice also, however, the quite elaborate scrollwork ornament on the cast-iron panel arching over the driving wheels and supporting the outer edge of the running board, along which mechanics servicing the engine could walk, protected by a hand rail, to refill the paneled sandbox atop the boiler, just ahead of the steam dome. The ornamentation of locomotives is a fascinating subject but has been largely neglected. Before 1850 there was little of it, either in Europe or America. As John White says in his brief discussion of decorative treatment and finish, the early locomotives were "straightforward machines devoid of fanciful bell stands, headlight brackets, and other such trimmings." There was some attempt to make them attractive by the use of color and polished brass, and a Baldwin freight engine of 1842 had an elaborately painted panel on the sand box and fluted columns around the drum of its steam dome. But it was not until mid-century that elaborate ornament and very bright colors—red wheels, green frames and wheel covers, vermilion stripes—were generally employed to "dress up" these work horses of emerging industrial democracy.

No such elaborate ornamental treatment seems to have been applied to European engines. Indeed locomotives evidently were not the focus of people's attention in England or on the continent to the same degree as they were here. In English prints and other pictures of the early railroad period, the prominent subjects are the viaducts, bridges, embankments, and tunnels, not the engines themselves. References to the railroads, favorable or unfavorable, made by Englishmen of all classes in private letters, books, and songs—as sampled in Stuart Legg's charming anthology *The Railway Book* (1952)—reveal that people were primarily interested in the engineering structures over and through which the iron rails were laid, not in the locomotives that rode on them.

This was natural enough, considering that the first

British railroads ran through long-settled country and connected populous centers. Confident of heavy and remunerative traffic, British railroad builders had available capital sufficient to build substantial, carefully graded, relatively straight and level roads. Admirable as these roads were from an engineering point of view, they enormously disrupted the regions they traversed. Charles Dickens, in *Dombey and Son* (1846), gave a description of the building of a deep cutting through Camden Town that provides a vivid glimpse of the topographical and social effects:

> The first shock of a great earthquake had . . . rent the whole neighborhood to its center. . . . Houses were knocked down; streets broken through and stopped; deep pits and trenches dug in the ground; enormous heaps of earth and clay thrown up; buildings that were undermined and shaking, propped by great beams of wood. . . . There were a hundred thousand shapes and substances of incompleteness, wildly mingled out of their places, upside down, burrowing in the earth, aspiring in the air, mouldering in the water, and unintelligible as any dream. . . . Mounds of ashes blocked up rights-of-way, and wholly changed the law and custom of neighborhoods.

Even in English countryside the law and custom of neighborhoods was wholly changed. A British M.P. protested the building of a railroad "running right through the heart of our hunting country . . . destroying the noble sport which I have been accustomed to from my childhood," and John Ruskin berated those who built a railroad through the rocky valley between Buxton and Bakewell:

> You blasted its rocks away, heaped thousands of tons of shale into its lovely streams. The valley is gone, and the Gods with it; and now every fool in Buxton can be at Bakewell in half an hour, and every fool in Bakewell at Buxton; which you think a lucrative process of exchange. (*Fors Clavigera,* 1871)

In America the construction of railway lines was a much less impressive and less disruptive phenomenon. For one thing, the lines were chiefly through unsettled, often uninhabited country where the necessary cuttings, embankments, and bridges were of small concern to anyone (except in places, the Indians). For another, railroad companies building through sparsely settled country, where remunerative traffic was only an uncertain hope, could not muster capital enough to pay for the sort of engineering projects the British carried out. English companies spent an average of almost $180,000 per mile for their early roads; few of ours spent more than $20,000 or $30,000—about one-seventh as much.

This economy was achieved largely by interfering as little as possible with the terrain through which our roads were constructed. Lines were built around and over hills and through tortuously winding valleys in order to avoid tunnels, bridges, and expensive cuts and fills. So American awareness of railroads centered more upon the engines and cars than on the roadways they ran over. Americans generally were conscious of railroads chiefly in the distance, where only the chugging of the engine or its long-drawn-out whistle reminded them of the road's existence, or at stations and terminals where the boiler-lunged engines overwhelmingly rolled to a sighing halt, gleamed for a while in breathy repose, then shuddered magnificently into lanky motion again.

All this played a part, surely, in disposing American designers to care more about the appearance of their locomotives than English designers did. By the late 1840s the American locomotive was far more than a mere mechanical wonder. It already rivaled, and it soon surpassed, the steamboat as the dominant symbol of the new civilization's mobile energies. Yet its form—its overall configuration—had not yet been sufficiently refined and perfected to be fully expressive of its mechanical and psychological functions and the emotional values associated with them.

Figure 6. The "New Jersey," built by Rogers, Ketchum and Grosvenor about
1852. (Reproduced from *American Locomotives*, by John H. White, Jr.
By permission of the publisher. ©1968 by The Johns Hopkins Press.)

This disparity is illustrated by a lithograph of the "New
Jersey" (figure 6) designed and built by Rogers, Ketchum,
and Grosvenor about 1852. Mechanically the form is quite
adequate. In fact, it was so effective that with minor var-
iants it was the standard shape for American locomotives
from 1840 to the 1880s, when the need for more powerful
engines called for changes in design. Despite its mechanical
efficiency, however, the general form has a humped and
bunchy character basically at odds with the idea of power-
ful horizontal speed which is the essence of the idea of a
locomotive. It was, I think, to compensate for this aesthetic
deficiency that embellishment was applied. Contrast the
cab from whose traceried window the proud engineer of the
"New Jersey" looks out, with the vernacular Baldwin cab
(figure 5), and notice how the vernacular form of the steam
dome on Baldwin's 1848 engine has been disguised four
years later in a Byzantine dome, borrowed from the culti-
vated tradition's stockpile of forms.

The headlights you see on these engines, with their
baroque brackets, were, by the way, a distinctively Ameri-

can contribution to locomotive design. There were none on English locomotives of the period. Indeed, English designers did not provide them on any of the engines they built in the nineteenth or early twentieth centuries, except those for service in less developed countries such as Australia, New Zealand, India, or Canada. British designers saw no need for powerful headlights on engines running along the completely fenced, relatively straight, substantially ballasted double-track English roads. If the men who drove the engines might have preferred to be able to see ahead when hurtling through the dark at the high speeds they regularly maintained, that was not something that concerned British designers or railroad managers.

In America, however, the roads were laid down along unfenced rights-of-way across which cattle, deer, and other animals could wander at will. This posed difficulties even in the early years when trains ran only by daylight, but the cowcatcher, first contrived in 1835, took care of this problem pretty well by plowing errant beasts to one side or the other, thus preventing their carcasses from getting under the wheels and derailing the train. Other hazards, however, posed by the badly laid single tracks, the tight curves, and the insubstantial trestles and bridges characteristic of early construction here, could be avoided only if the engineer could see ahead. When trains began running at night, engineers had to be able to see a displaced rail, a washed-out bridge, or a sharp curve before they came to it. By the end of the 1830s, at least one firm was manufacturing oil-burning box lamps with parabolic reflectors capable of beaming the light a thousand feet ahead of the engine. By the mid-fifties such headlights were standard equipment, and their decorative side panels and fancy brackets were important visual elements in American locomotive design.

It has been pointed out by John White and others that one of the arguments justifying such elaborate decoration was that engine crews would be inspired to give more care

to engines assigned them if the engines were handsomely and elegantly finished. Certain it is that a locomotive designer such as Ross Winans, who operated on the theory that "we do not look for beauty in a freight engine or a mudscow" and who took an almost perverse delight in designing coarse and ugly though mechanically interesting engines, did not succeed in selling many of the locomotives he designed. At all events, engines like these, in whose design the forms of the vernacular and of the cultivated tradition were amusingly and sometimes touchingly intermingled, were typical on American roads throughout the 1850s and '60s.

In the 1870s, however, the embellishment of engines declined. John White's engineering history of locomotives suggests that the great economic depression following the panic in 1873 may have had something to do with the elimination of bright work. The Reading Railroad, for example, saved $285 a day by dismissing the wipers who had polished its 410 locomotives. White also suggests that the change may have resulted from abandonment of the old system of assigning particular engines to particular crewmen, putting an end to the era when the crews felt they owned the engines and made pets of them. But a more important reason, I suspect, was that by the 1870s the vernacular had evolved a fully satisfactory design on its own terms.

In all the arts certain designers are ahead of their times, and this was true, I think, of the designer of the passenger locomotive shown in figure 7, built at the Trenton Locomotive Works in 1855. I have not been able to determine for sure who the designer was, but it was probably Isaac Dripps, who became a partner in the Trenton firm in 1854. Dripps was an inventive, self-taught designer who had been involved with locomotives from the start. As a young employee of the Camden & Amboy Railroad, he had been the mechanic assigned to assemble the parts of the "John Bull" (figure 3), that rigid little engine sent over to this country by Robert Stephenson in 1831. It was he who de-

The "Assanpink," built by the Trenton Locomotive Works in 1855. Figure 7.
(Reproduced from *Iron Horses: American Locomotives 1829–1900*, by
E. P. Alexander. By permission of W. W. Norton & Co., Inc. ©1941,
1968 by E. P. Alexander.)

signed the first cowcatcher and fitted it to Stephenson's
engine. And it was he who invented the spark-arresting
smokestack, with the flaring shape that became standard
on our wood-burning American engines. I think it is safe to
assume that this extraordinary locomotive, built for the
Belvidere Delaware Railroad Company and oddly named
"Assanpink" (after a stream in New Jersey), was the prod-
uct of his distinctive skill.

In any event, I am sure that whoever came upon this
lithograph in a chronologically arranged series of pictures
of mid-nineteenth-century locomotives would recognize the
"Assanpink" as a very advanced design. There are, of
course, some elements borrowed from the cultivated tradi-
tion—including the baroque headlight bracket, the panels
on the sandbox and on the bases of the steam domes, and
some details of the cab; but these are for the first time
subordinated to an overall design emphasizing the horizon-
tal lines appropriate to the locomotive's powerful speed.
Even the protruberant domes are flattened and the smoke-
stack given a trimmer shape; and the driving wheel guard
is carried straight across the tops of both wheels instead of

Figure 8. Detail of the cab of the "Assanpink." (See figure 7.)

dipping down between them in the conventional *V* still employed by other designers several years later. There is little trace in the "Assanpink" of the hunched and stubby verticality characteristic of the standard American locomotives of the period.

The absence in the "Assanpink" of many "borrowed" features (especially the moldings and brackets) is less significant, however, than the "modern" feeling achieved in the design of the cab (figure 8) with its almost Mondrian-like reduction of form to rectangular abstraction. Remember that this form was arrived at in 1855, the year of the first edition of Walt Whitman's *Leaves of Grass*. Now compare it with a detail of one of the architectural masterpieces of Louis Sullivan, the first of our important modern architects. Figure 9 shows part of the Charnley House in Chicago, designed by Sullivan in 1892. Compare it also with figure 10, an interior view of one of Frank Lloyd Wright's most influential early buildings, Unity Church in Oak Park, Illinois (1906). As Peter Blake points out in his fine book, *The Master Builders* (New York, 1960): "Everything about it [the interior of Unity Church] suggests De Stijl Cubism—which did not come along until a dozen years later."

Detail of portion of the Charnley House, Chicago, designed by Louis Figure 9.
Sullivan, 1892. (Reproduced from *The Architectural Annual,* 1901.)

Interior detail of Unity Church, Oak Park, Illinois, designed by Frank Figure 10.
Lloyd Wright in 1906. (Detail from a photograph courtesy of the Chicago
Historical Society. Reproduced by permission.)

The influence of Wright's design upon Mondrian and his Dutch colleagues is ascertainable. We know they saw and were impressed by the photographs of this and other Wright buildings exhibited in Holland in 1910. But I cannot therefore conclude, as Blake does, that "thus we find Wright giving birth, almost absent-mindedly, to one of the most influential and one of the most powerful groups in the whole history of modern art." A scheme of forms as expressive as the dynamic and asymmetrical arrangement of lines and rectangles Wright employed, and which spread through Holland and Germany till it was embodied in the paintings of Mondrian and the architecture of Gropius and Mies van der Rohe, is never, I think, suddenly or absent-mindedly evolved.

As I have tried to show, by tracing the evolution of a particular vernacular design, the so-called "International Style" in twentieth-century architecture is based upon a scheme of forms gradually evolved in the vernacular long before Frank Lloyd Wright and his Lieber Meister Sullivan made it the vehicle of expressive art. The cab of the "Assanpink" antedates Unity Church by a half century. But it in turn was antedated in other areas of the vernacular a half century earlier still.

Figure 11 is a black-and-white reproduction of a Mondrian painting in the Museum of Modern Art. Its relation to Wright's interior is clear enough, as is its relation to the vernacular iron storefront in figure 12, manufactured in the same year Wright designed Unity Church. But note the similar features of design captured in figure 13. This is a photograph of a doorway in the Wash House, or laundry, at the Shaker Community in New Lebanon, New York. The doorway was designed in 1806, exactly a century before Wright's Unity Church, by anonymous members of a religious sect whose first community was established, appropriately enough for our purposes, in 1776.

"Composition in White, Black and Red," by Piet Mondrian. (Oil on
canvas, 40 × 41; original in Museum of Modern Art, New York. Repro-
duced by permission.) Figure 11.

Figure 12. Iron storefront by the Standard Company, Chicago, 1906. (Reproduced from *"Sweet's" Indexed Catalogue of Building Construction,* New York, 1906.)

Doorway to and antechamber in the "Wash House" or laundry; New Lebanon Church Family (Shakers), 1806. (Photograph reproduced by permission from files of the Index of American Design, National Gallery of Art, Washington, D.C.)

Figure 13.

In recent years the folk art aficionados and their allied merchandizers have done their best to preempt Shaker design. But the Shakers were vernacular artists, in my sense of the term, not folk artists. The "World" they rejected was the world of the cultivated tradition, not the nascent world of democracy and machine technology. Their democratic motivation was strong. As Elder Frederick Evans of the New Lebanon community said, it seemed to the Shakers "marvelously inconsistent" that any human government should be administered "for the sole benefit of its own officers and their friends and favorites, or that more than half the citizens should be disfranchised because they happen to be females ... or chance to possess a darker colored skin." Negroes and whites, males and females, Christians and Jews were equally welcome to join the United Society of Believers, as the Shakers were officially called. As to machine technology, Shaker communities produced more ingenious mechanics and inventors per capita than towns of comparable size. They designed and used mowing machines, machines for making barrels and hogsheads, and many others; they mechanized their cattle barns; they used steam engines to drive machines in their laundries, and their approach to architecture was thoroughly vernacular. When someone complained to Elder Evans that Shaker buildings looked like "mere factories or human hives" and suggested that they might aim at "some architectural effect, some beauty of design" if they built anew, Evans flatly said no. What those accustomed to the cultivated tradition of architecture thought beautiful was, he said, "absurd and abnormal." If the Shakers built anew, they would build, he said, with an eye to "more light, a more equal distribution of heat, and a more general care for protection and comfort"—the very things Reyner Banham describes as major ingredients of modern design in his *Architecture of the Well-Tempered Environment,* which I discussed earlier in this volume.

Wherever the vernacular was free to create its own schemes of forms, in the Shaker Wash House or in the cab of a locomotive, those forms had a family resemblance. And no one who looks attentively at these much earlier products can, I think, be persuaded that Wright's influential design was suddenly and absent-mindedly born out of nothing but his own creative imagination. Such a notion could occur only to someone wearing the blinders of the cultivated tradition, whose seeing is focused by the preconception that Art is the arts of Western Europe and that those who create art in this country are those whose work manifestly relates to the cultivated tradition. It is my hope that these illustrations will stay with you as specific visual evidence that the expressive forms of modern art derive, in large part, from the empirical attempts of untutored designers to give satisfying order to elements introduced into our lives by modern technology and the democratic spirit.

The Eiffel Tower and the Ferris Wheel

This was written to be read at a symposium, "New Perspectives on American Art, 1890–1940," in honor of Professor Milton W. Brown on his retirement as executive officer of the Art History Program he created at the City University of New York. It was published, along with other symposium papers, in *Arts Magazine,* February 1980.

The Eiffel Tower, built with a subsidy from the French government as the dominant feature of the Paris International Exposition of 1889, was intended by the authorities in charge of the exposition to be an enduring symbol of France's nineteenth-century supremacy in the art of metal structures. It has dominated the skyline of Paris ever since.

Four years later the skyline at the World's Columbian Exposition in Chicago was dominated by the original Ferris Wheel—no part of the officially sponsored "White City," as the exhibition buildings themselves were called, but simply the loftiest and most visually striking attraction in the fair's commercially sponsored entertainment zone, relegated by the fair's managers to a detached area (behind the Women's Pavilion) called the Midway Plaisance. Because the Ferris Wheel had no official status among the structures at Chicago and did not remain in place as the Eiffel Tower did after the fair was over, it has never been considered by historians or critics concerned with the comparative significance of the structures erected at these two great expositions summing up European and American achievements in art and industry near the close of the nineteenth century. Yet it is in a sense true, as a well-known western American historian said at the time, that "the Ferris Wheel is to the Columbian Exposition what the Eiffel Tower, yet standing in the Champs de Mars, was to the

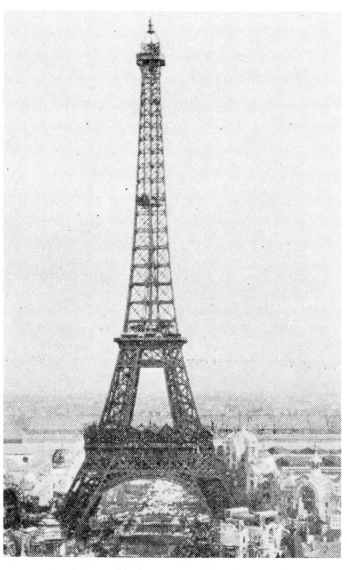

Figure 14. The Eiffel Tower. (Reproduced from James P. Boyd, *The Paris Exposition of 1900,* Philadelphia, 1900.)

Paris Exposition of 1889."[1] Had Siegfried Giedion and those art historians who follow in his footsteps recognized this fact, they would have been less ready to accept the verdict of a Belgian critic who thought the Chicago struc-

1. Hubert Howe Bancroft, *The Book of the Fair* (Chicago and San Francisco, 1893), p. 868.

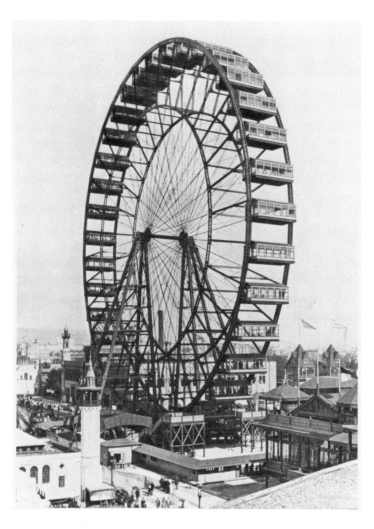

The Ferris Wheel as an ellipse. (Reproduced from H. H. Bancroft, Figure 15.
The Book of the Fair, Chicago and San Francisco, 1893.)

tures "were only imitations of what we have known in
Europe for a long time. We expected better, much better,"
he said, "from the well-known audacity, initiative, and
originality of the Americans."[2]

2. Quoted in Giedion, *Space, Time and Architecture* (Cambridge,
Mass., 1941), p. 210.

It can, of course, be objected that the Ferris Wheel is not properly a structure in the sense that the Eiffel Tower is. My friend David P. Billington, professor of engineering at Princeton, took pains to point out to me[3] that in the strictest sense the Ferris Wheel is not a structure but a machine. From the point of view of a civil engineer, structures are static, machines dynamic. Engineering structures generally are more permanent than machines, and are usually large-scale, unique, and custom-made for a local site. They are usually public works, and their funding comes through the political process. Conversely, machines are generally designed for a relatively short life span, are generally designed to be small-scale, reproducible, and mass-produced to be used almost anywhere, and are usually funded by private citizens."[4]

Clearly the Eiffel Tower conforms to Billington's definition of an engineering structure, but it seems to me that the Ferris Wheel escapes the boundaries of his definition of a machine. Certainly it was not small in scale, nor was it designed to be mass-produced. And even though it turned out to be the prototype for smaller Ferris Wheels at other fairs, including the Paris Exposition of 1900, it was certainly a unique design, custom-made for a specific site at the Chicago Fair. Certainly it was regarded at the time as more than a mere machine. Hubert Howe Bancroft, the eminent western historian whose book about the fair I have already quoted, spoke of it as a "stupendous fabric" (p. 869). A civil engineer, writing about the wheel in an engineering journal, referred to its "architectural effect," claiming that "not even the domes of the finest buildings on the grounds show to such advantage from a distance. In fact," he added, "as one watches the domes from the windows [of one of the elevated cars bringing visitors to the fair] they seem to pass one by one through the circle of the

3. In a letter dated 26 June 1979.
4. See David P. Billington, "Structures and Machines: The Two Sides of Technology," *Soundings,* Fall 1974, pp. 276–77.

wheel, which, for the moment, surrounds them like a halo."[5]

Certain it is that the designer—or inventor, if you will—of the wheel conceived of it as a structure. He was a thirty-three-year-old Pittsburgh bridge engineer with the assertively American name of George Washington Gale Ferris. It is reported that his idea for what an English engineering journal ineptly called "a gigantic merry-go-round set vertically"[6] originally occurred to Ferris about a year before the fair opened, at a banquet for the architects and engineers engaged in designing and building the exposition's structures—a banquet hosted by Daniel H. Burnham, the fair's organizing genius. After commending the labors of the architects in his speech of welcome, Burnham reportedly complained that the engineers "had fallen short of expectation, suggesting nothing novel or original for the Fair in the way of engineering science, as was the Eiffel Tower at the Paris Exposition." It was this rebuke to his profession which is said to have elicited from Ferris his conception of a structure which, "while serving as a medium of observation for passengers" as the Tower had done, would also, like the Tower, "stand as one of the architectural monuments of the Fair" (Bancroft, pp. 882, 870).

The idea was "somewhat coldly received" by the other engineers, however, and hence was not incorporated into the official plan of the White City. But so persuaded was Ferris of the merits of his scheme that he invested $25,000 in plans and specifications, on the basis of which he was granted a concession in the fair's entertainment zone. With the concession in hand, he formed a joint stock company that spent more than a quarter of a million dollars on fabrication and installation of the unprecedented wheel.

It was, of course, a tremendous success. More than a

5. William H. Searles, "The Ferris Wheel," *Journal of the Association of Engineering Societies* 12, no. 12, (December 1893): 616 and 614.

6. *Engineering* (London), 21 April 1893, p. 584.

million five hundred thousand passengers paid fifty cents each to travel up and around the huge wheel's 320-foot vertical circumference during the fair's five-month season. A number of couples were married on the wheel while it was in motion. And the fair's managers and Ferris and his associates split profits of more than a half million dollars before the wheel was finally disassembled and sold for use elsewhere.[7]

Who bought the Ferris Wheel I do not know. There were rumors during the last weeks of the fair that Nate Salisbury of the Buffalo Bill Wild West Shows would take it to Coney Island,[8] but that did not happen. A Ferris Wheel half the size of the original was ordered by George C. Tilyou of Coney Island's Steeplechase Park, who thereupon announced with characteristic Coney Island rhetoric that "the world's largest Ferris Wheel" would soon be erected there.[9] At the World's Fair in St. Louis in 1904 the original wheel made its final appearance before being scrapped, and no wheel larger than Coney Island's half-size version has been built since.

But a wheel scaled down to half the original's size or less could not have the architectural or monumental qualities that the wheel at the Columbian Exposition obviously had. As the civil engineer I quoted earlier explicitly said, the wheel was "the most conspicuous object" in the whole agglomeration of structures as one approached the fair, whether by train from the south or by the elevated railroad from the north. And though he wrote principally about the wheel as an engineering feat and disclaimed any intention of dwelling on its "aesthetic qualities," he could not resist speaking of how its great circles "described by day magnificent ellipses upon the sky," and by night, shining with

7. Bancroft, p. 882. Despite the financial success of the wheel, Ferris died in poverty three years after the fair closed.

8. *Chicago Sunday Tribune,* 15 October 1893, p. 1.

9. John F. Kasson, *Amusing the Million: Coney Island at the Turn of the Century* (New York, 1978), p. 57.

thousands of electric lights, appeared "like a galaxy of stars." As one moved about the wheel, he noted, it appeared to pass through "all phases possible to it of a circle, ellipse, and straight line," while nearer by one was struck by its "slow and majestic motion," as it carried its carloads of people "silently and steadily through its great orbit" (Searles, p. 614).

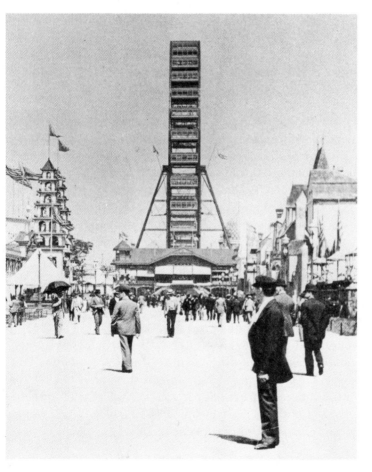

The Ferris Wheel as a straight line. (Reproduced from H. H. Ban- Figure 16. croft, *The Book of the Fair,* Chicago and San Francisco, 1893.)

That slow and majestic motion, that dynamic characteristic of the Ferris Wheel is, of course what justifies Professor Billington's insistence upon classifying it as a machine. Yet, as Billington is careful to point out, there is always "a close interdependence" between machines and structures, not only because structures are built by machines but also because "machines have structure to hold them together" (p. 275). In this instance—as in such vast machines as the Corliss steam engine which dominated the exhibits in Machinery Hall at an earlier world's fair, the Centennial Exhibition at Philadelphia in 1876—the machine's structure rivalled its dynamic function in impressiveness. The Ferris Wheel was, I think it fair to say, structure in motion. And in this respect it contrasts in significant ways with the iron tower in Paris which it was deliberately intended to rival as an engineering feat.

The tower, like the wheel, bears the name of its engineer and promoter. Alexander Gustave Eiffel was fifty-three years old when he originally proposed the structure (in 1885) and was already internationally famous as a machine designer and builder of large railroad viaducts and bridges in France, Portugal, and Hungary and of the iron framework supporting the beaten copper Statue of Liberty in New York harbor, designed by the sculptor Frédéric Auguste Bartholdi.

The tower apparently originated in a suggestion by an engineer named Ruquier who worked in Eiffel's office,[10] though the first sketch of it is attributed to one of the draughtsmen in the office named Maurice Koechlin.[11] In any event, it was one of 700 projects submitted in 1886 for consideration by a French commission authorized to select a design for a tower 300 meters (984 feet) high which would be the focal point of the forthcoming international exposi-

10. James P. Boyd, *The Paris Exposition of 1900* (Philadelphia, 1900), p. 539.
11. David P. Billington, *Structures and the Urban Environment* (Department of Civil Engineering, Princeton University, 1978), p. 2.

tion. The commission apparently had little difficulty eliminating the other proposals, which included one for an immense tower pump to humidify the entire city of Paris by a gigantic spray during periods of dry weather and another for a 984 foot high guillotine to commemorate the opening on 5 May 1779 of the States General Assembly, which initiated the French Revolution.[12]

Eiffel's carefully worked out proposal was promptly approved, and on 8 January 1887, a contract was signed between the French government, the city of Paris, and Eiffel. The contract bound Eiffel to complete the tower in time for the exposition, then less than two and one half years away, gave him a subsidy of about $292,000 (almost a third of his estimate of total cost), and gave him the right to charge admission and keep the proceeds for twenty years. Like the Ferris Wheel, the tower was a success financially, admissions for 1889 alone repaying the entire cost (which had considerably exceeded Eiffel's estimate).

I do not need to dwell here on a description of the tower. Its form is familiar to everyone, whether they have been to Paris or not. To art historians it is perhaps best known as the theme or subject of a number of modern paintings, especially the Eiffel Tower sequence by Robert Delauney (1885–1941). But pictures of it are everywhere—in advertisements of French perfumes and wines and cars as well as in travel posters and airline publicity. And for those who visit Paris, as for those who live there, it is inescapable. Indeed, Roland Barthes has recently reminded us that Guy de Maupassant often ate lunch at the restaurant in the tower, not because he liked the food there but because it was the only place in Paris where you don't have to see the tower itself.[13]

The essential point, in the context of this paper, is that the tower is, as Eiffel intended it to be, a demonstration

12. Ibid., p. 4.
13. Roland Barthes, *The Eiffel Tower and Other Mythologies,* trans. Richard Howard (New York, 1979), p. 3.

that France, despite its loss of industrial supremacy to England early in the nineteenth century and despite its military defeat by Germany in the Franco-Prussian war, was still "at the forefront in the art of metal structures." Yet its structural form, so familiar to us now, was not as novel as it seemed to Eiffel's contemporaries. It was, in fact, derived from and similar to the piers supporting the high railway viaducts Eiffel himself had designed in the 1860s and '70s. But those vertical cantilever piers, spreading at the base in parabolic curves, were in remote provinces of France, in rough mining regions, not in the French capital; even the refined version of their vernacular form which Eiffel developed for the tower, decorated as it was with nonfunctional arches and elaborated cornices, contrasted so sharply with the spires and domes and towers of traditional architecture that there were howls of protest from the custodians of French culture.

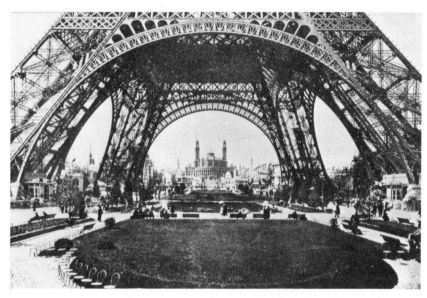

Figure 17. The nonfunctional arches at the base of the Eiffel Tower. (Reproduced from James P. Boyd, *The Paris Exposition of 1900*, Philadelphia, 1900.)

In February 1887, just after ground was broken for the tower's foundations, the director of construction received a formal protest, beginning: "Writers, painters, sculptors, architects, passionate lovers of the beauty, until now un-spoiled, of Paris, we come to protest, with all our strength, with all our indignation, in the name of Art and French history now menaced, against the erection, in the very heart of our capital, of the useless and monstrous Eiffel Tower." It was, they asserted, an engineering outrage, the mercantile fancy of a builder of machines. And they climaxed their manifesto by saying that the tower, "which even commercial America would reject," would cause foreign visitors to the exposition to cry out in astonishment, "What? is this horror what the French have brought forth to give us an idea of their famous taste?"[14]

The signers of this protest included Charles Garnier, ar-chitect of the Paris Opera, the composer Charles Gounod, the painters Bonnat, Meissonier, and Bouguereau, and such writers as Alexandre Dumas, Sully Prudhomme, Leconte de Lisle, and Guy de Maupassant.

Maupassant, as we have seen, retained his dislike of the tower as a visible object, but even he went often to visit it—if only to lunch on one of its platforms. And younger artists, including Paul Gauguin, saw the tower as a pioneering example of the new architecture made possible by structural iron.[15] With the passing years, Eiffel's tower

14. Quoted in Billington, *Structures and Urban Environment,* pp. 7–8.

15. In his first published writing, "Notes on Art at the Universal Exhibition" (July 1889), Gauguin recognized that the exhibition was "the triumph of iron, not only with regard to machines but also with regard to architecture." But iron architecture was, he thought, in its infancy because "as an art, it lacks a style of decoration consistent with the material which architecture uses." Only in the Eiffel Tower did he find some examples of the "ornamental bolts, iron cornices extending beyond the main line, a sort of Gothic lacework of iron" appropriate to the decorative art of the engineer-architect. See Gauguin, *The Writings of a Savage,* ed. Daniel Guerin, trans. Eleanor Levieux (New York, 1978), p. 28.

has become what Jean Cocteau once called "the Notre Dame of the Left Bank"—not only a tourist attraction but, along with Paris's majestic cathedral, the joint symbol of Paris, if not of France—what Roland Barthes calls "a symbolic couple... articulated on the opposition of the past and the present, of stone, old as the world, and metal, sign of modernity" (p. 12).

Both the Eiffel Tower and the Ferris Wheel were designed to serve a twofold function, as observation posts and as monuments of engineering skill. As solutions to that double problem they differed in significant ways. For Eiffel, in the French metropolis which prided itself upon being the cultural capital of Europe, the natural response was to build the high tower men had dreamed of since Babel but had been unable to fabricate until structural iron became available. Its vernacular form, derived from the industrial structures he had been building for twenty years, had to be modified, of course, by certain concessions to conventional taste—notably the high and spreading arches which appear to, but do not, sustain the lofty superstructure. Those arches, like the ornamental masonry shells enclosing the bases of the four legs of the tower, are simply borrowings from the cultivated tradition's stock of forms, to satisfy the "custom of the eye" acquired over the centuries by those familiar with stone architecture.[16] To get people to the top of his tower, Eiffel depended upon elevators manufactured by the American Elisha Graves Otis, who had been making

16. The American engineer Ambrose Swasey reported in 1890 that he and other engineers who had gone to the Paris Exposition in 1889 had "especially noticed the ornamentation, or, as we may call it the architectural features of engineering works" in Europe, and specifically instanced the ornamental base of the Eiffel Tower and "the massive arches," which were designed "purely for architectural effect and have nothing to do with supporting the weight of the tower." See Swasey, "The Eiffel Tower from Foundation to Lantern," *Journal of the Association of Engineering Societies,* August 1890, p. 414.

them for thirty years. Nothing, in fact, was truly novel about the tower except its great height. From the point of view of the structural engineer, we are told, "the tower is a model of simplicity; the calculations (of stresses in its members) are even simple."[17]

To Ferris, in the sprawling Prairie City, the impulse was to create something altogether new; a vast vertical machine whose enormous wheel would be held in a perfect circle not by heavy, rigid spokes but by light steel rods in tension as it carried glass-walled chambers full of people 260 feet aloft—as high as the crown of the Statue of Liberty. In an interview with a journalist, Ferris said: "When I first proposed to build a tension wheel of this diameter, the feat was regarded as impossible. It was held that the spoke rods on the upper side of the wheel at any given moment, instead of sustaining the weight of the upper part of the wheel, would, from their own weight as they hung vertically, pull down that arc of the wheel which they bore upon, and thus cause the wheel to become elliptic. As a matter of fact, they do nothing of the kind. There is absolutely no deflection from the perfect circle."[18] Each of the thirty-six cars suspended at the circumference of this tension wheel was twenty-seven feet long, thirteen feet wide, and ten feet high—nearly as large as an entire floor of a narrow New York brownstone house. In each car there were thirty-eight revolving seats in four rows, with standing room for twenty-two additional persons—a maximum of sixty passengers per car, or a total of 2,160 people for the fully loaded wheel.[19]

17. Billington, *Structures and Urban Environment,* p. 15.

18. Quoted in Carl Snyder, "Engineer Ferris and His Wheel," *Review of Reviews,* September 1893, p. 274.

19. Searles, p. 615. Searles gives 24 feet as the length of the cars, but Bancroft (p. 869) gives 27 feet. Since the distance between the outer rims of the wheel was 30 feet, 27 feet for the cars seems to me the likelier figure.

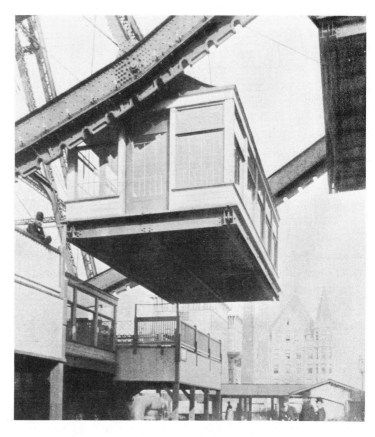

Figure 18. A car on the Ferris Wheel. (Reproduced from H. H. Bancroft, *The Book of the Fair,* Chicago and San Francisco, 1893.)

No structure like this had ever been built before, and the calculation of the stresses in it was by no means a simple matter. Indeed the engineering profession was preoccupied with possible methods of computing those stresses for a year or more after the wheel was erected.[20] To the layman

20. See, for example, J. W. Schaub, "Calculation of Stresses in the Ferris Wheel," *Engineering News,* 22 March 1894; and E. Gerber, J. W. Schaub, and H. H. Wadsworth, "Three Methods for Computation of Stresses in the Ferris Wheel," *Engineering News,* 26 April 1894. Ferris and his associates had been secretive about such matters. When asked about details, they "politely declined to furnish very much information" (see Searles, p. 614).

and the professional engineer alike, the Ferris Wheel bore a resemblance to a huge bicycle wheel,[21] but a bicycle wheel carries its load at the axle, which is supported by a single point on the ground. The Ferris Wheel carries its load at thirty-six points on its circumference and received its support from the axle.

That axle was the largest steel forging in the world, 33 inches in diameter and 45½ feet long, and was forged by the Bethlehem Iron Co., using a newly acquired steam hammer of unprecedented size, a full-scale model of which was on exhibition in Louis Sullivan's Transportation Building at the fair.[22] The axle, in turn, was supported 140 feet above the ground by a pair of simple towers built of inclined posts and horizontal struts, tied together with diagonal rods and further stiffened near the ground by plate iron arch girders.

The steel rods by which the rims of the great wheel were suspended from the axle extended in pairs from the axle to the circumference. Viewed at a distance they appeared like spider webs, giving to the fabric what Bancroft called "a dangerous and unsubstantial aspect." Yet no accident marred the performance of the wheel, even though at one time it was buffeted by a hurricane with hundred-mile-an-hour winds which severely damaged many of the fair's structures. Ferris, who rode the wheel with his wife and a reporter during the storm, had thoroughly tested each bolt and beam, each rod and girder, and had made full allowance for the effects of violent wind pressure.[23]

A comparative analysis of the Ferris Wheel and the Eiffel Tower can more easily be based upon engineering considerations than upon aesthetic ones. Whether or not we accept Ferris's own claim that American engineering was "the perfection of machine work" while French engineering

21. Bancroft, p. 868, and Searles, p. 616.

22. Victor S. Clark, *History of Manufactures in the United States* (New York, 1929), vol. 2, pp. 273–74; and Searles, p. 619.

23. Bancroft, p. 870; Snyder, pp. 272–73.

was "the product of a blacksmith's forge,"[24] there is little doubt that the wheel was more efficient than the tower in its use of materials. The tower employs 7,000 tons of iron to attain a height of 984 feet; the Wheel employed 1,300 tons of steel and iron to achieve a height of 260 feet. Reduced to tons of metal per foot of altitude this makes only five tons per foot for the wheel versus more than seven tons per foot for the tower—a difference which cannot, I think, be wholly accounted for by the necessity of greater weight to resist wind pressure in higher structures. In purely financial terms the tower cost more than sixty times what the wheel cost to provide a vantage point less than four times higher.

It is more difficult to assess the comparative aesthetic values of the two objects, especially since one was a temporary installation on the fringes of a temporary "city." The wheel could not become, as the tower did, a familiar object; nor is there any way of knowing what meaning it might have had for artists such as Alexander Calder if it had been susceptible of prolonged contemplation. When first built, both the tower and the wheel impressed those who observed or visited them as remarkably open forms, as unenclosed spaces defined by slender metal lacework. In both the visitor was raised by mechanical means to exhilarating heights whence panoramic vistas spread to distant horizons. Yet as a form against the sky, the wheel changed from circle to ellipse to straight line as the viewer's position changed, while the tower's form was essentially the same from all points of view. And the wheel did not merely suggest movement as the tower's ascensional thrust did; it was in fact in intermittent motion. By that motion and by its changing aspects it gave symbolic expression, as the tower could not do, to significant characteristics of nineteenth-century technology and democracy: those characteristics of movement and change with which modern art has been largely preoccupied.

24. Quoted in Snyder, p. 273.

Who's Afraid of the Machine in the Garden?

A Footnote on the Unwritten History of America's Response to Technology

This essay was written in spare moments in 1968–69 and rejected by the editors of two respected journals on grounds that seemed to me to be completely justified. But now that we've had *Star Wars* and have fallen in love with R2-D2, I am not so sure.

In one of his "Observer" columns in the *New York Times* several years ago, Russell Baker, with his customary wit and adroitness, probed our fears of the consequences of recent biochemical developments and of the technology of automation and "electronic brains." With absurd relevance, he asked us to consider the questions posed by the impending manufacture of synthetic man. Should it be a government monopoly, or should it be left to competitive exploitation by a few big corporations that have "the technical and financial resources to undertake production profitably and get the price down to a point that will appeal to the middle-income consumer?" What level of intelligence must some federal regulatory agency require the manufacturer to maintain in his product? And what about color? Should the market's choice be restricted to black and white or kept to a "neutral beige?"

The synthetic man Baker thus conjured up—the ultimate projection of contemporary distrust of scientific technology and automation—may be less of a threat than Baker's humorous column suggests, even if he is right that science is "guided by a mindless passion to know, and damn the consequences." For if synthetic man appears on the market, we have a long-forgotten precedent for dealing with him. We Americans had our first encounter with man-made man just over a century ago, and we had no

trouble with him whatever. We simply let a schoolteacher weave a myth around him. The man-made man himself soon dropped out of sight, but the myth sturdily and usefully survived for forty years or more, and history promptly caught up with the myth.

The myth was shaped in a dime novel called *The Steam Man of the Prairies,* published in August 1868 as number 45 in the series Irwin's American Novels. Its author was a twenty-eight-year-old Trenton, New Jersey, schoolteacher named Edward S. Ellis, who ground out dime novels at a phenomenal rate, along with dozens of volumes of history and biography. No one knows how many copies of the *Steam Man* were sold, but it was enormously popular and was reissued under various titles in at least six other dime-novel series in the next thirty-five years.[1]

Not even these many reprints exhausted the vitality of the myth Ellis created. A quarter-century after his novel was first published, his Steam Man was reincarnated in another dime-novel series, put out by rival publishers, that perpetuated the myth well into the twentieth century. If we bear in mind that the myth of the Steam Man was born just nine months before the completion of the first transcontinental railroad, it will be clear that *The Steam Man of the Prairies* has a significance that is often overlooked by those who derive their notions of the impact of technology upon our culture from less popular but more admired literary works.

II

We first see Ellis's steam man through the eyes of two traditional dime-novel figures: a limber and curious Yan-

1. Albert Johannsen's scholarly study *The House of Beadle and Adams* (Norman, Okla., 1950) lists, for example: *The Steam Man of the Prairies* in Starr's American Novels, no. 14, 1869; *The Huge Hunter; or The Steam Man of the Prairies,* Beadle's Half-Dime Library, no. 271, October 1882, and again in Beadle's New Dime Novels, no. 591, 27 January 1885; *Baldy's Boy Partner; or Young Brainerd's Steam Man,* in Beadle's Pocket Library, no. 245, 19 September 1888; and *The Huge Hunter; or The Steam Man of the Prairies,* in Beadle's Half-Dime Library, no. 1156, December 1904.

kee and a brave, superstitious, and good-natured Irishman who are hunting gold in a prairie-encircled ravine in the far west. At sight of this huge figure approaching across the prairie—a gigantic man moving at a rapid pace with smoke issuing from the top of his head, drawing a wagon behind him—the Yankee and the Irishman were astonished. When it let out a shriek, they were about to flee in terror. The Yankee's characteristic curiosity, however, sustained him. We are told that "His practiced eye saw," as any practical Yankee's would, "that whatever it might be, it was a human contrivance, and there could be nothing supernatural about it." It turns out later, as a matter of fact, that ever since this Yankee, whose name was Ethan Hopkins, had gone through Colt's highly mechanized pistol factory in Hartford as a boy back home in Connecticut, he had himself been thinking of making a steam man. The thing had long been "taking shape" in his head, but he'd never got it quite right.

At all events, Ethan calms his Irish sidekick, Mickey McSquiggle, and they both await the huge figure, approaching them "at railroad speed." When it comes to a stop near them, they discover that the "engineer" of the steam man is a dwarfed and hunchbacked youth named Johnny Brainerd, whose traveling companion is their old crony Baldy Bicknell, an elderly trapper of the gone-to-seed Leatherstocking tradition. It had been Baldy who brought the Yankee and the Irishman to the gold-rich ravine some months before. When the three of them discovered that they were likely to be harassed by "Indians of the most treacherous and implacable kind," Baldy had gone back to St. Louis for help and had brought the young hunchback and his Steam Man out on the prairies on purpose to assist his friends.

Baldy knew about Johnny Brainerd because one time, in St. Louis, he had accidentally discovered the workshop where Johnny was building his Steam Man. Baldy—"a brave, skillful hunter who had been engaged in many desperate affrays with the redskins" and had once, as his name

suggests, been scalped by them—never went farther east than St. Louis, but he did go there occasionally, since he had friends there and also, conveniently enough, "a good sum of money in the bank." It was on one of these visits that he strayed into Johnny Brainerd's shop. The "strong, hardy, bronzed trapper" was impressed by the "pale, sweet-faced boy, with his misshapen body," and he at once recognized that the invention on which this prettified Vulcan was working would be "just the thing for the West; we'll walk through the Injuns in the tallest kind of style," he told Johnny, "and skear 'em beautiful."

So Johnny, heartened by Baldy's enthusiasm—and unaccountably encouraged by a mother who had been widowed by the explosion of a steam boiler—went on working on his steam man and had completed it by the time Baldy returned to St. Louis to get help for his gold-seeking friends.

Johnny's mechanical ingenuity "bordered on the marvelous," of course. From the earliest youth he had invented all sorts of things which, "had they been secured by letters patent . . . would have brought a competency to him and his widowed mother." But Johnny, in the best Franklinian-Jeffersonian tradition, never thought of patenting them, even though "the principal support of himself and his mother came from one or two patents, which his father had secured upon inventions, not near the equal of his."

It was his mother, perversely enough, who had originally suggested that he devote his mechanical genius to making "a man that shall go by steam." Despite the fact that her own husband "went by steam," in another sense of the phrase, she was pleased when her son decided to follow her suggestion, "for, when her boy was at work, he was happy," and she knew that the steam-man project would keep him occupied for many months.

Johnny got busy, and with the aid of the proprietor of a neighboring foundry (who—as always seems to be case in the biographies of real and fictional mechanical geniuses —"took great interest in the boy" and permitted him to

make castings in his foundry), finally succeeded in making his steam man.

> It was about ten feet in height, measuring to the top of the "stove-pipe hat" [Ellis tells us]. The face was made of iron, painted a black color, with a pair of fearful eyes, and a tremendous grinning mouth. A whistle-like contrivance was made to answer for the nose. The steam chest proper and boiler were where the chest in a human being is generally supposed to be, extending also into a large knapsack arrangement over the shoulders and back.

In this knapsack were the valves and gauges by which steam pressure and water level were controlled. Fuel (coal or wood) was fed through a door opening into the steam man's belly, below his painted imitation vest, and ashes were removed through his knee caps. His broad, flat feet were shod with sharp spikes, "as though he were the monarch of baseball players," and his arms held the shafts of the wagon he pulled.

The wagon, resembling a small express wagon, was especially made by Johnny even though it would have been "a much easier matter" to have merely altered an ordinary wagon. It carried enough fuel and water for twenty-four hours of travel, as well as the tools necessary for repairs, and from it the driver controlled the steam man by lines, or straps, like horse reins that turned him right or left, and by a rod that "let out or shut off" the steam. The wagon had a covering for use in bad weather, variously described as "canvass" or "oil skin," that could be extended to shelter the Steam Man also when necessary. With this wagon in tow, the steam man could run very nearly sixty miles per hour, though Johnny thought thirty was about as fast as the wagon should be drawn on ordinary roads or across open country.

The general figure of the steam man is described as "exceedingly corpulent, swelling out to aldermanic proportions," giving plenty of room, as Johnny told Baldy, "to have everything strong" and to give the machinery "a

chance to work." Indeed, the body and limbs were "no more than shells, used as a sort of screen to conceal the working of the engine," in much the same way that the Sheraton or Hepplewhite cabinets of television sets nowadays are mere shells to conceal their mechanisms. Like these latter-day shells, the shell of Johnny Brainerd's machine was obviously nonfunctional, in the naively materialistic acceptation of that term, but like them it made its own symbolic sense.

When we remember that Ellis conceived Brainerd's steam man in a decade when more than 2,500 people were killed in steamboat explosions on U.S. rivers, and hundreds more died as a result of locomotive explosions on railroads, it is surely significant that the readers of dime novels—a vast cross-section of the American public—enthusiastically welcomed an image of mechanical power in at least vaguely human form. A steam *horse* would seem, after all, to have been a more logical choice to pull Johnny Brainerd's wagon, especially since it would have been mechanically easier to balance the mechanism on four legs instead of only two. Yet it seems unlikely that a dime novel about a steam horse would have had any of the culture-focusing qualities that the concept of a steam man obviously had in Ellis's story and the later imitations of it.

Buckminster Fuller long ago pointed out that the chief difference between an agrarian and an industrial civilization is that the former depends predominantly on animate slaves (human beings, horses, oxen, dogs, even squirrels) while the latter depends upon "the inanimate servitude of abstract power."

The steam engine was, of course, the principal nineteenth-century source of abstract power and the prime symbol of the machine technology that was rapidly converting the United States from an agrarian to an industrial nation. Ellis's steam man, made in St. Louis—still at that time the metropolis of the trans-Mississippi West—by a young mechanic for his own use, thus symbolizes the aver-

age man's control of the new civilization's power base.

The fact that Ellis's mythical figure was created just three years after ratification of the Thirteenth Amendment abolishing human slavery may tempt us to make something of the fact that the face of the steam man is initially described as "painted a black color" with a "grinning" mouth. But a few paragraphs later we are told that the face "was intended to be a flesh color, but was really a fearful red," and nothing in the cover illustration suggests Negroid features (see figure 19). What matters, and what is repeatedly emphasized throughout the narrative, is that the power of steam has been harnessed in human form, the form of a man. The steam man, frequently referred to as "the gentleman," is the embodiment of abstract power in a form suggesting that it could be, even if it had not yet been, humanized.

"BEGORRAH, BUT IT'S THE OULD DIVIL, HITCHED TO HIS THROTTIN' WAGING, WID HIS OULD WIFE HOWLDING THE REINS!" EXCLAIMED MICKEY.

Cover illustration, Edward S. Ellis, *The Huge Hunter; or The Steam Man of the Prairies,* Beadle's Half-Dime Library, no. 271, Beadle and Adams, New York, October 1882. Figure 19.

The novel is full of the general awareness that steam power had not, in fact, yet been humanized. Johnny Brainerd's mother is not the only friend and admirer of the steam man who is personally acquainted with the destructive terrors of steam. Baldy, Ethan, and Mickey had, indeed, first met in the aftermath of a steamboat explosion on the Upper Yellowstone River; all three of them happened to be on board the boat, en route to St. Louis, and Baldy was seriously injured. Only the timely assistance of the Yankee and the Irishman saved his life. So in gratitude he had subsequently taken them to the ravine where he knew there were rich deposits of gold and where we first encountered them.

Throughout the narrative of the adventures of Johnny Brainerd and his companions—chasing Indians and being chased, hunting buffalo and being attacked by them—Ellis nevertheless reiterates that there is nothing really frightening or supernatural about the steam man, since it was simply a machine invented and controlled by a human being. Early in Baldy's and Johnny's trip across the prairies from Independence, Missouri (where the steam man had been shipped from St. Louis by steamboat), they have great sport chasing a dozen or so mounted Indians who run from the shrieking figure "as though all the legions of darkness were after them." But Ellis takes pains to assure us that had the Indians understood the real nature of the creature, they would not have hesitated to charge it when its fires were out and demolish it. Later, after some Indians had a chance to examine it one time when Johnny left it untended, they no longer feared it because they understood "that there was some human agency about it." So too, when Johnny and Baldy drove the Steam Man up to a train of emigrant wagons and Johnny blew its nose-whistle, some of the men were "too appalled to do anything except gaze in stupid and speechless amazement." But one or two of the emigrants, Ellis assures us, "had sense enough to perceive that there was nothing at all very supernatural" about the machine, and there was no such consternation

and terror as had greeted Robert Fulton's steamboat a half-century earlier. "At this late day," Ellis observes, "no such excitement can be created by any human invention."

Curiosity, not fear, is the emotion the steam man chiefly arouses, despite its "grotesque and fearful look." When Baldy first caught a glimpse of it in St. Louis, he casually thought he would "come in and see what in blazes it was." One of the startled emigrants in the wagon train was "determined to know something more about it" and raced after it on horseback—though of course he couldn't catch up with it. And when the Indians found it untended, they at once "congregated around it, and made as critical a scrutiny as they knew how," several of them climbing in the wagon, others climbing "in and around the helpless giant," and one hitting it an irreverent thwack on the stomach with a tomahawk. Baldy was quite right when, with the eye of a Barnumesque entrepreneur, he decided that after the western trip he would buy the "old feller" and take him around the country and exhibit him. In the climate of opinion Ellis's novel reflects, Baldy was surely justified in thinking that people would "break their necks to see him" and that he would "make more money with him than Barnum ever did with his Woolly Horse."

Baldy never got the chance, as things turned out, because the steam man, like the Yellowstone steamboat and the steam engine that killed Johnny's father, ultimately blew up. But this explosion was planned and controlled and—from the point of view of Johnny and his friends—beneficent. The steam man and our heroes, laden with gold, were on their way back to St. Louis when they were trapped by Indians in a narrow valley. The Indians, hiding behind a wall of huge rocks they had rolled down the hillsides to block the way, seemed to have the entire party at their mercy. Johnny, however, knew what to do. Stoking up the steam man till it was red-hot and the steam pressure in its boiler was near the bursting point, he aimed it directly at the stone wall and set it going at forty miles per hour. It struck the boulders, shot over on its face, and fell

upon the far side "directly among the thunderstruck Indians." As it did so, it exploded like a bomb. Those Indians who escaped death were understandably "beside themselves with consternation," and in the ensuing confusion it was no trick for Johnny and his friends to round up their gold and the Indians' horses and head for Independence. Safely arrived there, they took the steamboat to St. Louis and journey's end.

III

Midway in the novel, when Baldy first sees Johnny's invention, he exclaims admiringly, "Whoever heard of a man going by steam!" To which Johnny quietly replies, "I have, often."

So, as a matter of fact, had many Americans who may have bought Ellis's dime novel. On 16 January 1868, more than six months before *The Steam Man of the Prairies* was published, a St. Louis newspaper, the *Missouri Democrat,* reprinted an article from the Newark, New Jersey, *Advertiser* about a steam man invented by a twenty-two-year-old Newark mechanic. From the U. S. Patent Office records we know that the young inventor's name was Zadoc P. Dederick, not Zadock Deddrick as the newspapers gave it, and that his partner (and financial backer) was Isaac Grass, not Graes as in the paper. All I know about either is what is given in *Gopsill's Newark City Directory 1867–68.* Dederick is listed there as a "patternmaker" who lived at 87 Spring Street and worked at 105 River Street, the address listed for "Grass & Rosenbaum, trunkmakers," of which Isaac Grass was the senior partner.

The Newark *Advertiser*'s account of Dederick's steam man was no doubt picked up by many papers besides the one in St. Louis, and must surely have been read in nearby Trenton, where Ellis was teaching at the time and turning out dime novels at the rate of one or more each month. There are, in any event, striking similarities between the steam man described in the newspapers in January, and the one in Ellis's novel published in August.

Dederick's steam man was seven feet nine inches tall, the trunk of its body consisting of a three-horsepower steam engine like those used to run the pumps on fire engines of the period. Dederick planned to dress "the fellow" as the *Advertiser*'s reporter called it, like a human being so that it would not frighten horses on the city streets.

Its legs were "complicated and wonderful," we are told, so arranged that as the weight of the body was thrown forward onto the advanced foot, the other was lifted from the ground by a spring and shoved forward by steam. Since each full stroke of the piston produced four paces, the contraption could travel a mile a minute, but Dederick (like his fictional counterpart, Johnny Brainerd) thought thirty miles an hour was fast enough. The steam man could be stopped by means of "appliances" Dederick had perfected to tilt it backward from the vertical and bend the knees in the opposite to normal direction. Like Ellis's fictional steam man, Dederick's invention was supported in its vertical position by the shafts of the vehicle it pulled—in this case "a common Rockaway carriage" beneath whose seats there were a supply of coal for fuel and a tank of water to feed the boiler. According to the *Advertiser*'s report, the entire contraption cost $2,000 to build, but Dederick and Grass expected to manufacture others that would sell for only $300 and be "warranted to run a year without repair."

Some idea of what Dederick's steam man looked like can be got from the drawing he submitted to the Patent Office in support of his patent application (figure 20), though the picture shows it pulling a simple two-wheeled cart instead of the Rockaway carriage he actually used. The newspaper reporter does not say anything about the steam man's head, but the care with which it is represented in the patent drawing, with a pipe protruding from its thick lips and a stove-pipe hat on its curly pate, indicates that Dederick wanted to emphasize the human aspect of his device and must certainly have made some attempt to equip the actual machine with a recognizably human face.

What became of Dederick's steam man is not recorded,

Figure 20. Drawing accompanying patent application of Zadoc P. Dederick and Isaac Grass, 1868. (From *Report of the Commissioner of Patents,* Washington, 1868).

so far as I know. Possibly it blew up, like the fictional one though less beneficently. Whatever happened to the steam man, Edward Ellis, the Trenton teacher who was soon to become a school principal and later superintendent of schools, took hold of Dederick's conception and built it into mythic significance in his dime novel.

IV

In one sense the conception Ellis borrowed from the young Newark mechanic was not new. Men had been making mechanical men and other automata for many years. There are references in old encyclopedias, all some-what dubious, to mechanical animals made in ancient Rome and, even earlier, in Egypt. Authenticated examples date from the early eighteenth century in France. In 1738 Jacques de Vaucanson, a mechanical genius of a high order, exhibited to the Paris Academy of Science a decep-tively lifelike mechanical man which played the flute,

moving its lips, tongue, and fingers to produce acceptable music. Three years later he exhibited his masterpiece, a life-size mechanical duck that waddled and swam, wagged its head and quacked, beat the air with its wings, ate and drank with avidity, "and muddled the water which it drank." You can read all about it in Sir David Brewster's *Letters on Natural Magic,* which was published in many editions in England and America after its original appearance in 1832. Brewster tells how, when corn was put before the duck, it stretched out its neck, picked up the corn in its bill, swallowed it, and digested it in a miniature chemical laboratory from which the decomposed constituents were caused "to issue forth at will."

Descriptions of Vaucanson's emunctory duck and other early automata were familiar to many readers in the mid-nineteenth century. Edgar Allan Poe quoted freely from Brewster's account of them in his widely read article on "Maelzel's Chess Player"—a purported automaton that wasn't what it seemed to be, as Poe took ratiocinative pleasure in proving. But such automata, as well as such ancestors of our modern "electronic brains" as the never-perfected mechanical computer designed in 1823 by the English mathematician Charles Babbage (to which also Poe refers), differ in essential respects from Dederick's, and Ellis's, steam man. In making them, the dominant impulse was to demonstrate mechanical ingenuity, to show what complicated things machines could be contrived to do, or—as was true of the early eighteenth-century French automata especially—to prove by demonstration the current philosophical belief in the mechanical nature of life. It is noteworthy that Vaucanson's flute player and duck are enthusiastically described in Denis Diderot's *Encyclopedia* (1751), the most comprehensive and effective presentation of eighteenth-century French materialism, and that Vaucanson was a contemporary of Julien Offray de la Mettrie, the cantankerous French physician and philosopher who in 1748 published *L'Homme Machine,* arguing that man

is really nothing but a highly complicated mechanicism.

There is no evidence that either Dederick or Ellis was interested in philosophical speculation, but if their steam men had philosophical implications, they were the absolute converse of those embodied in the eighteenth-century French automata. What they proved, if they proved anything, was that a highly complicated mechanism is really, as the Yankee Ethan Hopkin's practical eye saw, nothing but "a human contrivance."

The many editions of Ellis's novel were only one sign of the widespread and persistent appeal of the idea that abstract mechanical power was subject to man's control. In 1883, a year after the fourth publication of Ellis's story (in Beadle's Half-Dime Library), another dime-novel publisher brought out *Frank Reade and his Steam Man of the Plains*—one of a long series of "Frank Reade" stories, most of which were written by Lu Senarens. These Frank Reade stories were much and deservedly admired by Jules Verne for the mechanical wonders that were preinvented in them, including armored tanks, submarines, and helicopters. But Frank Reade's "Steam Man of the Plains" is nothing but Ellis's (and Dederick's) in slightly altered form (figure 21). It is taller (twelve feet to the top of its "plug hat"), but like its prototype is "corpulent," has a knapsack accommodating part of the mechanism, has feet "spiked like a baseball player's," and is capable of traveling at high speed though its "inventor" does not plan to run it at more than thirty or thirty-five miles per hour. Furthermore, like Johnny Brainerd's steam man, Reade's pulled a wagon, stocked with its fuel and water, having "a tent-like covering" for protection in bad weather.

Though there was nothing really new about Reade's steam man, he was as popular with the dime-novel readers as the original—so popular, indeed, that in September 1892 the publisher began issuing a new series of novels, the first of which was called *Frank Reade, Jr., and His New Steam Man; or the Young Inventor's Trip to the Far West*. This

Cover illustration, "Noname" [Lu Senarens?], *Frank Reade and His* Figure 21.
Steam Man of the Plains, The Five Cent Wide Awake Library, vol. 1,
no. 541, Frank Tousey, New York, 24 January 1883.

novel tells how the son of the elder Reade, who had "out-
stripped his sire" as an inventor, was spurred to new
heights by his aging father's claim that his original steam
man had been "really the most wonderful" of all inven-
tions—even more wonderful than young Reade's "flying
machines, electric wonders, and so forth." Laughing
quietly and patting his father on the back, Frank, Jr. said,
"with an affectionate and bantering air":

> "Dad, what would you think if I should produce a
> most remarkable improvement upon your Steam Man?"
> "You can't do it!" declared the senior Reade. Frank, Jr.
> said no more, but smiled in a significant manner. One
> day later the doors of the secret draughting room of de-
> sign were tightly locked and young Frank came forth
> only to his meals.

Three months later young Frank had finished a "new steam man," causing Frank, Sr. to exclaim fulsomely that "young blood is the best after all." Despite this insipid bit of deference to the young, the "new" steam man is scarcely distinguishable from the one created by Johnny Brainerd in Ellis's novel twenty-four years earlier. Except for a "more nicely balanced" mechanism and "steel of finer quality" it is the same old fellow, as the cover illustration shows (figure 22). And the dime-novel readers were well content to have him remain the same, as witnessed by their purchases of a whole series of novels about Frank, Jr.'s adventures with him in Central America, Texas, Mexico, Montana, and other places.

V

Both in fact and in fancy the steam man was a product of the eighteen-sixties, the decade that foreshadowed future mechanical and scientific developments with extraordinary swiftness. As Siegfried Giedion has observed, in his *Mechanization Takes Command* (1948), "a collective fervor for invention" seemed to take hold of the American people during this decade. There had, of course, been great ages of invention in the past, but in them the creative and inventive urge had been concentrated in a few savants and philosophers, as in the times of Descartes, Leibniz, and the immensely fertile Dutch scientist and inventor Cornelius Drebbel, during the seventeenth century. But in the United States during the 1860s everyone, it seemed, was inventing. At no other time in history has a nation produced so many inventions per capita, or so many by inconspicuous or anonymous citizens. Mechanization, at every level from the manufacture of huge locomotives to the design of domestic carpet-sweepers and egg-beaters, was literally an American folk way.

The appearance in 1868 of Dederick's actual steam man and, a few months later, of Ellis's mythical extension of him tells us more about underlying popular attitudes toward the machine than we can learn from the ambivalent

Cover illustration, "Noname" [Lu Senarens?], *Frank Reade, Jr., and* Figure 22.
his New Steam Man; or, the Young Inventor's Trip to the Far West,
Frank Reade Library, vol. 1, no. 1, Frank Tousey, New York, 24
September 1892.

imagery that appears in the writings of such major literary
figures as Hawthorne, Melville, and Henry James. The
"pale, sweetfaced" Johnny Brainerd of Ellis's dime novel
has little in common, for example, with the pale and sensi-
tive Owen Warland of Hawthorne's story "The Artist of the
Beautiful." Both are mechanical geniuses, but Hawthorne
tells us that Owen, as a child, looked "with singular dis-
taste at the stiff and regular processes of ordinary ma-
chinery," and, when taken to see a steam engine, "turned
pale and grew sick, as if something monstrous and unna-
tural had been presented to him." What fascinated Owen
were the accounts of such "marvels of mechanism" as Vau-
canson's duck, and it became his dream not to humanize
but "to spiritualize machinery"—a dream he finally ful-

filled by making a mechanical butterfly, so perfect as to be "Nature's ideal butterfly."

Johnny Brainerd, in Ellis's story, was not ignorant of the "monstrous and unnatural" potentialities of the steam engine, but his aim, and his symbolic triumph, was to humanize it; not outdoing nature by mechanically producing nature's ideal man, but making a powerful machine manlike and companionable. And it is a measure of the validity of Ellis's mythic creation that, less than three years after the Newark mechanic Zadoc Dederick created its material prototype, another New Jersey mechanic succeeded in making the steam engine a domestic toy. In 1871 Eugene Beggs of Patterson patented and began manufacturing the first toy trains, whose miniature steam locomotives, fired by alcohol burners, were soon pulling toy cars around circular tracks in the parlors and nurseries of many American homes "to the admiration of all and the special delight of small boys," as noted in L. R. Trumbull's *Industrial History of Patterson* (1882). The steam engine, first conceived in Egypt by Hero of Alexandria before the Christian era as a means of creating magical effects in the temple to awe the ignorant populace, had at last become not only a docile "inanislave" but a toy for a nation's children.

Our world, of course, is not the same world that delighted in Ellis's myth-making dime novel and its successors. One measure of the difference is the shift from the small Newark shop where Zadoc Dederick made his steam man to the multimillion-dollar laboratories whence synthetic man may emerge. But in one respect at least our world is probably more like that of Dederick and Ellis than we are disposed to think. Those modern substitutes for dime novels, the comics, have already begun to grope for a mythic figure adequate to the contemporary scene. Just a few months after Russell Baker's column about synthetic man was published—and almost a century after *The Steam Man of the Prairies* first appeared—*Adventure Comics* introduced "Computo, the Conqueror," made in the "United

Planets Lab Complex" by one of Superboy's associates in the Legion of Super-Heroes. But Computo is a "mutinous mechanism" in the European "R.U.R." and Frankenstein-monster tradition, bent on destroying his maker, not a descendant of the serviceable American steam man.

There are hopeful signs, however, even in this rather routine strip cartoon. Despite Superboy's modishly disconsolate reference to Computo as a "heartless, soulless monster," some of his comrades in the Legion of Super-Heroes seem capable of a more vernacular response, referring to the electronic creature as a "heartless jukebox" and a "boiler factory Benedict Arnold." Perhaps it will not be long before someone does for the contemporary symbol of abstract intelligence what Ellis did for the nineteenth century's chief symbol of abstract power. Perhaps, indeed, the job has already been done somewhere on the cultural landscape, in a form as ubiquitous and as unheeded by the custodians of culture as were the dime novels of a century ago.

Living in a
Snapshot
World

I delivered a lecture with this title
on 22 November 1972 as the third in a
series of lectures on photography
given by different people under the
joint sponsorship of the Museum of
Modern Art and the Metropolitan
Museum of Art. I revised that lecture
for delivery at the New York State
Historical Association on 1 March
1973 and rewrote it entirely in
November 1973. (Excerpts from a
taped transcription of the original lec-
ture were printed in the *Photo Re-
porter* without my prior knowledge,
and portions of the lecture were pub-
lished in *Aperture* 19, no. 1, 1974.)

Painting was difficult, expensive,
and precious, and it recorded what
was known to be important.
Photography was easy, cheap and
ubiquitous, and it recorded any-
thing: shop windows and sod
houses and family pets and steam
engines and unimportant people.
And once made objective and
permanent, immortalized in a
picture, these trivial things took on
importance. By the end of the
century, for the first time in history,
even the poor man knew what his
ancestors had looked like.
 John Szarkowski
 The Photographer's Eye, 1966

All of us live, without realizing it, in a world of which we are aware primarily because of photography. And the overwhelming majority of the photographs to which we owe our awareness are snapshots. We live, quite literally, in a snapshot world.

My own encounter with this extraordinary fact occurred very recently while looking at the snapshots in an album assembled from about 1885 to 1915 by one of my mother's older sisters—one of the Philadelphia maiden aunts who dutifully but not joylessly "kept house" for their widowed mother, my Quaker grandmother. Most of the pictures in the album are snapshots in the sense of the term I am employing: they are predominantly photographs taken quickly, with a minimum of deliberate posing on the part of the people represented and with a minimum of deliberate selectivity on the part of the photographer so far as vantage point and the "framing" of the image were concerned.

The earliest pictures in the album were taken when my mother was eight or ten years old; the latest when I was six and my parents were a still-young married couple. Looking through them now, trying to decipher the faded blue prints and sepia prints, has its melancholy aspects. None of those pictured in the album, except my sister and me, are now alive. Even the houses they lived in then are gone. And yet in a curious way those vanished people and places and events are a vivid part of my present world. Thanks to these familiar snapshots I am, I suddenly realize, a member of the first generation in human history whose awareness of the past comprises a multiplicity of unarguably real informal images of our parents' childhood worlds as well as our own.

I mean by this more than I think John Szarkowski meant when he said even the poor man knew, by 1900, what his ancestors had looked like. It was true, of course, that almost anyone who was of age at the turn of the century could have a daguerreotype or carte de visite photograph of his grandfather or even his great-grandfather. But these were not snapshots. They were formally posed images, often taken amid the "luxurious and elegant" settings pro-

vided by the photographer's studio—painted landscape backgrounds, Grecian columns, balustrades, draperies, tassled sofas, carved oak chairs. They were the poor man's substitute for a portrait by John Singer Sargent or Carolus-Duran. Nothing like an album of snapshots was possible before the 1880s.

Beginning then, however, people with cameras ran rampant, as a professional photographer of the time bitterly complained. They haphazardly photographed objects of all sorts, sizes, and shapes, he lamented, "without ever pausing to ask themselves, is this or that artistic?" The results, gathered into family albums, grant us a visual acquaintance with the past unlike that available to anyone, rich or poor, in previous generations.

Many of us have inherited such albums, for even in our mobile, throwaway society people keep such intimate memorabilia—if only because of some vague feeling that it is indecent to do otherwise. The one I own is, I suppose, much like hundreds of others of the same period, and I discuss it and a few of the pictures it contains not because it is uniquely interesting but because it is representative. It just happens to be the one to which I owe my awareness of what snapshot vision has done to our conception of past and present reality.

The album's pages are large (10¾ by 13½ inches), big enough to hold as many as fifteen of the small prints produced from the roll film used toward the end of the period. A typical page (figure 23) contains at the top a group of vacation snapshots taken at Rockport, Massachusetts, in the summer of 1909, a few months before I was born, and at the bottom a similar group taken at the same resort two summers later. At the center a slightly tilted picture of the shingle cottage, half of whose ground floor was open porch with the dormered second floor projecting over it. Several snapshots of the rocky coast, one with a ready-to-launch Coast Guard lifeboat dominating the entire right half of a picture in which it was obviously intended to be only a minor focus of interest. Snapshots of posed groups of adults and children arranged in tiers on the porch steps.

Figure 23.

Figure 24.

Not all the snapshots of people are self-consciously posed, however. Some are "caught" accidentally, as it were, and some of these have a visual interest beyond any associations they necessarily evoke in a member of the family. Look, for example, at the snapshot of my grandmother with her parasol, sitting by one of my aunts on the sun-warmed rocks across the water from the Straitsmouth Inn (figure 24) or at the snapshot taken from the porch of Grandmother's cottage during the arrival of a visitor who has come by automobile (figure 25). In neither instance did the human subjects deliberately assume poses they thought were pictorially suitable. It may be that the photographer's pre-snap selection of pictorial elements to include in figure 24 was quite carefully considered, but in the other picture many of the elements of the design were obviously accidental—as, for instance, the off-balance posture of the smiling woman in dark traveling clothes who is approaching the

Figure 25.

camera. The particular way her arms are disposed and the way the folds of her long skirt curve toward the ground combine to create an image of lively motion, contrasting with the casual repose of the three white-clad female figures at the left and the straight, dark, unrounded form of the man standing at the center. And surely the photographer, intent on snapping the picture before the visitor came too near the camera, cannot have deliberately composed the picture so that the two telephone poles at the center and the one up the hill near the Straitsmouth Inn serve as markers for the three contrasting types of human figures, while the fourth pole, at far left, provides a visual accent against the water and sky to balance the heavier form of the inn against the sky at the right. Nor could he or she have realized that the lines of the post-and-rail fence would converge as they do upon the smooth rectangular plane of the automobile's roof.

Only a few of the photographs on the earliest pages of the album have these accidental qualities that are characteristic of snapshots. The young lady who took them, Elizabeth Atlee, saw the world about her with eyes accustomed to seeing what the pictures by well-known painters and illustrators had taught her to see. She and her younger sisters were conventionally educated according to middle-class Philadelphia standards. They took music lessons; they did embroidery and needlepoint and mending; they carved things out of wood; they drew and painted pictures with varying degrees of skill. Several of their acquaintances were artists—one of whom, Cecilia Beaux, in 1882 painted from a daguerreotype a picture of my grandmother as a little girl. It is one of many paintings on porcelain plates Miss Beaux did in the eighties but, as she tells in her autobiography, later repented of when she discovered in Paris what the art of painting really was.

Inevitably, therefore, when my eldest aunt got her first camera in the mid-eighties, when she was about sixteen, she selected her subjects with a painter's rather than a photographer's eye. Many of her early photographs are interior shots—time exposures taken with the camera on a tripod, by gaslight, or by window light reflected from mirrors or white sheets hung behind the camera. Some are quite lovely, but like that of one of my aunts at the piano (figure 26) could not have been composed or lighted by someone who had never seen paintings or engraved reproductions of paintings by Eastman Johnson, or Sargent, or my aunt's distinguished fellow townsman Thomas Eakins. But it is not primarily from such "artistic" photographs that I have built up my visual awareness of my family's past.

That awareness comes from the snapshot images which appear with increasing frequency as one turns the album's pages: my mother as a girl of twelve, off to school at Miss Gordon's across the street (where Cecilia Beaux had also gone) while Grandmother watches benignly from the bay

Figure 26.

Figure 27.

window (figure 27); her older brother strolling through a field one summer day in the early nineties by the side of a pretty girl who has no need of a hat since she walks in the shade of a parasol he is holding for her (figure 28); my mother and a young friend on a snowy day in the winter of 1888 coasting down traffic-free Spruce Street hill while children from neighboring houses trudge in countermovement back up to the top of the rise (figure 29); my never-seen grandfather—dead fifteen years before I was born—in his untidy hunting clothes and rumpled gaiters, standing in the back entryway of his house with his gun in one hand and a brace of birds hanging from the other, looking down at the spaniel, Spy, who has dropped in contented weariness at his feet (figure 30).

Figure 29.

Figure 28.

Figure 30.

I do not wish to imply that these snapshots are true images of past reality in any absolute sense. I am quite aware that the visual sense of my mother's childhood I have derived from them is a limited and heavily edited one. And I am quite ready to concede that a single picture of my mother as a young girl, painted let us say by Thomas Eakins or Mary Cassatt, might have been a truer, or at least more significant image than even the visual synthesis I am able to put together from the accumulation of discrete snapshot images in my aunt's album.

Photographs record only unstoried instants of ever-changing reality, while paintings include aspects of that reality that were perceived over a period of time and deliberately selected by the painter for their significance. There is, of course, a process of selection involved in snapshots also, but it occurs prior to the making of the image and at most determines the instant at which the unedited details will be recorded. It cannot select some details and ignore others visible at that instant, nor can it incorporate details that were visible at other moments no matter how significant the photographer might consider them to be. A continuing process of selection determines what details are included in a painting, and the painting's truth is the truth of that sustained process. No painting can tell the truth of a single instant; no snapshot can do anything else.

The point I want to insist on is the obvious but seldom considered fact that a visual sense of the past synthesized from a multiplicity of snapshot images such as those in my aunt's album is altogether different from any visual sense that could be derived from even the truest painting, simply because the synthesized details were not sequentially selected from a single emotional or intellectual point of view.

The earliest of these snapshots were taken with a hand-held camera using the recently perfected dry-plate negatives. When we broke up Grandmother's house in the 1940s after the last of her unmarried daughters gave up trying to maintain it, I found on a closet shelf one of the cardboard

boxes in which a dozen of these 3¼ by 4½ inch glass plates had been packaged. The blue label tells us they were Arrow Brand "Extra Rapid Dry Plates for in or out-door Photography," made by the M. A. Seed Co. of St. Louis. One of my aunts had "written "Odds and Ends" on the side of the box and had kept in it two exposed plates, both damaged but both readable. One showed a skating party in the flooded back yard of my grandparents' house. The other, shown here in a print made from it (figure 31) shows my mother as an eighteen-year-old, perched on the porch railing of a seaside cottage, sewing while her cousin reads to her. The plate is marred by fingerprints and spots where

Figure 31.

the gelatin coating was nicked from the glass. There are no prints from either of these blemished negatives in the album, but the plates themselves were carefully kept, no doubt because, as Szarkowski says, even such trivial images, once made objective and permanent, seemed too important to destroy.

Gelatin-coated dry plates like these, commercially available at relatively little cost in the early 1880s, brought about a major change in the nature of photographic images. For one thing they freed the photographer from the necessity to remain close to his darkroom. With the earlier wet plate process, you had to prepare the glass plate in the darkroom (illuminated only by a dim red or orange light) by coating it with collodion and soaking it in a silver nitrate solution; then insert it in a lightproof holder, carry it to where your camera had already been set up and focused, insert it (still wet) in the camera, uncap your lens, and make your time exposure; then take the exposed plate in its resealed holder immediately back to the darkroom and put it through a series of chemical baths to bring out and fix the image. Only if you had a portable darkroom, in a tent or horsedrawn wagon, could you move about with any freedom at all. Even then the time required to select your subject, set up and focus your camera, prepare your chemicals and make your plate ready precluded the possibility of anything like spontaneous picture taking.

The dry plates available in the 1880s, however, were ready whenever you wanted them, and the new compact hand cameras with fast-acting mechanical shutters and simple view-finders were quite light and easy to carry. So you were relatively free to wander about taking pictures wherever you wanted to.

Furthermore, the new cameras and plates were amazingly cheap. The average amateur's equipment in the late 1880s cost less than twenty dollars, including camera, tripod, six double plate-holders, and a box of a dozen dry

plates. Since the plates were, as the Arrow Brand label says, extremely sensitive, you could get a clear picture with an exposure of one twenty-fifth of a second or less in normal daylight, and even at night you could do so with the aid of inexpensive magnesium flares. So you didn't have to carry your tripod with you, fix your camera to it, and fiddle with its adjustable legs to level your camera every time you took a picture.

The whole business of picture taking, thanks to the dry plates, suddenly became both easy and unobtrusive. A picture-taking expedition had been reduced from something like an African safari to the equivalent of a mere stroll with a picnic basket. You could photograph anything or anybody with a minimum of fuss and—even more importantly—without enlisting the cooperation of your subject. And because you *could* do so, you *did* do so. The era of snapshots had arrived. When George Eastman came along at the end of the '80s with his extraordinarily compact and handy Kodak and his celluloid roll film, he vastly increased the number of snapshots you could take on a single loading of the camera, and by cheapening and simplifying the process vastly increased the number of people who could indulge in the sport. But hundreds of thousands of snapshots had been taken on dry plates before Kodak's "You press the button; we do the rest" became one of the best-known advertising slogans in history.

The word "snapshot," interestingly enough, was originally a hunting term. According to the great Oxford dictionary the earliest recorded use of the word is in the diary of an English sportsman with the apposite name of Hawker who in 1808 noted that almost every bird he got was "by snapshot"—meaning a hurried shot, taken without deliberate aim. As early as 1860 Sir John Herschel, one of the pioneers of photography and the inventor of its name, speculated about the possibility at some future time of being able to take photographs in a tenth of a second "as it

were by a snapshot," but this was a figure of speech depending for its effect upon the reader's familiarity with hunters' lingo. Even in the late 1880s, by which time it appears frequently in articles about the new instantaneous photography, its hunting origins were still remembered and acknowledged by putting the word in quotes. But by 1890 the takeover was complete and *Anthony's Photographic Bulletin* could and did publish what it labeled "Snapshots taken with a hand Camera," no quotes or apologies whatever.

The term had been appropriated to photography because it was appropriate. Ever since the dry plates became available people had been fascinated with the idea of shooting pictures surreptitiously. They went about hunting for unposed images to record, taking pictures of people before they had time to freeze into the formal expressions and stances we instinctively adopt when we ready ourselves for posterity, even taking pictures of people without their knowledge. Indeed, the early hand cameras were generically referred to as "detective cameras," and George Eastman's advertisements of his first Kodak claimed only that it was "the smallest, lightest and simplest of all Detective Cameras," not something altogether new. Even that claim was only partly justified. The Kodak was considerably larger and heavier than the "Concealed Vest Camera" advertised in 1889, which could be hung around your neck, under your vest or coat, with its buttonshaped lens protruding through a convenient buttonhole. It came in two sizes, but even the large fifteen dollar size was only seven inches in diameter and three-quarters of an inch thick, and it had been on the market for two years before the Kodak. An article in *Harper's* in January 1889 said that as many as three hundred of these buttonhole cameras were carried in Russia by the police and that in Germany they were very popular "especially with artists"—a clientele that tells us, I suppose, as much about late nineteenth-

century German art as it does about the Czar's police.

In any event, the insistence in advertisements on the concealed, invisible aspect of such cameras and their being "always ready and in focus" bears witness to the then current interest in unpremeditated shots at unwitting subjects. And if one looks at any group of snapshots made at the time and compares them with the paintings and engravings and other pictorial material then available, one can easily see why. For without intending to do so, and without realizing what they were doing, the amateur takers of snapshots were revolutionizing mankind's way of seeing. We do not yet realize, I think, how fundamentally the snapshot altered the way people saw one other and the world around them.

I am, of course, aware that much has been written about the effect of photography on many aspects of our culture. William M. Ivins, Jr., for some years curator of prints at the Metropolitan Museum, said some of the wisest, crispest, and most profound things that have ever been said on this topic twenty-five years ago in that fascinating book of his, too-scrupulously entitled *Prints and Visual Communication*—a title that gives no hint of its far-reaching implications and illuminating insights into the way changes in the techniques of picture making and picture reproduction have affected not only the visual arts but science and technology as well. But we have paid little heed to the effect snapshots have had upon all of us—photographers and nonphotographers alike—by reshaping our conception of what is real and therefore of what is important.

Ivins was of course right in saying that we tend to see and value only what the pictorial techniques and conventions of our time are calculated to show us. From pictures made by those techniques and in accordance with those conventions we learn what is worth looking for and looking at. And never before in the world's history has a change in the technology of picture making so suddenly and so drasti-

cally altered pictorial conventions, and hence our ways of seeing, as the development of snapshot photography has done.

What differentiates snapshots from all earlier modes of picture making is that they taught us to see things not even their makers had noticed or been interested in. The snapshots you and I make always call our attention to things we were unaware of when we pointed the camera toward them; and not infrequently, when we pick up the finished prints in the drugstore, those unnoticed elements of the scene are obtrusively evident. On occasion they prove to be as interesting as—or even more interesting than—the things we intended to record. For the camera lens is after all indiscriminate. Unlike our eyes it pays equal heed to the light reflected from the surfaces of everything within its field of vision. Unless the photographer deliberately interferes in some way, which amateur photographers are not (or used not to be) likely to do, the pattern of forms and textures revealed in prints made from a photographic negative is determined by the impartial objectivity of light, not by the photographer's subjective preoccupation and aesthetic choices.

Look, for instance, at figure 32. One summer day in 1902 someone with a camera in hand stood on the front porch of George Burnham's summer cottage on Sutton's Island, off the Maine Coast, taking pictures of the sea and of Mount Desert Island in the distance. There are several of these seascapes on contiguous pages of my aunt's album, all of them taken from that place. At some point he or she turned and noticed my mother, then a young woman of twenty-four, and George Burnham's daughter Persis at the sheltered end of the porch, mother reading and Persis writing letters at a trestle table islanded on an oriental rug. Whoever it was behind the camera saw, I suppose, two young women in a delightfully relaxed vacation moment and, after centering them in the camera's finder, snapped the

Figure 32.

picture. What the camera recorded, however, included many things of which the photographer was surely unaware. Inconspicuous but significant details such as the dog curled asleep on the rug under the table where Persis has tossed the crumpled pages of answered letters or of impulsively discarded drafts of her own. Salient aspects of the scene such as the oddly juxtaposed rocking chairs in the foreground with their tightly laced rattan seats and backs; the reflection in the window above them of a pine tree, silhouetted against the sky above Mount Desert and

against the intervening ocean, the reflection of its branches blurred just enough to indicate a breeze coming in off the water; the texture of weathered shingles and the sawtooth profile they make at corners of walls and columns; the intricate zigzag perspective of receding openings framed by the serrated edges of these columns, and their inverted reflection in the varnished matched-board ceiling.

Like the photographer, I have a personal interest in the people who were evidently the intended subjects of this snapshot. Both of them became important in my life, one as my mother, the other as my beguiling, adventurous, lavish and much-loved adoptive aunt. And yet, for me—and, I suspect for the photographer after seeing the finished enlargement of the snapshot—this is less a picture of the young women than of the asymmetrical space in which they are centered, a sharply defined space, open to sunny woods but itself only gently illuminated and, in an inexpressibly touching way, almost absolutely shadowless.

My point here is simply that by isolating a group of forms and textures within the arbitrary rectangular frame provided by the edges of its glass plate or film, a snapshot forces us to see (and thereby teaches us to see) differently than we would have seen through our own unaided eyes, and also differently than people had been taught to see by prephotographic pictorial conventions. All pictures, of any sort, have edges that cut off our peripheral vision and thereby dissociate their forms and surfaces from surrounding forms. By the mere act of isolating certain forms and textures in this way, all pictures give enhanced significance to whatever images they contain. But the peculiarity of the snapshot photograph is that the hierarchy of images within its frame is not ordained by the picture-maker. Whatever hierarchy of forms appears in the snapshot is ordained by the indiscriminate neutrality of light. Once people began to look at snapshots they had taken, they therefore began to see *as significant* a great many things

Figure 33.

whose significance they had never seen before.

They probably did not altogether enjoy being forced to see in this way. I do not suppose my aunt was pleased, when she printed the snapshot reproduced as figure 33, to see the prominence it gives to the shabbily dressed men on the corner and to the old overcoat and dirty blanket thrown over the back of the trash cart's horse. She had been on a sentimental pilgrimage to downtown Philadelphia one day in 1885 to take a picture of a building at the corner of Fourth Street and Appletree Alley which forty years earlier had been the house where her mother, my grandmother, lived. Long before 1885, when the snapshot was taken, the building had been remodeled for stores on the ground floor and tenements above. No doubt my aunt wished that the idle blacks and the dump truck and horses would go away,

so she could get an unobstructed view of the building. Certainly she wasn't interested in the street traffic or she would not have angled her camera to get in as much of the house as possible. Yet the picture she took, as she must have realized when she saw the print, nullifies whatever sentimental selectivity there may have been in her vision of the house as a historical object. Thanks to the snapshot's unbiased hierarchy of forms, we cannot help seeing historical truths of a different order: unarguably truthful images of urban realities which were in fact a part of the house's history and are here inextricably associated with it, no matter how disinclined the photographer may have been to see them.

It is more than a mere chance of chronology that the classic book about life in the tenements and slums of our cities appeared in 1890, at the end of the first decade of snapshot photography, and that it was written by a man who had taken thousands of snapshots in the hallways and rooms of tenements, in slum alleys, in cheap lodging houses, sweatshops, and degraded hovels of all kinds. Jacob Riis's *How the Other Half Lives* was a powerful and influential book precisely because its author had a snapshot sense of the reality of life in the slums. Many of his pictures were made in places so dark he could not have seen in advance the details of texture and form they record so convincingly. They were taken by the light of the explosive flash produced when a mixture of powdered magnesium and potassium chlorate is ignited in a pan. It is a blinding light; but so brief were the exposures that the snapshot was made even before the subject's eyes could blink shut in reaction, quite literally quicker than a wink.

Riis was thoroughly aware that his knowledge of the actuality of the tenements was founded upon his documentary snapshots of the inhabitants and their surroundings, and he wanted to show that reality to others. The title page

of his book proclaims that it is illustrated "chiefly from photographs taken by the author," and the stories he wrote as police reporter for the *New York Sun* were also illustrated "from" his photographs. But it is misleading to be told, as we are in some histories of photography, that although Riis's writing was effective, it was his camera that was decisive in making his work "an incontrovertible, powerful weapon" in his successful campaign to have rear tenements torn down, child labor laws strengthened and enforced, police lodging houses abolished.

Riis's photographs are indeed compelling and incontrovertible, as many of us have seen for ourselves. Thanks to Riis's son, who gave the original glass plate negatives to the Museum of the City of New York, and thanks to Grace Mayer, who was then the museum's curator of prints and photographs and had excellent prints made from the plates, these wonderful pictures are now often reproduced and have become a part of almost everyone's consciousness of our urban history. But relatively few of Riis's contemporaries ever saw them. For there was no effective technology for transferring photographic images to the printed page.

The first halftone reproduction of a photograph had been printed in a newspaper in 1880, but even in 1890 the quality of halftones was still crude and undependable. So *How the Other Half Lives,* far from being "a book of photographs of the New York poor" as Susan Sontag recently said it was, contained only a few illustrations, and most of those were reproductions of pen and ink drawings based upon Riis's photographs, not reproductions of the photographs themselves. A good example is the picture captioned "In a Chinese Joint" (figure 34), signed "Kenyon Cox——1889——after photograph." Next to it is a typical example of the cruder drawings used to illustrate Riis's newspaper articles (figure 35), this one of a child in a Mulberry Street stairway-hall from the *Sun,* 25 May 1895.

IN A CHINESE JOINT.

Figure 34. (Reproduced from Jacob Riis, *How the Other Half Lives,* New York, 1890.)

(Reproduced from the *New York Sun*, 25 May 1895.) Figure 35.

Figure 36. Photograph from the Jacob A. Riis Collection, Museum of the City of New York.

I have juxtaposed with these drawings the Riis photographs "after" which they were made but which readers of his books and articles never saw (figures 36 and 37). Notice how both of the photographs bear out what I said earlier about the way a snapshot's arbitrary edges enhance the significance of every element of the pattern of forms and textures they isolate, as the frames or edges of all pictures do. But notice also that the hierarchy of images in the snapshots—the ranking, or grading of forms and textures according to their visual significance—is determined by the unbiased play of light, independent of the photographer's volition. One can guess that if Riis himself had made salon

Photograph from the Jacob A. Riis Collection. Museum of the City of Figure 37.
New York.

prints from his plates, he might have cropped them to
exclude some of the same elements Kenyon Cox and the
anonymous *Sun* artist decided were pictorially irrelevant.
But there they are in the snapshots. And they are by no
means irrelevant, except from the point of view implicit in
conventional notions of pictorial balance and order.

Bear in mind that the drawings (plus a few inferior half-
tones) were given to readers of Riis's articles and books, not
the snapshots, and that when historians speak of the pow-
erful effect of Riis's photographs upon his contemporaries
—thereby suggesting that the photographs we see beauti-
fully reproduced in modern books reached a wide audience

in Riis's own time—they are misrepresenting his achievement. Nothing like that occurred. Riis succeeded in persuading his generation of the harsh reality of urban poverty because he was able to translate into words his emotional response to that reality. He had seen his snapshot image of the ominously half-faced figure with its single shifty eye recorded in his plate of the Chinese Joint and, in the other plate, the mysteriously blurred image of an adult slum-dweller from unknown upstairs regions intruding on the solitude of the forlorn child; the refuse on the floor; and on the uncropped expanse of wainscot, the irrational hieroglyphics of human misery. None of this incontestable imagery was, or could have been, accurately conveyed to the reading public by the techniques of pictorial reproduction then available. But it had burned itself into Riis's own consciousness and underlay the passionate conviction of his altogether serviceable prose.

During the twenty years after 1890 the number of people whose vision of reality was altered by snapshots increased enormously as more and more people took such pictures. But the snapshots one saw were chiefly those taken by members of one's own family or by friends, and this meant that the revolution brought about by the snapshot in our way of seeing tended to be limited to certain areas of life. Riis and the friends and associates to whom he showed his pictures (sometimes projected by a "magic lantern" to illustrate lectures he gave in New York and other cities) shared a revolutionary change in their vision of how the other half lives. My aunts and their friends acquired a shared snapshot awareness of a very different realm of existence. Indeed part of the significance of albums like theirs inheres in what they do not include. Some of these omissions are explainable on technical grounds. There are, for instance, no closeups of faces or objects in my aunt's album, since she had no lenses capable of producing them. But technical deficiencies do not explain the absence of pictures of the

kitchen in my grandparents' house, though every other room except the bathroom is recorded. Nor do they explain the absence of any pictures of the servants who worked in that kitchen. The only snapshots in the album showing members of what we still irrelevantly call "the working class" are one of a four-horse private coach, with a portly coachman on the box, and the one reproduced here as figure 33, in which the two blacks are apparently idling on a street corner.

Not until the second decade of the twentieth century was it possible for almost everyone to have a snapshot awareness of the world beyond the precincts of his own life-routine. By then, however, it was not only possible but practically unavoidable. Everyone's Sunday newspaper had a "Rotogravure Picture Section" or a "Pictorial Magazine," and though these supplements contained a fair share of "mug shots" of the great or notorious, their editors were not unaware of the convincing qualities of snapshot vision. The *New York Times* rotogravure section for 14 July 1918 featured a picture of a Handley-Page bomber taking off on its test flight, caught in an unblurred image just as its wheels left the ground—a "Remarkable Photograph," the caption assures us. The *New York Sun* (Riis's old paper) published later that year what it proudly labeled the "First Actual Photograph" of ex-Kaiser Wilhelm in exile and a "Snapshot," not a posed picture, of the former Crown Prince.

Editors were also well aware that such snapshot images were historical documents. When the *Sun* published two pictures of the signing of the Armistice, both of them drawings, it did so under a boxed caption which said, "Unfortunately for history no photographs of the armistice proceedings were taken and these drawings constitute the sole record." It was indeed unfortunate for history, and would have been even if the drawings had been a great deal better than they are. For, as Ivins says at the end of his wonderful

book, "at any given moment the accepted report of an event is of greater importance than the event, for what we think about and act upon is the symbolic report and not the concrete event itself." By 1918 the nonverbal symbolic reports upon which men were willing to act, and about which they were willing to think seriously, were predominantly reports made by the snapshot camera and widely reproduced in newspapers and magazines.

Yet, as the *New York Sun's* art critic, Charles Fitzgerald, said a few years earlier, the camera had "the awkward habit of reporting the significant and the impertinent with equal indifference." That habit was indeed awkward for those photographers who were exploring the possibilities of photography as art, who wanted to make pictures expressing their personal vision, their subjective decisions about what is and is not important. Only a very few photographers have ever succeeded in using the camera effectively to that end. The overwhelming majority of photographic images have been made by people who were content to let available light determine what was significant. The cumulative effect of thirty years of mass participation in the process of running amok with cameras, "without ever pausing to ask . . . is this or that artistic," had been the discovery that there was an amazing amount of significance, historical and otherwise, in a great many things that were deemed impertinent until snapshots began forcing people to see them.

I am not making the absurd claim that every snapshot has importance as revelation or even that any sizable group of snapshots, like an album full, will surely reward you with an awareness of the hitherto unrealized significance of some class or type of forms or surfaces. I am saying that because snapshots often revealed impressive or delightful significance in things no earlier mode of seeing had enabled mankind to see, our postulates about what really matters have been profoundly altered. And I am also saying that because snapshots taken a century ago and those we see on

TV news shows today (made in quick succession half a world away) can now be seen, thanks to modern techniques of transmission and reproduction, by almost everyone simultaneously, we really do live in what can be called a snapshot world.

What the consequences will ultimately be, no one can know. What some of the consequences have already been seem to me worth noting.

In all the arts, indeed in all our attempts to impose order upon chaos, one can see during the past hundred years a new concern with the significance of surfaces, a new preoccupation with objects as we have been forced to see them by light's nonselective revelations in snapshots. Much has been written, for instance, about the way the development of what we call "modern art" from Courbet through Seurat, Cézanne, and Picasso parallels the development of photography and owes many of its technical and formal elements to photographic imagery. Think, for instance, about the "snapshot" composition of Degas's canvases, whose edges arbitrarily crop an implicitly larger scene; or about Monet's technique of capturing the fleeting effects of light with his so-called "Comma" brushstrokes, derived from the halation, or blurred aura of light, around bright or moving objects in photographic images. It is surely more than a coincidence that the first exhibition of paintings by the French Impressionists was held in a Parisian photographer's studio.

Similarly, the patterns and forms revealed by such technologically advanced snapshots as the photomicrographs of organic and inorganic substances, or by time-lapse photography, have taught more than one of our contemporary painters and sculptors to see such patterns elsewhere, if only in the mind's eye.

In literature, too, snapshot vision has had notable consequences. It is well-known that the modern novel and short story have been profoundly affected by the movies. But it is worth reminding ourselves that it was a group of poets

born in the snapshot era who associated themselves just before World War I as self-styled "Imagists," brought together by a professed desire to be free of formal conventions and of all restrictions upon subject matter, and by a determination to use the language of common speech to present "hard and clear" images. "We are not a school of painters," their spokesman wrote, "but we believe that poetry should render particulars exactly and not deal in vague generalities." Surely these Imagists had been affected by their awareness of the visual precision and the unconventional subject matter of instantaneous photographs.

Perhaps the most important and far-reaching consequence of snapshot vision has been its impact upon our sense of history. Few would deny that publication of Thomas Beer's *The Mauve Decade* in 1926 and of Frederick Lewis Allen's *Only Yesterday* in 1931 bore witness to a fundamentally changed conception of what "history" is. Their authors were born, respectively, in 1889 and 1890, members of the first generation born in the Kodak era. I can think of no writer of history before Beer who would have begun his book with a verbal snapshot of such an apparently trivial event as the one Beer selected: the aged and garrulous Bronson Alcott, father of Louisa May and hanger-on of Emerson, stepping back in bewildered shock from the edge of Emerson's grave, his face startlingly bloodless; a small boy pressing forward among the assembled mourners to get a look down into the hole; the distraught Alcott grasping the boy with a grip so cruel that his daughter raised her hoarse spinster's voice in the hush, commanding, "Pa! Let go!" and, as she stooped to wrench the child's arm free, "You're hurting Georgie's arm."

It is, I think, inconceivable that anyone whose hierarchy of values had been formed in the pre-snapshot era would have based a whole chapter, as Beer did, upon the framed snapshots of writers he saw in a livingroom overlooking Gramercy Park. "There are some of our correspondents in

Cuba on July 3, 1898," he writes, directing our attention to one of the snapshots. "That is Frank Norris leaning on the tree. That's Richard Harding Davis shaving over the bucket." Henry James is "the man in gaiters" in another snapshot.

Allen's *Only Yesterday* begins with Mr. Smith cranking up his Model-T Ford, first setting the projecting spark and throttle levers on either side of the steering-wheel column in a position like the hands of a clock at ten minutes to three; then going to the front of the car where he seizes the crank with his right hand and hooks the forefinger of his left through the wire loop controlling the choke and cranks mightily till the engine roars; then leaping to the trembling running board to reach in and set the spark and throttle levers to twenty minutes of two, whereupon the Model-T's violent agitation subsides to an impatient quiver.

Both books are full of what Allen called "tremendous trifles," those in Allen's book being events and things which his readers remembered well—as if they had happened only yesterday. They remembered these tremendous trifles—the sordid divorce trial of Daddy and Peaches Browning, Lindbergh's transatlantic solo flight, the pig-woman testifying in the Hall-Mills murder trial from a hospital bed wheeled into the courtroom—because they had watched them through the snapshot images of thousands of newspapers. The permanence of this imagery, endlessly proliferated, surely had much to do with the recognition of such recent events and circumstances as significant data of history.

Since then "history" has moved even closer to us; history for our generation is what is happening at the very instant we are watching: Oswald being escorted by police down a jail corridor in Texas as a paunchy man steps forward and shoots him; Aldrin and Armstrong kangaroo-hopping on the dusty surface of the moon. One of our local TV stations recently advertised that its news teams "can cover a fast breaking news event at 9 o'clock and have it on the

air... at 9 o'clock... it makes the difference between news we can talk about and news you can see."

When Columbus arrived in Portugal to report the discovery of the Indies, bringing back an alligator and some gold as proof, the event was already months in the past and not yet very convincing history. And it must have been many more months before people in Europe like you and me even heard rumors of this altogether dubious event. Almost four centuries later, when Brady and Gardner were taking their stark photographs of dead soldiers on the battlefields of the Civil War, it was a quarter of an hour before even they saw the unarguable realities recorded on their glass plates, several weeks before the public saw even secondhand, and therefore suspect, engraved translations of them, and several years before the photographs themselves were seen by more than a handful of people.

Stepping ashore at San Salvador and Hispaniola was actuality; a dead soldier splayed in a shell hole was actuality. Neither was history until people possessed a symbolic report of it. Reports made in verbal symbols, however vivid or detailed, are open to doubt—as Columbus discovered. So is the most carefully drawn or painted picture; so is the translation of a photographic image into the most conscientious wood engraver's syntax of lines and dots.

History for many centuries was therefore something untrustworthily reported that happened long ago. Thanks —or no thanks—to the snapshot, history is now what we live in from the moment we are old enough to look at pictures. That is one consequence of the modern technology of visual communication. Our "now" instantaneously becomes history, and for most of us "history" is our own immediate present.

Other consequences are flowing from the fact that, willingly or unwillingly, we are participants in a revolution in seeing—the revolution which began, as noted earlier, when people like my aunt began running amok with snapshot cameras almost a century ago. Call it, for want of a better

term, the democratization of vision. From the innumerable images objectively recorded by undifferentiating light in the snapshots we and others have taken we may yet learn the import of certain lines in Whitman's *Leaves of Grass:*

> All truths wait in all things...
> I do not call one greater and one smaller...
> That which fills its period and place is equal to
> any...
> And there is no object so soft but it makes a hub
> for the wheeled universe.

Photographs as Historical Documents

As a very good historian said not long ago, "Some of the best historians are not very interested in pictures."[1] Though a number of so-called pictorial histories have been published in recent years, relatively few give one the impression that the historians involved in their production had much to do with choosing the pictures reproduced or with determining how they should be laid out in relation to the text. I suspect that a good many living historians are as willing as William Stearns Davis was, fifty-odd years ago, to let someone else worry about how their masterpieces should be illustrated. Pasted into the front of my copy of the first edition of Davis's *Life on a Medieval Barony* (1922) is a letter the historian wrote to Harper and Brothers after receiving his "author's copies," expressing special thanks to "my friends in your office who arranged for the *very helpful illustrations* which of course constitute a most essential and valuable part of the work." Essential as the pictures may have seemed to him when he saw the book, they obviously had not served him as documents in the course of writing it, even though its subtitle is, ironically enough, "A Picture of a Typical Feudal Community in the Thirteenth Century."

As it happens, the illustrations in Davis's book are not the sort that could have served as historical documents

1. A. Rupert Hall, in *Technology and Culture,* Fall 1960, p. 316.

even if he had been interested in visual documentation of his "picture." They are either halftone reproductions of some twentieth-century illustrator's conception of medieval scenes or line cuts of modern pen-and-ink drawings based either upon medieval sculpture or upon the illustrations in medieval manuscripts. If they document anything, they document such things as Viollet-Le-Duc's nineteenth-century "restorations" of medieval artifacts and costumes or a modern illustrator's notion of the visual realities of the thirteenth century. They do not furnish decisive evidence or information from which any conclusions could be reached about medieval times.

Even if medieval drawings and carvings had been photographically reproduced, they would have been reliable evidence only of how a medieval artist chose to represent a feast, a knight on horseback, a reaper at work in the fields. And that representation would likely owe more to a pictorial or sculptural tradition, or convention, than to direct observation of actuality. For, as Lynn White, Jr.—one of the wisest living historians—has pointed out, the artists of early medieval Christendom had little interest in observable objects; they were dedicated to elaborating traditional patterns of line, form, and color having symbolic value.[2] Even as late as the middle of the thirteenth century, White tells us, when Villard de Honnecourt deliberately attempted a naturalistic sketch of a lion, beneath which he proudly scribbled, "Note well that this was drawn from life," he nevertheless drew "exactly one of those tame little poodle lions, with a mane of symmetrical ringlets, universally found in late Romanesque and early Gothic sculpture."[3]

Villard, in other words, could not help seeing as the pictorial conventions of his time had taught him to see. Neither, of course, can we. If we see lions differently than

2. *Medieval Technology and Social Change* (Oxford, 1962), p. 24.
3. "The Changing Canons of Our Culture," in *Frontiers of Knowledge,* ed. White (New York, 1956), p. 307.

Villard did, it is because our vision has been instructed by other conventions. If pictures drawn and painted "from life" in our time are more reliable as evidence of objective detail—how a lion's mane is coiffed, how a galloping horse disposes its legs—it is because for a century and a quarter our vision has been principally instructed by the conventions of photography. And those conventions include a nonselective accuracy of detail that no other pictorial medium can rival.

Anyone who looks through the pages of the illustrated periodicals of the last half of the nineteenth century and the early years of this century will see how "photographic vision" gradually altered the reportorial and informative pictures that were published in them, even before the halftone process made it possible to print actual photographs. The faces of individual people, the accidental details of a street scene (litter on the sidewalk, a broken lamp), everything delineated becomes more convincing as the years pass. And there is ample evidence that the editors of these periodicals began demanding more and more "photographic" accuracy of their illustrators soon after daguerreotypes and photographs became available. In 1855, for example, the editors of the *United States Magazine* published a wood engraving of Henry Ward Beecher made by Nathaniel Orr from a drawing by someone with the initials E.S. In a footnote the editor wrote:

> The same face often has a very different appearance, when taken by one artist or in one mode of art, from what it exhibits in the hands of another artist or by another mode of art. We have seen several likenesses of Henry Ward Beecher, which were very unlike each other. Although we had one of these on hand, which was engraved for us some time ago, yet in order to give the truest possible "counterfeit presentment" of Mr. Beecher's features, we have been at the expense of having another one engraved for the present number of our magazine. It is copied from a photograph likeness taken

in this city within the past month. It may therefore be considered authentic, for the sun is an artist that seldom mistakes in his drawings.[4]

"Authentic." That is the key word. Since the engraving was "copied from a photograph" it was incontrovertible.

To us, of course, it is not incontrovertible because we know that the original photographic image has gone through translations, first by E.S. into a line or wash drawing, then by Nathaniel Orr into the wood-engraver's language of line. Nothing but the photograph itself would satisfy our notion of incontrovertible visual evidence. But the photographs *would* do so, despite all that has been said by some very knowledgeable people about the untruthfulness of photographs.

In some sense it can be argued that photographs often fail to tell *the* truth; our subjective perception of outer reality often differs from what is visible to the camera's eye. Thus Isak Dinesen, commenting on the way great sportsmen nowadays hunt with cameras (a practice which began while she lived in Africa), noted that because she did not "see eye to eye with the camera," their pictures bore less real likeness to the wild animals "than the chalk portraits drawn up on the kitchen door by our native porters."[5] Nevertheless, it is nonsense to argue that the image recorded by unfiltered lens-focused light on a photographic negative does not tell *a* truth. The only lying done in photography is done by those who deliberately tamper with the images recorded on their negatives with intent to produce prints that *appear* to be straight photographs but are not. There is no dishonesty in combining and otherwise manipulating photographic images to produce interesting designs, but the resulting print is not a photograph, and unless the print maker has deliberately taken pains to be deceptive, no one will mistake it for other than what it is: a

4. *United States Magazine of Science, Art, Manufactures, Agriculture, Commerce and Trade,* July 1855, p. 53.

5. *Shadows on the Grass* (New York, 1961), p. 58.

photochemical image of more or less interest depending upon its creator's abilities as a designer.

Most of what is called fakery in photography is no such thing. The photographs made during the 1860s by William Notman in his Montreal studio, of trappers and hunters rigidly posed amid elaborately contrived settings of stone walls, trees, and heaps of salt and white-fox fur, do not lie. They tell unvarnished truths—namely: that salt and fox fur under studio light look quite a lot like snow; that men posing rigidly by a real tent set amid small trees brought into the studio look exactly like men posing rigidly in an ingeniously contrived studio setting. If, as I have read, Notman publicly claimed to have taken such photographs "in the bush," *he* was a liar. He was also a fool because whoever looked at his transparently honest photographs would believe them, not him.

Conversely, there is nothing untruthful about Edward Steichen's greatly admired gum prints of the early 1900s, despite his own assertion in the first issue of Stieglitz's *Camera Work* that he was indeed a faker who took liberties, as all artists do, with reality.

No one looking at Steichen's famous picture of Rodin among his sculptures would for a moment consider it incontrovertible evidence that at some instant in the past Rodin in fact sat thus, in this pattern of light and shadow, juxtaposed in this way with *The Thinker* and Victor Hugo. The picture makes no claim to that sort of truthfulness. If it is a document at all, it documents Steichen's perception of Rodin as artist. It is a work of art, and works of art are historical events, not historical documents in the sense we are concerned with here.

When we talk of photographs as historical documents we mean, of course, the kind of photographic images that are available in the New York State Historical Association's Smith & Telfer collection, described in a recently published catalogue. What Washington Smith and his successor Arthur Telfer unselfconsciously did in Cooperstown, and

what other commercial photographers did in hundreds of other American towns, was to produce in effect the kind of photographic archive the *British Journal of Photography* had pleaded for in 1889, "containing a record as complete as it can be made of the present state of the world."[6] We are just beginning to realize that their accumulated pictures are, as the *Journal* knew such pictures would be, "most valuable documents."

The photograph of an elderly woman and child reproduced in figure 38 is a case in point. Whatever deceptive appearances there may be in such a picture are the unpurposed contingencies of reflected light and are spontaneously discounted by everyone habituated to the conventions of photographic vision. We accept the blurred image of the child as evidence that the child did not hold still, not as proof that it had a broad snout like a dog. The documentary value of the picture—as evidence, for instance, of how difficult it was to keep elderly people comfortably warm in an old Cooperstown house without parching the air they breathed—is unimpeachable.

Cataloguing such pictures and making them available to those interested in how people and things looked at particular moments in other days will, I suspect, lead to a new kind of sense of the past, a new kind of history. Yet no matter how imaginatively and carefully the cataloguers index their collections (the Smith & Telfer pictures are currently indexed according to their principal subjects under more than six hundred separate headings), the value of these archives depends ultimately upon the researcher's firsthand acquaintance with the pictures. No headings in the Smith & Telfer index would lead a historian of heating or air conditioning to the file containing figure 38. And no practicable system of indexing could anticipate all the uses to which any picture might be put.

A sampling of the Smith & Telfer collection reveals an amazing coverage, an enormous variety of visual images.

6. Quoted in Beaumont Newhall, *The History of Photography* (Museum of Modern Art, New York, 1949), p. 167.

Courtesy of the New York State Historical Association, Cooperstown. Figure 38.

The fifty-five thousand pictures, most of which are iden-
tified (or identifiable) as to time, place, and circumstance,
are a mine of information about faces, costume, architec-
ture (in its context, not isolated from its surroundings as in
the pictures published in architectural magazines and
books), vehicles, all sorts of trades and occupations and the
tools and implements involved as well as the way individ-
ual people handled them, social customs, and just about
every aspect of life experienced by the rich and the poor,
except those activities that were regarded as utterly pri-
vate. We can, of course, learn almost as much about the
past from discovery of what photographers did not (or were
not permitted to) take pictures of as from what they did
record.

There are, however, a number of things to be borne in
mind when using photographs as historical documents,
some of which I have already hinted at. No matter how
straightforward and "documentary" a photograph appears

to be, it is not, of course, the same thing as its subject matter. Figure 39, for example, is not an unidentified woman, seated in a chair on a carpet-covered platform before a studio screen with reflectors mounted on an adjustable standard to provide "proper" lighting of her face and figure. It is Smith's or Telfer's way of looking at these things by means of a camera, equipped with a certain kind of lens and a certain kind of light-sensitized plate. It does, however, document irrefutably the facial contours, the pose, and the costume of a specific person in a Cooperstown photographer's studio in 1890, and the exact details of several items of the studio's equipment.

We know the date of this picture because the photographer's journal has been preserved, along with the glass plate negatives—a piece of good fortune that greatly increases the value of this collection. For the usefulness of photographic images as historical documents depends in large part upon reliable information about them as well as upon their own inherent visual reliability. Where the photographer's own records do not exist, there are of course other means the historian can (and does) use to identify subjects and dates, but the work is tedious and the effort frequently unrewarding.

To insist as I have done on the reliability of photographic images would be misleading unless a distinction were made between the photographer's negatives, positive prints made therefrom, and photomechanical prints reproduced from the positives in the magazines and books whence most of us derive our knowledge of old photographs. As historical documents the negatives are unrivaled, because from them only can we get an unchallengeable record of the forms and textures recorded thereon by the unbiased objectivity of reflected light.

We tend to forget that photographers often retouch their negatives in order to make prints that conform more closely to some pictorial ideal than prints from the unretouched

Figure 39.

Courtesy of the New York State Historical Association, Cooperstown.

negative would do. Many of the Smith & Telfer negatives were thus retouched, and by working directly with the negatives, rather than with prints made from them, we can determine exactly how the original photographic image has been altered. For in arranging and filing the glass plates great care was taken "not to take off any touch-up on the

Untooled half-tone from photograph that has not been painted

Figure 40. Reproduced from *Engraving and Printing Methods,* International Correspondence School Reference Library, Scranton, Penna., [1909].

face of the negatives" in the process of cleaning them to get rid of fly specks, dirt, and other accumulations on their surfaces.[7]

When prints derived from retouched negatives are to be reproduced in printer's ink, further alterations of the original photographic image are often made. By skillful painting, details of texture, form, and tone may be added to or eliminated from the print before the metal halftone plate is made, and engravers may then "improve" the plate by tooling and burnishing it to produce still more alterations of the image. Figures 40, 41, and 42, reproduced from the 1909 edition of the International Correspondence Schools' textbook *Engraving and Printing Methods,* illustrate what can happen to a photograph in consequence of these procedures.

Though the ICS text claims that "this illustration was

7. I found this reassuring item in the informal "Manual of Procedure" prepared by Amelia Bielaski of the New York State Historical Association, on whom the exacting task of reading, classifying, and filing the Smith and Telfer negatives has principally devolved.

Half-tone from painted photograph; plate untooled

See figure 40. Figure 41.

Tooled, or hand-engraved, half-tone made from painted photograph

See figure 40. Figure 42.

greatly improved by special work on the part of the engraver," no one would mistake either figure 41 or 42 for an unmolested photographic image. To employ either as evidence that the young woman who posed wore a white blouse and dark skirt and had a stubby forefinger on her left hand would require a good deal of temerity. But the processes involved in converting this photograph into an illustration for an advertisement are often so subtly used to "improve" photographic images that they are undetectable, and those who use photographs as historical documents cannot afford to overlook that fact. The authenticity of the details in a photographic print or in a photomechanical reproduction of it can be determined only if the original negative is available.

It is true, of course, that thanks to the "straight" photographers of the 1920s and the "documentary" photographers of the 1930s there was increasing respect for the integrity of photographic images, and when *Life* magazine was started in 1936, its staff turned away from the conventions of retouching used by most magazines and newspapers. *Life* set a new standard, acting, as its first executive editor said, on the strong conviction that "if the photograph as information was to be worth-while at all, it should transmit the world of appearance to the reader in the purest form possible ... If a picture was important or interesting enough, it was used, unretouched, even though of inferior technical quality."[8]

Had *Life* consistently held to that conviction and by its own example established a journalistic tradition of respect for unretouched images, the pictures reproduced in its pages and elsewhere would indeed have been an unimpeachable source of contemporary historical data. Unfortunately it did not, and the devastating potential of its failure to do so was shockingly demonstrated during the

8. Wilson Hicks, *Words and Pictures. An Introduction to Photojournalism* (New York, 1952), p. 42.

Warren Commission's investigation of the assassination of President John F. Kennedy. Sometime in March or April 1963 Lee Harvey Oswald's wife took a snapshot of him holding a rifle and pistol. As published by *Life* (and also by *Newsweek* and the *New York Times*) it showed a rifle that was not the kind used in shooting the president, giving rise to speculation that Oswald was not the killer. When the commission investigated, they found that Mrs. Oswald's snapshot had been retouched prior to publication in ways that "inadvertently altered details of the rifle"[9]—thus destroying its value as information in the interest of God knows what nonphotographic ideal of pictorial quality.

Even unretouched prints from unretouched negatives can be misused by those who are ignorant of the processes and techniques involved in their production. To present enlarged images of the staring eyes in photographs taken during the 1890s in a small midwestern town as evidence of the suffering and mental illness resulting from an economic depression—as was done in a widely praised recent book—is bad history, whatever it may be as surrealistic self-expression on the part of the author. Those images of staring eyes are not "primary data" for the psychic history of a community;[10] they are visual documentation of specific people's difficulties holding still during the long exposures required by available lenses and emulsions—the kind of difficulties Emerson had described more than a century ago in his *Journals*.

Were you ever daguerreotyped, O immortal man? And did you look with all vigor at the lens of the camera, or rather, by the direction of the operator, at the brass peg a little below it, to give the picture the full benefit of your expanded and flashing eye? And in your zeal not

9. *Newsweek*, 5 October 1964, p. 57.
10. See "The Mystery of the Past: A talk with Michael Lesy," *Yale Alumni Magazine*, April 1974, pp. 11 ff.

to blur the image, did you keep every finger in its place with such energy that your hands became clenched as for fight or despair, . . . and the eyes fixed as they are fixed in a fit, in madness, or in death?[11]

From one point of view it is of course true, as John Szarkowski has said, that "regardless of historic fact, . . . a picture is about what it appears to be about."[12] But that point of view is the connoisseur's, not the historian's. As a picture, a photograph is indeed "about" what it appears to be about; as a historical document it may be "about" something else altogether.

This is true, I think, because of a basic difference between photographic images and all other documents, pictorial or verbal. As I said in the preceding essay, unmolested photographs record very brief instants of reality. A painted or written portrait of a person can include—indeed, cannot help including—aspects of a constantly changing reality perceived over a period of time. Not *all* the aspects, but a selected few. The process of selection, carried on throughout the process of painting or writing the portrait, therefore becomes the principal determinant of the details included in it. In photography also there is a process of selection, but it occurs prior to the making of the image and at most determines the instant at which the details visible to the camera's eye will be recorded. It cannot select some details and ignore others, nor can it incorporate details that were visible at other instants or that are outside the camera's range, no matter how helpful those details might be in establishing relations that would "explain" the ultimate picture. This, I suppose, is what Charles Sheeler meant when he said that photography "records inalterably the

11. *Journals of Ralph Waldo Emerson,* ed. E. W. Emerson and W. E. Forbes, (Cambridge, Mass., 1911), vol. 4, pp. 100–101.
12. John Szarkowski, *Looking at Photographs* (Museum of Modern Art, New York, 1973), p. 172.

single image, while painting records a plurality of images willfully directed by the artist . . . It is inevitable that the eye of the artist should see not one but a succession of images."[13]

As historical documents photographs are therefore uniquely nonnarrative as well as nonfictitious. While it is true that a photograph says more convincingly than a painting or a written document, "I was there," it is "a window into the past" that is open for only a fossilized, unstoried instant whose significance may be undiscoverable unless other data, visual or verbal, are available.

Here again we are back to the documentary value of such collections as the Smith & Telfer holdings at Cooperstown. For in this collection we not only have access to the photographer's own verbal records of ancillary data, as indicated earlier, but we also have, in many instances, more than one photograph of a given subject, providing something like the "succession of images" that reveal character or provide narrative interest in other kinds of documents. When I came upon the photograph reproduced as figure 43, in the course of leafing through the file prints made from the Smith & Telfer negatives, it made no special impression upon me. But when, sixty-odd prints later, I saw the image recorded in figure 44, there was a shock of recognition that made me believe in the historical reality of the young woman as no single fossilized image of her could have done, even though it is not possible to determine from the photographer's journal exactly who she was.

I did not get out the glass plate negatives of these photographs because there was nothing about the prints to suggest that the negatives might contain additional evidence. But those who use photographs as historical documents should bear in mind that, for a variety of reasons,

13. Quoted in Constance Rourke, *Charles Sheeler* (New York, 1938), p. 119.

Figure 43. Courtesy of the New York State Historical Association, Cooperstown.

Courtesy of the New York State Historical Association, Cooperstown. Figure 44.

Figure 45. Courtesy of the New York State Historical Association, Cooperstown.

photographic prints are often misleading. Figure 45, for example, reproduces a hastily made file print of a photograph taken by Telfer at the Otsego County Fair in 1908. If I had been looking for visual documentation of tricks done by performing horses at such fairs, I would have passed it by. But coming upon the print of another picture made by Telfer on that occasion (figure 46), I requested a new print from the original negative of figure 45, and thanks to the careful work of Patricia McCue, then in charge of the darkroom, got the print reproduced as figure 47.

As I later discovered, there are in the Smith & Telfer collection three prints made by Telfer himself from this negative, each differently cropped to exclude details at top, bottom, or sides of the negative, and each printed with different intensities of light and shadow so that different portions of the picture are decipherable. There is, as I said earlier, no substitute for the original negative when photographs are used as historical documents. Yet even when a negative is available, the image it records is a storyless fragment, and its value to the historian is greatly increased

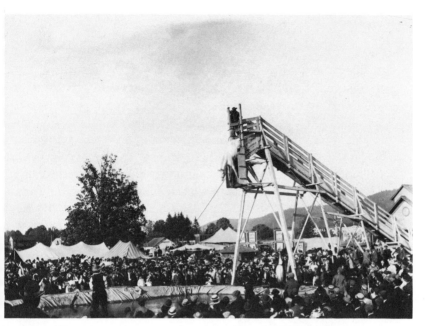

Courtesy of the New York State Historical Association, Cooperstown. Figure 46.

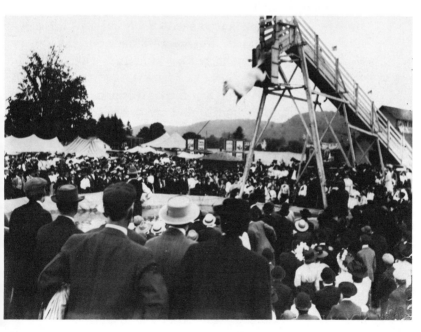

Courtesy of the New York State Historical Association, Cooperstown. Figure 47.

by its juxtaposition with other related images as in Cooperstown's splendid collection of the work of Washington Smith and Arthur Telfer.

Within the limits mentioned earlier in this essay, the photographs taken by such photographers, if properly stored and sanely used, are truly "most valuable documents." Yet we are only beginning to appreciate their documentary value as distinguished from their pictorial qualities. Though it is true, as John Szarkowski has said, that photographs have been most widely used and broadly accepted as substitutes for the subject itself, as simpler, more permanent, more clearly visible versions of the plain fact,[14] photographers themselves and those who collect photographs have traditionally been more interested in the pictorial values of photographic images than in their documentary quality. Not even the photographer's eye is wholly instructed by the conventions of photographic vision when determining which negative to use, how to crop the image, how to touch it up, and what to bring out or play down when making the final print. We still have our equivalents of Villard's lion's mane with symmetrical ringlets taken from life.

The truth seems to be that there are elements inherent in many photographic images that are incompatible with our ideas of pictorial quality, and since these elements are accidental and unwilled we have had few compunctions about altering them for aesthetic ends even when the documentary value of the image is our ostensible concern, as in the case of Mrs. Oswald's snapshot. If photographs are to serve as historical documents, historians must treat them as they would treat other documents, making every effort to determine their authenticity and the circumstances surrounding their production and taking care to reproduce them accurately, without any unacknowledged omissions or alterations. The Smith and Telfer collection at Cooperstown is a good place for historians to begin.

14. John Szarkowski, *The Photographer's Eye* (Museum of Modern Art, New York, 1966), p. 12.

Design and Chaos

The American Distrust of Art

This essay, with a different subtitle and many differences in phrasing, was first published in 1972, in *The Shaping of Art and Architecture in Nineteenth-Century America,* a volume issued by the Metropolitan Museum of Art containing papers read at a symposium held at the museum in May 1970 in connection with its centennial celebration.

My earliest speculations on the subject were provoked by an invitation from the California Council of the American Institute of Architects to deliver the summation address, "The Consequences of Design," at the Second Pacific Rim Architectural Conference, held in Mexico City in 1963. I read a preliminary draft of that address at Iowa State University on 15 March 1963, and completely rewrote it for delivery in Mexico City on 17 October. Since then I have written three other versions, one for a lecture at Brown University, 29 March 1965, another for a lecture at Alfred University, 10 November 1966, and finally—taking advantage of criticisms and comments elicited by these earlier presentations—the version printed here.

In the last report he wrote as president of the Carnegie Corporation, John Gardner told a story that has haunted me ever since. It was the story of a little girl in school who was drawing a picture. The teacher, looking down over Mary's sedulously bent head and intent shoulder, asked her what she was drawing. "A picture of God," Mary replied. "But Mary," the teacher protested, as teachers seem always to do, "no one knows what God looks like." "They will," said Mary, undaunted, "when I get through."

All of us, I suppose, have moments when we almost share Mary's joyous confidence in a private insight, but our teachers—paid and unpaid—have taught us to be wary of confidence, and of joy, too, for that matter. So, for the most part, if we want our ideas to be taken seriously, we try to keep within the bounds of our specialties as chemists, bird watchers, sociologists, drag racers, theologians, art historians, or whatever our associates acknowledge us to be.

I am generally, if not wholeheartedly, acknowledged to have been a teacher of English, not an art historian. But like most people I am not quite willing to be bounded by the limits of a specialty. However aware we may be of the hazards involved in conjectures based only on an amateur's miscellany of knowledge, we are equally aware that such

conjecturing occasionally enables us to glimpse, momentarily at least, the truth contained in one of Emerson's engagingly homely metaphors. "It is necessary," Emerson said in "Natural History of Intellect" about a century ago, "to suppose that every hose in nature fits every hydrant. Were it not so, chaos must be forever."

Other passages in Emerson's lecture make it clear that he was acknowledging here the "tyrannical instinct of the mind" that repudiates the idea of chaos and compels us to look for patterns of relationship among the diverse phenomena by which we are surrounded. All of us, I think, are conscious of this tyrannical instinct of our minds. We know that where we perceive no patterns of relationship, no design, we discover no meaning. If the items of information we acquire from news broadcasts, books, and other sources lie around in our minds, unrelated to one another and to our everyday experience, they constitute a pointless and boring miscellany. But the moment our minds go to work on these apparently unrelated items, and we start fitting them together, they become interesting.

The reason apparently unrelated things become interesting when we start fitting them together is that the mind's characteristic employment is the discovery of meaning, the discovery of design. The search for design, indeed, underlies all arts and all sciences. The forms created by the artist, like the formulas (the "little forms") of the scientist, are symbolic records embodying the design, or meaning, their creators have perceived. The root meaning of the word *art* is, significantly enough, "to join, to fit together." All artists are, etymologically at least, joiners. The delight we derive from the artist's forms is largely, I think, a delight in the revelation of how things fit together—of the ways in which the Emersonian hoses fit the hydrants. The enjoyment of the arts, like the enjoyment of the elegance of a scientific theorem, is a natural response to symbolic structures revealing perceived relationships, or designs, in the phenomena of human life and in the phenomena of the universe, which is our dwelling place.

Yet it is a curious fact and one that has not, so far as I know, been commented on, that most, if not all of the words we use in talking about these enjoyable patterns of relationship have somewhat sinister overtones. The word *design* itself curdles in many contexts. It will function inoffensively enough in a discussion of the decorations on a morocco leather wallet I carry; but if someone suddenly said there were designs on my wallet, I might clap a protective hand to my trouser pocket. The noun *order* goes abruptly sour when we put it in the plural; to give order may be commendable, but to give orders is somehow arrogant and unendearing. Even in the singular it is currently suspect in such a phrase as "law and order." In literary discussions we talk about the *plots* of novels, and about rhyme *schemes,* but in other contexts plots and schemes are disreputable things. And the word *fiction,* of course, is at once the name of one of the principal forms of literature and a euphemism for a lie.

Similarly, in discussing the constructive arts, we use such verbs as *fabricate, frame, engineer,* and *forge,* and nouns such as *artifice, contrivance,* and *device*—all of which in other contexts have an aura of fraudulence hovering about them. Even the word *form,* and such derivatives as *formal* and *formula,* are tainted, as when we speak of the formulas of politeness or of doing something for form's sake. Indeed, the words *art* and *craft* refer to chicanery and deceit almost as often as they designate the making or doing of things whose design and form give pleasure.

Evidently, the language we use in talking about the arts is haunted by a latent mistrust and uneasiness. Many of the terms we employ in discussing form and design are readily convertible into terms suggesting duplicity or downright fraud. The fact that this is apparently a spontaneous development in language suggests that it has a profound, if covert, significance—especially since, in our conscious thinking about literature, painting, sculpture, music, and architecture, we recognize the pattern-revealing activity

embodied in their forms and designs as the principal source of our delight. Perhaps, if we reexamine the nature and function of design, we may get some understanding of the paradox involved in our unconscious distrust of the very things in art that delight us most. And in the process we may gain some fresh insights into the relation between the arts and life, between the artist and the public.

Let me begin by reminding you of a familiar truth: design, or form, in the arts is achieved by selection. The artist selects certain details out of the vast flux of his total experience and joins, or arranges, those details in what Suzanne Langer calls "a perceptible, self-identical whole" expressive of human feeling. The act of selection is, for all the arts, primordial. Life, as Henry James rather patronizingly wrote to his fellow novelist H. G. Wells, is "all inclusion and confusion"; art "all discrimination and selection."

The design, or expressive form, of a novel, for instance, is the result of a number of selective and interpretive processes, starting with the selection of the particular items in this area that can be ordered in an effective way. So, too, in the visual arts. "A picture," Degas said, "is something which requires as much knavery, trickery and deceit as the perpetration of a crime... The artist does not draw what he sees, but what he must make others see." To understand what Degas meant, one has only to look at such a picture as his *Dancer with a Bouquet* (figure 48). This is, overtly, a view of a stage, upon which we look down from one of the boxes in which a lady sits, at the lower right corner of the picture, holding an open fan. The fan cuts off our view of the ballerina's legs, just as it might cut off the view of a gentleman sitting behind the lady in the box. Everything seems very intimate and real. But the knavery here is how Degas forces us to see and respond to the dark convex curve of the fan as the inverted, negative echo of the white concave curve of the ballerina's tutu, which it intersects, and also of the curves of the ballerina's bouquet and the similar arc plotted by the feet of the grouped dancers be-

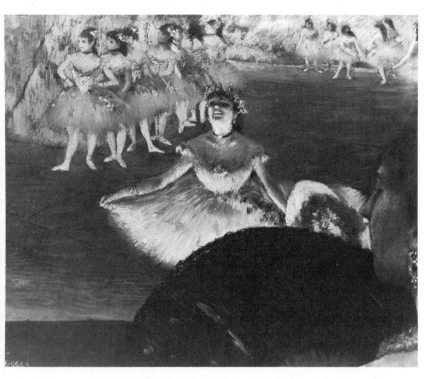

Edgar Degas, "Dancer with a Bouquet," circa 1878–1880. (Pastel and wash over black chalk on paper, 15⅞″ × 19⅞″. Museum of Art, Rhode Island School of Design; Gift of Mrs. Murray S. Danforth.) Figure 48.

hind the ballerina. What Degas forces us to see is, in other words, not a bouquet or a ballerina but design.

The ultimate form of all works of art is prescribed not by the way things actually occurred in the writer's or painter's experience, but by the design, which is to say, the meaning he discovered in the experience; much as the form of a geologist's theory is determined not by the position of the fossil-bearing strata as he finds them at present in nature, but by the meaning he perceives in their relation to one another and to other geologic evidence. That meaning, that design, is determined by the artist's cerebral activities, not by his immediate sensory responses to actuality.

This does not, of course, mean that literature or any other art is primarily a cerebral pursuit. On the contrary, the function of literature and other arts is primarily to arouse and direct feelings. Even the kind of literature deeply concerned with ideas is shaped first of all by the author's feelings about those ideas. Its literary function, its function as a work of art, is primarily to elicit and control the reader's emotional response to those ideas. Hence it is that a literary work concerned with ideas most of us no longer hold—for example, Milton's *Paradise Lost*—nevertheless retains its value as literature. Something analogous to this must be true of architecture, painting, and the other arts, else we cannot account for the persisting appeal of structures such as Notre Dame of Paris and the pyramids of the Aztecs, or of pictorial compositions as divergent as Titian's *Assumption of the Virgin* and Thomas Cole's splendid series of paintings, *The Voyage of Life*.

But though works of art are forms expressive of human feeling, they are not forms evolved by human feeling. T. S. Eliot said of poetry that the largest part of the labor in creating it is the intellectual or cerebral part. Eliot called this "the frightful toil" of "sifting, combining, constructing, expunging, correcting, testing," but he meant the same thing that Degas meant when he talked of "knavery, trickery and deceit." At times, apparently, these complexly related constructive activities are carried on less painfully than at others; Robert Frost once spoke of the ease with which his lyric "Stopping by Woods on a Snowy Evening" shaped itself in his mind. Yet the surviving manuscript of the poem indicates that the job of selecting and ordering the elements going into it was not quite so simple as Frost liked to remember. Many a painting whose composition seems inevitable in its rightness reveals under X ray or infrared photography the labor with which its original elements were recomposed. The truth seems to be that the elements of actuality, even when carefully preselected, are recalcitrant to order.

But the mind demands order. There is a great deal of recent scientific evidence of this tyrannical instinct of the mind. In 1965 at the Center for Cognitive Studies, Harvard University, people were asked to memorize four different kinds of word sequences: normal English sentences; anomalous sentences having the grammatical structure of normal sentences but no meaning; anagram sentences, having the same words as the normal sentences but in ungrammatical sequence; and haphazard strings of words. As one would expect, the normal sentences proved to be the easiest to memorize, and the haphazard string of words the hardest. But what interested me in the report on the experiment, published in the Carnegie Corporation's *Quarterly,* were these statements: "In trying to repeat sentences which are grammatical but meaningless, people tend to introduce other words which *give* meaning; in trying to repeat ungrammatical sentences, they tend to invert the word order (that is, make it correct)." Thus, the experimenters conclude, people "err on the side of making their responses more meaningful and grammatical than the materials presented to them—if to seek meaning and order is to err." (Note that the writer cannot quite bring himself to consider the production of order as erroneous even when the whole point was to reproduce disorder.)

What the investigators at Harvard noticed was essentially the same thing that W. M. Ivins, Jr., had observed more than a decade earlier in *Prints and Visual Communication* (1953)—a book that has not yet received adequate attention from those concerned with the nature of the visual arts. Ivins was concerned with the ways in which pictorial reproductions affect our ways of seeing and even our ways of thinking. At one point he considers the pictures of plants appearing in the numerous herbals published from 1480 to 1526. The illustrations in the first of these printed herbals were woodcut copies of hand-drawn illustrations in a ninth-century botanical manuscript, which, in turn, were the final step in a long series of copies of copies

that went back to original drawings made by some Greek botanists. The woodcut illustrations in the first printed herbal were then copied for publication in later books, and those in turn were copied, and so on. If this long series of copies of copies of copies is arranged in chronological order, Ivins tells us, they clearly reveal what he concluded to be a basic human characteristic. So long as the illustrators did not return to the original plants as sources of information, but confined themselves to such knowledge as they could abstract from earlier pictures, they overlooked or disregarded "what appeared to them to be mere irrationalities in the pictorial accounts given by their predecessors." They rationalized their drawings, and this rationalization "most frequently took the form of an endeavor for symmetry," resulting in a balanced arrangement of parts and forms. Ivins wryly observes that this rationalizing process, "however satisfying to mental habits, resulted in a very complete misrepresentation of the actual facts."

It is interesting to remind ourselves that art has generally been admired for its capacity to do precisely what produced the "errors" in the Harvard experiments and the "misrepresentation" in the herbal woodcuts. Proclus, writing in the fifth century, asserted: "He who takes for his model such forms as nature produces, and confines himself to an exact imitation of them, will never attain to what is perfectly beautiful. For the works of nature are full of disproportion, and fall very short of the true standard of beauty." And early in the sixteenth century in his introduction to the *Book on Human Proportions,* Albrecht Dürer said: "We like to behold beautiful things, for this gives us joy." Therefore, if the artist has to make a figure, he should make it as beautiful as he can. But Dürer added: "No single man can be taken as a model for a perfect figure, for no man lives on earth who is endowed with complete beauty ... You therefore, if you desire to compose a fine figure, must take the head from some and the chest, arm, leg, hand, and foot from others, and, likewise, search through all members of every kind." In the late eighteenth century,

in *Discourses,* Sir Joshua Reynolds said essentially the same thing: "All the objects which are exhibited to our view by nature, upon close examination will be found to have their blemishes and defects." It is the artist's job, Sir Joshua concluded, to learn "to distinguish the accidental deficiencies, excrescences, and deformities of things, from their general figures," and thus be able to perceive "an abstract idea of their form more perfect than any one original."

By these quotations spanning thirteen centuries I hope to establish the point that the order achieved in a work of art, or what Aristotle, long before Coleridge, called its organic unity, has almost universally been conceived of as an order imposed upon it by the mind of man, not derived from actuality. The fine arts as well as the practical arts have been felt to be a conquest of nature. Vasari, four hundred years ago, spoke admiringly of how the painters, sculptors, and architects had "almost vanquished nature," and of how they "triumphed" over it. In our own century Geoffrey Scott, in his influential book *The Architecture of Humanism* (1924), talks of the arts as a means of projecting the image of our own distinctively human functions upon the outside world, thus creating "that coherence which the beauty of Nature lacks."

The idea that coherence is the primary quality of artistic order, and is achieved only by selection, is implicit in Scott's assertion that architectural style subordinates beauty to the mind's pattern, "and so selects what it presents that all, at one sole act of thought, is found intelligible, and every part re-echoes, explains, and reinforces the beauty of the whole." This will not sound strange to anyone familiar with Coleridge's often quoted definition of a poem as the species of composition that proposes to give "such delight from the *whole,* as is compatible with a distinct gratification from each component part," which, of course, requires that all the parts "mutually support and explain each other."

Coleridge's ideal of organic unity has, in various guises,

dominated a good deal of criticism of the arts, and much of artistic practice, for the past one hundred and fifty years, and has cooperated with other forces that tend to free art from any obligations to nature or objective reality. In the philosophy of æsthetics, Suzanne Langer has reached the point, in her *Philosophical Sketches* (1962), of insisting a work of art is to be judged solely as an appearance, "as an apparition given to our perception," and "not as a comment on things beyond it in the world, or as a reminder of them." Works of art, Miss Langer concedes, are symbols formulating our ideas of inward experience, but she says a work of art differs from other symbols because "it does not point itself to something else," to things or facts in the outside world. Similarly, Northrup Frye maintains that in "pure" poetry the words are to be considered solely in their relations with one another, not in their relations to their customary meanings, and that the world of the poem should be "closed and self-sufficient, being the pure system of the ornaments and the chances of language." And we all have experienced the excitement, and perhaps the consternation, of contemporary paintings that are also closed and self-sufficient forms, disinfected of all comment on things beyond them in the world.

Yet, as the critic Donald Davie pointed out in *Articulate Energy* (1958), there are many poems that delight us precisely because they are open to another world, and because their syntax, or structure, refers to and mimes "something outside itself and outside the world of [the] poem, something that smells of the human, of generation and hence of corruption." What is true of these poems is true of many architectural works, many paintings, and many musical compositions as well. But by and large, artistic structures of this sort have not appealed to the dominant critics of our time or to the contemporary arbiters of taste. Literary critics and art critics, and those of us who feel we ought to respond verbally to aesthetic experience and therefore pick up the critics' lingo have generally found it easier to justify a preference for those designs that succeed in fusing their

elements into a self-identical whole, in which every hose fits every hydrant, and in which nothing is left at loose ends to raise questions answerable only by appealing to something outside the work of art. A novel, a painting, or a piece of sculpture whose design is open, in Miss Langer's sense, is impure art, and thus of course inferior art.

Interestingly enough, however, in all the arts failures of this sort are often successes. I was reminded of this by reading a critical analysis of F. Scott Fitzgerald's story "The Rich Boy" by a writer (Aerol Arnold) who was bent on showing that the meaning of a work of fiction is conveyed by its total structure, its overall design, not by elements that can be extracted from it (such as the political or social ideas it contains). Fitzgerald's story was only one of several works discussed in an essay that shows how various authors have wrestled with their material, rewriting scenes to give them the proper tone, changing the order of scenes, and eliminating or distorting material in order to shape raw material provided by actual experience so that the meaning of the experience, not the experience itself, would be conveyed to the reader and the ultimate design would answer all questions raised by the elements of experience included in it. "The Rich Boy" is adduced as an instance of the author's failure adequately to do this part of his job.

Its structure, including its title, is designed to make the reader understand that what happens to the hero, including his loss of the beautiful heroine and all the miseries attendant thereupon, happens because the hero is rich. But there are things in the story making it impossible for the reader to accept that explanation. As readers we discover that the hero's trouble is simply that, rich or poor, he is incapable of accepting the obligations and responsibilities we know to be a part of love and marriage. "As we read and re-read Fitzgerald's story," the critic says, "we do not believe the narrator's explanation... We recognize in [the hero] people we know in literature and in life and the individual we recognize by his actions in this story is not the individual the narrator explains."

This analysis of "The Rich Boy" provokes an interesting question. Why, if the design of the story is so seriously flawed, does anyone enjoy it enough to "read and re-read" it? The answer, I think, is that we do indeed recognize in the hero "people we know in literature and life." In other words, we enjoy the story precisely because the design of the story, in Miss Langer's terms, points beyond itself to something in the world outside the story.

Does this not suggest that the design, or structure, of a work of art need not be quite so rational as our theories often assume? Does it not suggest that an effective story, for instance, may include elements of actuality that get in inadvertently? And, still more disturbingly, does it not suggest that in some instances at least these inadvertent inclusions are the vital source of interest?

Such anomalous situations occur in all sorts of designs, even in such apparently scientific and mathematical structures as those of civil engineers. Most people, I assume, are familiar with the George Washington Bridge across the Hudson. We can, I suppose, call to mind its essential form: the double-decked roadway depending from the transactive curve of huge cables slung between high steel towers at the water's edge on either side of the river.

These towers are, in a sense, the principal features in the total design of the bridge, and it is their design that illustrates my point. The basic units in the design are similar in appearance to what you would have if you formed a square out of four kitchen matches and then, within the square, made an X out of two crossed matches running diagonally from the corners. Four sets of twelve such X-ed squares, set on top of one another, make up each of the legs of the 635-foot towers, and other such squares join the two legs at the top of the towers and just beneath the roadways.

If you have been building the bridge towers in your mind's eye out of the X-ed squares, as I describe it, and if you remember that, in the actual bridge, at the lofty top of the opening through which the roadway pierces the towers,

there is a curved arch, you may be wondering how the curve of the arch got into the design. If so, you have hit upon one of the elements in the design that raises questions the design itself does not and cannot answer.

That curve, which to many is one of the most pleasing elements in the design of the bridge towers, got in by the back door, as it were. It happened this way: When the bridge was designed in the late 1920s, the towers were conceived not merely as supports for the cables but as massive and monumental architectural features. The steel frame of the towers would, of course, hold up the cables and support the entire dead and live load of the completed bridge. But the necessary steel components, those X-ed squares, were not arranged by the engineer, O. H. Amman, solely with that end in view. For the towers were to be faced with granite, designed by Cass Gilbert, architect of the Woolworth Building. That is why the curved arch appears in the design; for although the waist that connects the two legs of the tower could be most efficiently formed of straight members, like those boxed X's, an opening as wide as that between the tower legs can be spanned with stones only by arranging them in an arch. Actually, since the stones employed in facing the steel towers would not have been carrying any weight but would have hung on the steelwork, they could have been carried straight across the opening as we carry bricks straight across the top of a fireplace by supporting them on an iron bar or plate. But then it would not have *looked* like a stone tower. So the steel was curved to hold up the nonfunctioning arch of stones that was to be applied to it.

But as the huge steel skeletons rose from the shores of the Hudson, the unanticipated majesty of their mathematical lacework was so striking, so impressive, that there was a widespread protest against covering them with the granite shell they were supposed to support. Here, then, is an engineering structure whose design, like that of the Fitzgerald story, includes elements that raise questions the structure

itself does not answer; yet the towers of this bridge have an aesthetic impact more stirring than those of other suspension bridges from whose design such irrelevant features have been eliminated.

The reason for this apparent anomaly is, I suspect, that no conceivable rational structure can be commensurate with the complexity and wonder of reality itself. And since all of us are ultimately interested in reality, we are sometimes, at least, glad to be referred to it. Because we have an appetite for all aspects of reality, we regard as great works of art those that are most inclusive and deal most profoundly with life—Tolstoy's *War and Peace,* Shakespeare's *The Tempest,* Michelangelo's frescoes in the Sistine Chapel, Beethoven's Third Symphony.

There are times, of course, when life itself seems so bewilderingly or frighteningly complex and chaotic that we welcome the illusory tidiness of a fictional world where all questions are answered and the significance of everything is structurally understood. These are the moments when we prefer Henry James's *The Ambassadors* to Herman Melville's *Moby Dick,* or Mozart's Thirty-ninth Symphony to Beethoven's Ninth. But when the illusion of stability and order is not so necessary to us, we are likely to find all but the very greatest works of art terribly limited. At such times we may feel less interest in a design perfectly adapted to an understanding of some segment of experience than we can feel in an imperfect one. For the imperfection of a design, the presence in it of elements raising questions the total design does not answer, is the very thing impelling us to look beyond the limits of the thing designed to the ultimate source of its elements—to life itself. To understand the hero of "The Rich Boy," for instance, we have to go outside the bounds of the story; we have to compare him with people we know. To understand the George Washington Bridge towers, we have to see their arches as symbols or signs pointing beyond themselves to facts of aesthetic habit in an irrelevant world of masonry construction.

In these terms, I think, we can account for the fact that

commonly, when we are young and in good health and feel our energies are sufficient to cope with whatever chaos life presents, we think better of loosely organized vitality in the arts than we do when we get older. It was the relatively young who most enjoyed Jack Kerouac and Allen Ginsberg in their day, just as it was the relatively young in an earlier generation who were enraptured by Thomas Wolfe's timeless river of vitality. But all through our lives, fluctuating responses to the chaos of life as we experience it determine our fluctuating taste in such matters. At one moment we may prefer designs that inadvertently—or deliberately, as in Walt Whitman's *Leaves of Grass*—require us to go beyond them to life itself. At another moment we may prefer those in which the patterned relationship of selected elements of experience successfully creates the illusion of a world capable of answering all the questions it raises.

Recognition of this fact suggests that we might usefully differentiate between "closed" and "open" designs in the arts. In my present context I mean by closed forms those whose design answers all questions raised by the elements of experience they include. They are forms from which the artist has eliminated all irrelevant or inharmonious details. By open forms, on the other hand, I mean those comprising elements raising unanswered questions—elements the artist had been unable, or unwilling, either to expunge or to modify in such a way that they fit a self-consistent, or "self-identical," design.

Walt Whitman, Melville, and Mark Twain are all authors whose works are open forms in this sense. And the conjunction of these three writers—the three who in retrospect seem most "American" of all our nineteenth-century authors, whether we use this term with approval or disapproval—suggests that the prevalence of open forms in American literature and in other arts as practiced or developed in America might be worth considering.

Whitman repeatedly insisted that his book sought only "to put you in rapport. Your own brain, heart, evolution must," he said, "not only understand the matter, but

largely supply it." So, too, Melville, who in *Pierre* succinctly stated an idea that he developed extensively in *The Confidence Man* and restated at the end of his creative life in *Billy Budd*. Though common novels, he wrote in *Pierre,* "spin veils of mystery, only to complacently clear them up at last," the more profound books "never unravel their own intricacies, and have no proper endings." So much for those who are querulous about the imperfect and unanticipated ending of *Moby Dick,* or of Mark Twain's *Huckleberry Finn.*

For the moment, I can only mention such things as the panoramic style in American landscape painting, with its wide-angled view and shifting vanishing point, exemplified by Thomas Cole's *The Oxbow,* Frederic Edwin Church's *Heart of the Andes,* and Martin Johnson Heade's *Thunderstorm, Narragansett Bay.* I can only remind you of the many American still-life paintings in which all the objects rest upon tables whose ends are out of sight, although European still lifes are assembled on the surface of tables whose ends are part of the design. I cannot develop here the insight I borrow from Barbara Novak's recent book, *American Painting of the Nineteenth Century* (1969), wherein she convincingly demonstrates that the dominant quality in much nineteenth-century American painting was the fixation of a single moment in time, as in Winslow Homer's work, the almost photographically-stopped motion of Thomas Eakins's *Max Schmidt in a Single Scull,* and the "frozen continuum" of the luminist painters such as Heade and Fitz Hugh Lane. This obsession with absolutes in time and space, with "the clear, the measurable, the palpable," testifies, as Novak at one point suggests, to the almost terrifying awareness of flux and process in the American consciousness. Only in an environment permeated with this awareness would the compulsion to freeze time and motion become a formal obsession. And the resulting forms inevitably include elements raising questions unanswered by the composition itself; frozen wave crests

that do not fall onto beaches, oarmarks left at regular intervals in the Schuylkill's water, and other symbols of a flux and movement going on outside the timeless and motionless world of the painting, in the world of reality itself.

In her final chapter Novak speaks of the surprising predilection for futurist motion in twentieth-century American paintings such as John Marin's. But there has been a long tradition of interest in the visual portrayal or revelation of motion in photography and in other pictorial media unembarrassed by affiliation with the fine arts. Linear records of the complex movements of rolling and pitching ships were published in *Harper's* magazine in the 1850s—pictures having more in common with those of the twentieth century, like Kandinsky's and Klee's, than with those of Homer and Eakins. And Eakins himself had, of course, contributed to the development of motion-picture cameras. In our own times this interest in process and motion has been developed not only in movies but also in jazz, the comic strip, the skyscraper, and television shows like "Open End."[1]

This concept of closed and open forms in the arts is related, I think, to the latent mistrust of design which, as I pointed out earlier, lurks behind the words we use in talking about it. The mistrust, I suspect, expresses our unconscious awareness of the fact that in a very real sense all the perfectly patterned relationships the artist seeks to symbolize in design are in an ultimate sense untrue and, in a profound sense, antilife. The forms of art and the formulas of science all attempt to reduce experience to some sort of order capable of being represented by a symbolic structure. The symbols may be those of a chemical formula or the words of a poem, the terms of philosophic discourse or the forms defined by pigments on the painter's canvas, the rhythmic and tonal patterns of a symphony or the structural units of a bridge. But in every case they are arranged,

1. See my essay "What's 'American' about America," in *The Beer Can by the Highway* (New York, 1961), especially pp. 45–58 and 65.

insofar as our intellects can manage them, to symbolize a balanced and symmetrically ordered reality.

There is, or seems to be, something about the human mind that is affronted by chaos. Our minds are evidently so constructed that they want to impose a symmetrical structure upon the elements of experience reported to them by our senses. The idea of symmetry is embodied in all the historical principles of art, such as proportion, harmony, unity, and balance, as well as in the scientific principles of the conservation of mass and the conservation of energy. So strong is the mind's bent for order that man has generally conceived the structure of reality itself, cosmic or molecular, to be symmetrical.

There seems to be increasing scientific evidence, however, to undermine our notions of nature's universal symmetry. Almost ninety years ago, Louis Pasteur experimented with the living organisms causing certain fermentations, and in the process became convinced of the sharply defined difference between the chemistry of living matter and that of dead matter. The molecular structure of living matter was asymmetrical, he said; that of dead matter was symmetrical. Contrary to man's traditional assumptions, he told the French Academy, life appeared to him to be dominated by asymmetrical actions. Life was, he conjectured, "a function of the asymmetry of the universe, or of the consequences that follow from it. *The universe is asymmetrical.*"

Although I am not qualified to describe or evaluate any scientific evidence for or against Pasteur's conception, I note that René Dubos, considered one of the greatest living biologists, says recent discoveries have led scientists generally to accept the notion that the structure of the universe is, as Pasteur presumed it was, asymmetrical.

Even in the field of mathematics the old certainties have been disturbed, since a young Austrian mathemetician, Kurt Gödel, proved as long ago as 1931 what Jacob Bronowski recently called "two remarkable and remarkably

unwelcome theorems," which added up to the assertion that "a logical system that has any richness can never be complete" and furthermore "cannot be guaranteed to be consistent." The mathematical logic of Gödel and his successors in England, America, and Poland has apparently demonstrated that there cannot be a universal description of nature in a single, closed, consistent scientific language. Bronowski's lecture "The Logic of the Mind," delivered before the American Association for the Advancement of Science in 1965, means, if I understand it properly, that the tendency of the human mind to conceive of reality as a mathematically self-consistent, unified, and closed system is simply not consistent with the random asymmetry of reality itself.

If we accept this conclusion, we must, I suppose, conceive of existence as some sort of process maintaining an unstable equilibrium between contrary tendencies. In the realm of inorganic matter there is apparently a universal tendency toward the decrease of asymmetry, a tendency exemplified in the growth of crystals. In the organic realm, however, there is a countervailing tendency to maintain the tensions of asymmetry. Life is a process of sustaining relationships; and those relationships cannot be separated out from the process, as a crystal can be removed from the solution in which it grows, without interrupting the process, without causing death. The asymmetry of living structures cannot be stabilized and contemplated in static isolation from the process sustaining it.

Regarded in this light, the term "organic form" as applied to the arts from the time of Coleridge to that of Frank Lloyd Wright embodies an absurdity. For the moment that we extract certain elements from an organic process they cease to be organic; no pattern in which we can arrange such extracted elements can itself be organic. The relatively stable and symmetrical form that the artist's mind ineluctably imposes upon these elements cannot symbolize the asymmetrical tensions of the organic process

from which they have been fatally abstracted. The most it can do is symbolize some relatively stable and symmetrical truth perceived by the artist in a particular phase of the process—a process that ceased, let us remember, the moment he abstracted from it the elements he fitted together to form the symbol of his perception.

From one point of view, then, the mind's tendency to symbolize our experience of life in the closed, symmetrical forms and formulas of the arts and sciences is inherently antilife. The creation of artistic form is to some degree a way of saying, "Stop the world; I want to get off."

From this point of view one can understand why Henry James, of all American novelists the most ascetically preoccupied with form, seemed to Sherwood Anderson to be "the novelist of the haters." Anderson himself was, of course, a writer of very moving fiction, as readers of *Winesburg, Ohio* know. Like most of the books we recognize as distinctly American in quality, *Winesburg* is a hard one to classify. Certainly it is not a novel in the traditional sense. In his memoirs, Anderson said he felt that in some important way "the novel form does not fit an American writer. What is wanted is a new looseness." In *Winesburg,* he added, "I . . . made my own form." Elsewhere he elaborated on this idea of looseness, in words that clearly relate it to the conception of open forms set forth earlier: "In the more compact novel form I have never been comfortable," he wrote; "life itself is a loose flowing thing. There are no plot stories in life."

What some literary critics decry as the formlessness of Anderson's fiction was thus the result of a deliberate effort on his part to devise a form open enough to let life flow through it unimpeded to accommodate "lives flowing past each other," as he put it. To be sure, he wanted the form to possess structural integrity sufficient to convey "a definite impression," by which he meant, I assume, that he wanted it to symbolize accurately his momentary perception of the significance of the flow of life about him. But he

did not want the form to be closed in a way that would restrict the flowing life whose meaning he was incessantly trying to comprehend and reveal.

The Jamesian impulse to create a closed symbolic structure, which Anderson thus deliberately renounced, seems clearly to embody the will to attain a degree of stability and symmetry incompatible with life. Therein, it seems to me, lies the explanation of man's subconscious uneasiness about design and plot and scheme. Therein also, I suspect, lies the explanation of the deep-rooted distrust of the sciences expressed in the popular fantasy of the Frankenstein monster. Therein, perhaps, lies the real significance of the anti-intellectualism that seems especially conspicuous now but has always been more or less with us. It was Melville who said in a letter to Hawthorne more than a century ago, "To the dogs with the head! I had rather be a fool with a heart, than Jupiter Olympus with his head. The reason the mass of men fear God and *at bottom dislike* Him, is because they rather distrust His heart, and fancy Him all brain like a watch."

The structures of art, as well as those of science, are, as we have seen, the creations of men's minds. But the individual artist or scientist is not merely a cerebral cortex. Like other men, artists and scientists have highly developed transmissive nervous systems constantly assaulting the mind with signals from the chaotic asymmetry of life's and nature's elemental energies. The scientist handles these signals differently than the artist, to be sure. Thanks to his laboratory procedures the nerve signals his mind receives can be more narrowly channeled than those the artist's mind must cope with; and because they are more narrowly channeled they are more systematically referrable to the recording and conceptualizing activities of the cerebral cortex. The signals received by the artist's brain are perhaps less manageable because less systematically preselected. But, in either case, these signals from chaos batter more or less continuously at the symmetrical structures the mind

creates in its unceasing effort to reduce that chaos to order. No order conceived by the mind and expressed in a symmetrical symbolic design can permanently withstand the assault.

Thus artists and scientists alike not only reject the forms and formulas of their immediate predecessors, but also, in the course of their own lifetimes, reject the designs they themselves formerly created. If they do not do so, they know, as do we, that as artists, as scientists, they are dead.

We say artists and scientists lose themselves in their work, but happily we speak in romantic hyperbole. For he who lost his life in this way would not thereby save it in eternal form. No symbolic design devised by the mind of man is eternal. Nothing is eternal except the unknowable form of eternity itself, and we do not live into eternity; we die into it. So long as the artist or scientist is alive, the flooding intuitions of reality contravene the symbolic orders his mind successively designs.

These conjectures about the nature of design seem to provide some basis for understanding why it is the closed forms authoritarian regimes have been willing to tolerate and even encourage from the time of the Pharoahs to those of Stalin and Hitler. A chart of developments in Russian architecture and painting since 1917 would, I think, quite accurately reflect the varying intensities of the Soviet government's repressive activities, as would a chart of the regime's attitudes toward the American jazz enjoyed by Russian young people.

These conjectures also seem to me to make some sort of sense out of recent developments in American art. I am thinking of the "happenings" in the theater; the "chance" choreography of Merce Cunningham's dance company—performances that do not begin, develop, and end in traditional form but simply start at an apparently random point and after a while stop. I am thinking, too, of all the various forms of what is coming to be known as "art *povera*": The "antiform art," the "process art," the "random art," and the

"earthwork art" of men such as Bill Bollinger, art forms strictly proscribing the sense of something closed off from the rest of nature, or framed. As the young sculptor Patricia Johanson said in a letter to me, "Some 'vanishing point' sculpture is really about traveling from one place to another, since each part is virtually out of sight of all the rest."

The artists working in these forms are all reacting against what Harold Rosenberg called "the formalistic over-refinement" in the art of the 1960s. (In the 24 January 1970 issue of the *New Yorker* Rosenberg discussed these trends as part of a movement whose central concept is "that the artist's idea or process is more important than his finished product.") On the West Coast we have the "funk art" of Bruce Connor and others who deliberately work in perishable materials. Connor once made a show out of food, big sandwiches and things. It opened and closed within two hours. "People came in and ate the art," Connor says; "I like that."

Much of the vitality of contemporary design is finding expression in such experiments with open forms, even though, in quite understandable reaction against the prevailing chaos around us, popular designers such as Peter Max get rich by employing an arbitrary Rorschach blot type of symmetry to gratify our irrepressible hankering for the kind of repose and balance provided by the closed forms of traditional art.

In the light of these conjectures we can, it seems to me, profitably reexamine our cultural history, including the development of our architecture, sculpture, painting, literature, and music. In these terms it will be seen, I suspect, that the influence of the American public upon our artists was greater and more propitious than that of the patrons and tastemakers who conscientiously tried to be benefactors of Art with a capital *A*. For it is true, I think, that the American public—to a greater extent than the public of any other nation in the nineteenth century—gave

free rein to the innate human mistrust of closed forms permeating the language we use in speaking of the arts. Hence the widespread public indifference and hostility to art despite the efforts of the custodians of culture. (Significantly, it was not until the frighteningly chaotic days of the great Depression, in the 1930s, that the public acceptance of officially sponsored art became an important aspect of American life.) Hence also the "perpetual repudiation of the past," to use Henry James's phrase, characteristic of our civilization—a repudiation we can now see as life's revenge upon aesthetic and cultural forms, which, insofar as they achieve a closed structure, embody an unconscious but nonetheless lethal will to subdue or set limits to life.

But the influence of the public on our artists has not been merely negative. At the same time that the public's unawed and often contumacious distrust of closed forms discouraged those who sought to create or foster such forms, it also encouraged the creation and development of open forms in all sorts of vernacular areas of design not overshadowed by the tradition of the fine arts. To an extent that literary historians are just beginning to discover, the forms developed in popular newspaper journalism were exploited not only by Mark Twain but by Emerson, Whitman, and Melville as well. Art historians are now beginning to explore the relations between the work of painters like Mount, Homer, and Eakins and the forms and techniques of vernacular pictorial materials, in photography and in the cheap illustrated magazines and books made possible by the invention of high-speed presses and a new technology of picture reproduction. It is in such areas of investigation, I am convinced, that historians of American art will make their most exciting contributions in the next quarter-century.

Finally, these conjectures suggest that our arts and our sciences are more significantly interrelated than art historians and historians of science have yet made clear to one another and to the rest of us. To me, at least, it now seems

clear that our artists and scientists during the nineteenth century were leagued, as they increasingly are, in the universal organic process by which nature maintains an unstable equilibrium between symmetry and asymmetry. For both the arts and the sciences, in their different ways, seek to impose order upon the elements of experience our senses report to our minds. Insofar as they succeed, they temporarily confine elements that will ceaselessly batter and eventually demolish the design imposed upon them.

The ultimate consequence of all design is therefore quite literally chaos—the violent eruption into randomness and asymmetry of energies that, for a time at least, have been forcibly restrained, even in the most open forms, by patterns of symbolic order. But this chaos, this ultimate consequence of design, is of course the raw material of artists and scientists. It is the very stuff out of which, with their partial perception, they select those details whose significance they strive to symbolize in design.

It is therefore time, I think, to turn inside out the hoary cliché that life is chaos, and to say instead that the wonderful and fearful asymmetry we call chaos begets life. Perhaps then we will perceive that, in spite of their professed allegiance to the ideals of order and symmetry, the greatest artists, writers, and scientists have always felt this to be so and have somehow found ways to let their commitment to life transcend their concern with form. Certainly this primal commitment governed the billions of people who, over the centuries, created the language in which we talk about art and everything else we care deeply about. For language itself, the greatest of all works of art, defies analysis in terms of any closed, symmetrical system of formal grammar and syntax, as the linguistics scholars are now quite ready to admit.

Perhaps if we bring to the surface our unavowed awareness of the vitality of chaos, we can reject the notion that the primary function of the arts must be to create closed forms of enduring order—however appropriate this notion

may have seemed in the relatively static, hierarchical societies of the past. Perhaps then we can practice and enjoy the arts in the hopeful, if hazardous, assurance that it is their function in a dynamic free society to cooperate with chaos by creating open forms—forms honoring and passionately sustaining the unstable equilibrium between symmetry, which is death, and asymmetry, which is chaos. For this unstable equilibrium is life.

Acknowledgments

In an earlier volume of essays (*The Beer Can by the Highway,* 1961) I expressed my gratitude for the stimulation I have received, through conversation and reading, from many other minds—both those whose perceptions seemed to me, when I encountered them, to be anticipations of what I was about to say and those whose views became abrasives upon which I could sharpen my own. As in that earlier book, there are scattered indications of such obligations throughout the present volume, starting with the dedication to the Frosts and the Lyneses. Yet I am well aware of debts to many other people—family, friends, students and colleagues at Barnard College, some of whose names I have forgotten—who have had a tonic way of disagreeing, goading or encouraging me. Those who come to mind as I look back over the preceding pages include Pat Adams, Jacques Barzun, Milton and Blanche Brown, Frederick and Judith Buechner, Ralph Ellison, Thomas Hornsby Ferril, the late C. Hartley Grattan, Julius Held, Patricia Johanson, my son Gerrit W. Kouwenhoven, Melvin Kranzberg, Eleanor and Eric Larrabee, Millicent and Rustin McIntosh, George Nelson, David A. Robertson, John Szarkowski, Patrick and Janice (Farrar) Thaddeus, Eleanor Tilton, Barry Ulanov, Caroline and Peter Welsh, Forrest Wilson, and most especially my wife, Joan Vatsek Kouwenhoven.

233

Index

Numbers in italics refer to pages with illustrations.

235